Hollow Icons

Hollow Icons:

The Politics of Sculpture in Nineteenth-Century France

Albert Boime

THE KENT STATE UNIVERSITY PRESS
Kent, Ohio, and London, England

© 1987 by The Kent State University Press, Kent, Ohio 44242
All rights reserved
Library of Congress Catalog Card Number 87-4247
Manufactured in the United States of America
ISBN 0-87338-346-x
ISBN 0-87338-354-0 pbk.

The paper in this book meets the guidelines for permanence and durability of the
Committee on Production Guidelines for Book Longevity of the Council on Library
Resources.

Library Congress Cataloging-in-Publication Data
Boime, Albert.
 Hollow icons.
 Bibliography: p.
 Includes index.
 1. Sculpture—Political aspects—France. 2. Sculpture, French—Themes,
motives. 3. Sculpture, Modern—19th century—France—Themes, motives. 4. Art
and state— France. 5. Art patronage—France—History—19th century. I. Title.
NB547.B64 1987 730'.944 87-4247
ISBN 0-87338-346-X (alk. paper)
ISBN 0-87338-354-0 pbk.

British Library Cataloguing in Publication data are available.

Contents

Illustrations vi

Foreword ix

Preface x

1. Introduction 1

2. The Restoration 16

3. The July Monarchy 25

4. Revolution and Counterrevolution, 1848-1870 57

5. The Third Republic 88

6. Conclusion 111

Excursus on the Statue of Liberty 113

Notes 140

Select Bibliography 153

Index 158

Illustrations

Delacroix, *Liberty Leading the People* — 2

Dumont, Vendôme Column topped by statue of Napoleon — 7

Seurre, *Napoleon I in a Frock Coat* — 10

Communards cutting the base of the Vendôme Column — 11

Fall of the Vendôme Column — 12

David d'Angers, *The Grand Condé* — 17

Guérin, *Portrait of Henri de La Rochejaquelein* — 19

David d'Angers, *Death of General Bonchamps* — 20

David d'Angers, *Memorial to Marco Botsaris* — 23

David d'Angers, *Pediment of the Pantheon* — 26

Félicie de Faveau, *The Queen Christina of Sweden Refusing to Spare the Life of her Equerry Monaldeschi* — 29

Duseigneur, *Roland furieux* — 32

Feuchère, *Satan* — 34

Rosa Bonheur in Templar costume — 35

Cortot, *Triumph of Napoleon I* — 39

Rude, *The Marseillaise* — 40

Etex, *1814 (Resistance)* — 42

Etex, *1815 (Peace)* — 43

Etex, *Cain and His Race Accursed of God* — 44

Préault, *La tuérie* — 47

Daumier, *Rue Transnonain* — 51

Une scène de la rue Transnonain — 52

Barye, *Lion Crushing a Serpent* — 54

Soitoux, *Figure of the Republic* — 59

Interior View of the Crypt and Sarcophagus of Napoleon — 61

Simart, *Pacification of Civil Troubles* — 64

Rude, *Napoleon Awakening to Immortality* — 67

Carpeaux, *Napoleon III Receiving Abd-el-Kader at Saint Cloud* — 72

Ange-Tissier, *The Submission of Abd-el-Kader* — 73

Carpeaux, *Ugolino and His Sons* — 76

Carpeaux, *The Four Parts of the World* — 79

Carpeaux, *Why Be Born a Slave?* — 81

Carpeaux, *The Dance* — 82

Detail from Bertall, *"Revue du mois"* — 84

Frémiet, *Joan of Arc on Horseback* — 90

Le 30 Mai à Paris — 91

Frémiet, *Gorilla Carrying off a Human Female* — 93

Juglar, *Chez l'usurier* — 96

Metviet, illustration for *Les héros et les pitres* — 98

Frontispiece and title page for Lemire, *Jeanne d'Arc* — 100

Rodin, *The Burghers of Calais* — 101

Title page of *Livre d'Or des Bourgeois de Calais* — 103

Illustration from *Livre d'Or des Bourgeois de Calais* — 104

Rodin, *Tower of Labor* — 107

Dalou, *Monument of Jean-Edme Leclaire* 109
Dalou, *Monument to Workers* 110
Bartholdi, *Statue of Liberty* 114
Barre, Seal of the Republic 126
Oudiné, Medal of the Republic 126
Clesinger, *Figure of the Republic* 127
Nast, *Liberty is not Anarchy* 135

In his famous review of the 1846 Salon the French critic Charles Baudelaire wrote a short section unexpectedly entitled "Why Sculpture is Boring." Even if he deplored contemporary sculpture (as he did), his response to it still startles us by its sweeping denunciation. And it is even more jolting when we learn that French sculptors such as David d'Angers, Préault, and Etex were among the most exciting and newsworthy people of Baudelaire's time. How could Baudelaire consider their work "boring"? He claimed that in general the sculptural presence was neutralized by its potential multiplicity of projections in comparison with a painting which could forcefully lock the spectator into a particular vision by a single, concentrated viewpoint. Baudelaire also made an analogy between the three-dimensional sculpture and the tribal fetish which appealed more readily to the rustic peasant than to the sophisticated Salongoer. Finally, he felt that modern sculpture could get beyond this primordial level only by relinquishing its self-sufficient status and humbling itself in the service of church and state architecture.

Without realizing it, Baudelaire was making a solid case for sculpture's statistically prominent role in nineteenth-century cultural production. The precise meaning of Baudelaire's contemptuous but revealing attitude will be found in the very nature of the sculptor's calling and in the historical and political evolution of nineteenth-century France. In the end, his provocative commentary helps clarify Napoleon's otherwise paradoxical remark, "If I weren't a conqueror, I would wish to be a sculptor."

Preface

A social history of sculpture is long overdue. Perhaps because the medium's political fallout is more related to function than to formal qualities, it has been ignored as the subject of extensive art historical research. Over the past few years an international body of scholars in the social sciences and art history have begun investigating the links between "art and politics," but in the realm of sculpture this study has been confined mainly to monographic works and/or articles and essays devoted to a single monument or particular era. In 1981, Horst W. Janson—perhaps the most important pioneer of the revived interest in sculpture in this country—and his son Anthony, then Senior Curator at the Indianapolis Museum of Art, had the ingenious idea to invite art historians who specialized in painting to examine with fresh eyes nineteenth-century European sculpture. I was invited to talk on "The Politics of Sculpture in Nineteenth-Century France." I became so engrossed in my subject that it became clear I could never confine my findings to a single lecture. Out of this symposium sprang the seed for the present study, an attempt to argue the case for a consistent and pervasive relationship between sculpture—in both its "official" and "unofficial" guises—and statecraft in nineteenth-century France. It makes no pretense at being a comprehensive survey of the social history of sculpture, but rather seeks to introduce the rich possibilities inherent in a generally neglected area of cultural production.

To make this study available to a non-specialist audience I have translated quotes from the French and have used English whenever possible to aid readability. My charge for the symposium was a public one, and that sense of responsibility has carried over into the final manuscript. It is altogether fitting that I end it with a chapter on the Statue of Liberty, the most popular icon in the United States and the subject of a corporate takeover (friendly or hostile?) on its hundredth anniversary as a U.S. citizen.

A study of this scope cannot be done without the usual support network that one calls upon in scholarly emergencies. Were I to name everyone, these acknowledgments would read like a telephone directory. I hope that those whose names I have not included will not consider the omission a sign of ingratitude. My first thanks go to the two Jansons, father and son, who took a risk in inviting a specialist in nineteenth-century academic painting to participate in their symposium at the Indianapolis Museum of Art on April 11–12, 1981. The other speakers, Dewey F. Mosby, Elizabeth Holt, Gert Schiff, and Gerald Ackerman, all contributed to my rethinking of the problems by their stimulating and provocative contributions.

I also owe a debt of gratitude for advice on particular points to my colleagues in art history and history, Glenn F. Benge, Edward Berenson, Paul Duro, Albert Elsen, Peter Fusco, Charles W. Millard III, Jane Mayo Roos, and Debora Silverman.

UCLA art history graduate students Celia Johnson, Michael Orwicz, and Jeri Mitchell also contributed to my thoughts on the subject, and Nancy J. Rhan

typed the original draft. Grace Wax and Caroline Kent assumed the typing responsibilities at a later stage and patiently saw it through its final version. Eugene Nesterov took the cover photograph and several others herein.

Finally, I am grateful to John T. Hubbell, director of the Kent State University Press and editor Flo Cunningham, whose calm patience and efficiency made this book possible.

The term "politics of sculpture" may conjure up associations with official or socialist realist art, embodying a negative value in its implicit failure to meet the criteria of so-called "inspired" creation. This study, however, presupposes that all art is political, whether it serves directly the needs of the state or seems to hover in a realm of fantasy and escapism. Yet in nineteenth-century French sculpture the integration of culture and political ideology is most strikingly revealed. I shall be concerned mainly with the relationship of sculpture to government policy at the national, regional, and local levels, and at the same time with the ideological implications of sculpture in its expression of an artist-patron dependence.[1] This shall embrace an untypically complex view of the politics of art which shall span the spectrum from Right to Left. For example, we tend to assess the various medieval revivals in monolithic terms, and yet it is clear from the historical record that there was a right-wing medievalism and a left-wing medievalism. These occasionally intersect in time, and their contribution to the general flow of art history is crucial if we are to have a more balanced account of the relationship between art and politics in this period.

I intend to argue that the martialing of sculpture and its related cultural conditions was not the result of chance, nor meant to be mere attraction or eccentric, but deliberately designed to complement political policy and/or social aspirations. The various French governments and their constituencies or pressure groups used all available aesthetic means to project a particular image. Broadly speaking, three levels of influence can be distinguished: that of the general practical applications of sculpture in articulating the face of a new regime, that of giving shape to a statement of political principle or polity, and finally that of recognizing the rise of one or more social groups in the shifting of power relationships in the evolution of the French state. The most easily accessible of these levels is the last, since it was not only the state but also the social groups and individuals who ordered or otherwise influenced the commissioning and production of sculpture. In this sense, I am not only interested in the official or bureaucratic apparatus but also in private benefactors who made sculpture an instrument of power and direction and a carrier of their social attitudes.

When compared to paintings, sculpture reveals several singular features of a political nature. Firstly, there is no work of nineteenth-century sculpture comparable to Delacroix's *Liberty Leading the People* (Fig. 1), no revolutionary statement as dramatic and as politically charged as David's *Oath of the Horatii* (1784) or *Oath of the Tennis Court* (1790s). Certainly there are sculptures dedicated to the cause of liberty, to democratic and even revolutionary ideals, but none assume the sense of immediacy, of urgency, of inner and outer-connectedness we find in the work of David, Géricault, Delacroix, Daumier, and Courbet. This is a startling fact on the face of it, but it becomes even more bizarre when we investigate the class backgrounds of painters and sculptors. As Wagner has suggested, most French sculptors of the nineteenth century came

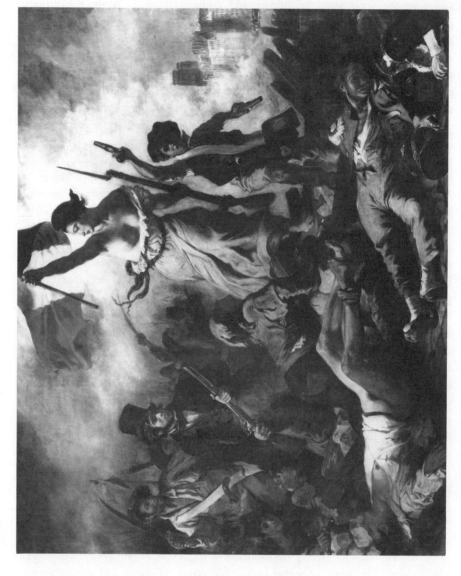

Fig. 1. Eugène Delacroix, *Liberty Leading the People*. Oil on canvas, 1830.
Musée du Louvre, Paris.

from artisanal backgrounds; often their fathers—and occasionally mothers—
exercised a skilled craft such as ornamental sculpture, stonecutting, masonry,
carpentry, smithing, and other practical trades.[2] Painters on the other hand
descended largely from the middle classes; more rarely did they stem from
artisanal backgrounds in the nineteenth century (although not uncommon in
the previous century), with the families loosely classified as "lower" middle
class in several instances.

The sculptor's dependence on the bronze founder would have plunged him
into working-class agitation and issues. The professional organization of
workers in bronze sculpture was backed by bronze workers employed in the
manufacture of fixtures for gas heaters and lamps. Organized in the 1860s as
the Société de Crédit Mutuel des Ouvriers de Bronze, this group actively
fought for a wide-ranging program including higher wages and shorter hours,
healthier job conditions, and the right to outside arbitration. Their successful
strike against the founder F. Barbedienne, who led the fight to maintain the
eleven-hour working day, was endorsed by the Association Internationale des
Travailleurs.[3] This volatile activity in the workshop and foundry would have
had direct consequences for the sculptor's personal production.

Sculptors therefore knew intimately the social, political and economic
problems of the class that most often took the lead in revolutionary struggles,
whereas the painters knew it only at second hand. Sculptors themselves knew
how to organize workpeople, understood more thoroughly the ways in which
bureaucracies functioned, knew how to manage large-scale enterprises, and
were generally more sophisticated politically than painters. This is demonstrated
in the actual lives of several prominent sculptors: David d'Angers, Etex, Rude,
Ottin, and Lemaire served in or ran for political office, or thought themselves
capable of administering such an office. Rude, whose bid for a political position was
rejected by the prefect of his region, was certainly a capable administrator. Already
as a young practitioner he organized the sculptors of the Arc de Triomphe project
to demand greater compensation for their labors; he signed himself at the head of
a number of petitioners whose statement revealed a thorough analysis of cost expen-
ditures, materials, manpower, output, and even offered a cogent alternative for the
official in the event he disagreed with their assessment.[4] Except for the rare cases
of the French David and the Italian Massimo d'Azeglio, there are few instances of
painters entering the political domain or revealing the political insight of sculptors.

Why then does the sculpture of the period appear generally more conserva-
tive than the painting? There are several reasons for this, all of which tend to
diminish the possibilities of experimentation and invention which appear con-
temporaneously in the most progressive painters of the period. Above all was
the cost of sculpting, the sheer material expenditure involved in the execution
of three-dimensional works of art. As opposed to the painter who had a rela-
tively low overhead, the sculptor faced not only the provision of clay, tools,
modeling stand, tubs, and buckets, but also of armatures for both clay and

plaster (which involved welding by a smith for large pieces), as well as the enormous expense for the final execution of his work in bronze or marble.[5] Often, the sculptor required the help of *praticiens* or journeymen assistants who executed the plaster cast in marble. The sculptor therefore had to have on hand much more ready capital to pay in advance for material and the wages of the *praticiens* who were a tough lot and could make it difficult for a negligent master.

Sculpture thus demanded huge outlays of cash before sculptors could enjoy a return on their capital investment, even when the work was a private commission. It is noteworthy that sculptors in general found fewer private buyers than painters. Etex wrote in his essay on Pradier that a rich bourgeois who thinks nothing of spending twenty to fifty thousand francs in furnishing his apartment or town house with the latest carpet styles will balk at paying two thousand francs for an excellent bust. The critic Thoré referred to the paralyzing effect on sculpture of the demands of the Salon jury when he wrote in 1847: "Where can a plaster group or a marble statue be exhibited? And who will buy them? There are not half a dozen sculptors in Paris who can make a living without the publicity of the Salon and state patronage."[6] These declarations demonstrate the almost total reliance of the sculptor on the state for support, including the blocks of marble supplied by the government from its storehouses on the Isle de Cygnes or government-connected entrepreneurs. Along with high costs, this reliance on the government prevented sculptors from undertaking the kind of experimentation available to painters. Most French governments were less interested in innovation than in preserving traditional links. Sculptors simply could not take the risks of a Realist or an Impressionist until late in the century. Whereas the sketches and maquettes of sculptors often show the impulsive gesturing of the modernist painters, the plaster models—executed with an eye to marble or bronze transference—remained fairly conservative in execution. Compared with the sculptor, the painter could afford to act more independently; with a relatively low overhead and investments one could attract more private buyers.

There was, however, one trend in the period that promoted sculptural experimentation and that had to do with the growing appreciation for decorative and industrial art applications. The most progressive sculptors of the period, such as Barye, Feuchère, Carpeaux, Carrier-Belleuse, and his disciples Dalou, Falguière, and Rodin, functioned as entrepreneurs as well as artists, satisfying a growing market for bronze miniatures and architectural decoration and often working in conjunction with major industrial art firms like Christofle et Cie, Froment-Meurice, Susse, and the founder Barbedienne. These sculptor-entrepreneurs were also served by new methods of reproduction like the Collas reduction machine and the various electrometallurgical processes. Their commercial outlet permitted fairly novel approaches, and the most experimental sculptors—Barye, Carpeaux, and Rodin—were deeply involved with the art market. Carrier-Belleuse was a crucial model for the atti-

tude of Rodin, and it is significant that the rupture of their relationship occurred when Rodin tried to peddle a work he executed with the forged signature of his master.

The close connection between sculptors and the applied arts movement in the nineteenth century is also reflected in the number of sculptors active in promoting the union of fine and applied arts through organizations, unions, and publications. At first stimulated by the government of the July Monarchy, these groups enjoyed their greatest prestige during the Second Empire whose urban redevelopment, industrial expansion, and commercial rivalry with Great Britain required the services of an army of sculptors trained and ready to execute the government's scheme. Sculptors were far more active than painters in this process, with Feuchère, Klagmann, Etex, Guillaume, Ottin, and others devising schemes for reforming art instruction and encouraging the union of the fine and applied arts. Their arguments provided the basis for the government's far-reaching reforms of the Ecole des Beaux-Arts in 1863. Experimentation in sculpture also can be said to have been made possible by the Second Empire's encouragement of arts in industry and its widespread urban improvements and architectural program. The pedagogical systems were overhauled to conform to the government's program and to turn out the bodies necessary for its realization.

There is still another side of the basic nineteenth-century sculptural conservatism, and that is the enduring academic concept of sculpture as the "image of eternity." Until late in the century, sculpture was still perceived as the embodiment of "great men" and noble ideas in an imperishable substance, the material equivalent of their "immortal" status. Naturally, the model of antiquity was constantly paraded before neophytes and would have been inculcated early on by their required reading of Eméric-David's *Recherches sur l'art statuaire* (1805). The vacant stare, idealized pose, and monochromatic marble or stone surface was the acceptable type of heroic sculpture, and it was mainly through identification with this type that the sculptor and the official public recognized sound, qualitatively superior achievement. But this antique prototype was no more than an accepted convention and was perpetuated by governmental and privileged interests requiring legitimacy through the projection of themselves and their ancestry in immortal guise. Great men are descendents of other great men, and alone deserved to be eternalized in imperishable materials. While sculptural subjects became more democratized and modernized in response to more popular forms of government, an allegorical context or complement was still required to sustain the link with the past and guarantee the subject's greatness. Official doctrine stated that the government undertook the erection of public monuments mainly devoted "to the memory of celebrated men or to the commemoration of important events."[7] During the Third Republic a few allegorical approaches were standardized and adapted to changing circumstances. They were submitted to evaluation by a wide representation of the

municipal or regional community whose subscriptions often defrayed the expenses of the sculpture. These allegorical images had to be communicable, legible, and answer to what people expected of heroic sculpture—that is, the type of antique monumentality and idealization sponsored by generations of aristocratic elites.

An excellent example of the discrepancy between the experimental potential of painting and the traditional constraints in sculpture during the Third Republic is seen in the work of Falguière. A friend of Rodin and ex-disciple of Carrier-Belleuse, Falguière was himself a painter of talent well aware of progressive tendencies. He tried to close the gap between advanced painting and contemporary sculpture by infusing his sculptural works with dynamic movement and experimenting with fresh modeling techniques. But he was much more successful in his modernist painting than in his sculpture, and this probably explains why he devoted a significant amount of his activity to it. This split in the painter-sculptor approach is exemplified in the exhibition of his work at the Salon of 1875. A reviewer contrasted the "brutal realism" of his painting *The Wrestlers* with the dignity and restraint of his sculpted group, *Switzerland Welcoming the French Army.*[8]

Both images were topical, but the *Wrestlers*—directly influenced by Courbet's similar subject of 1853—designated a particular milieu and identifiable types while the sculpted group was allegorical. The city of Toulouse, Falguière's hometown, commissioned the sculpted group as a gift to the municipality of Geneva in honor of the Swiss people. Although Switzerland proclaimed its neutrality during the Franco-Prussian War, immediately after receiving news of the September insurrection it recognized the Republic. The Swiss, moreover, acted generously and hospitably toward French refugees and wounded soldiers who fled across the border. Later, following the smashing of the Commune by the Versailles government, Switzerland became the place of exile for the Communards including Courbet himself. Toulouse, traditionally a center of radical politics, also admired Swiss democratic movements in the early 1870s which took an increasingly liberal and anticlerical tone.

Yet Falguière's sculptural group belongs to a conventional category; while the female personification of Switzerland wears the Helvetian costume she is nevertheless identical to the familiar allegories of Liberty, Victory, and the Republic. She supports an exhausted French soldier, analogous to an image of religious suffering and consolation. This combination of dominant allegory and dependent actuality conformed to a standard type of the Third Republic, a period when France was affected by what Agulhon called "statuemania."[9] In this sense, the *Wrestlers,* with its coarse technique and topical allusions, including the complementary reference to a Communard safely sheltered in Switzerland, is far more politicized than the sculpture.

The standardized formula of the Third Republic related to the extreme systematicization of the traditional conception of sculpture in a heroic, classical

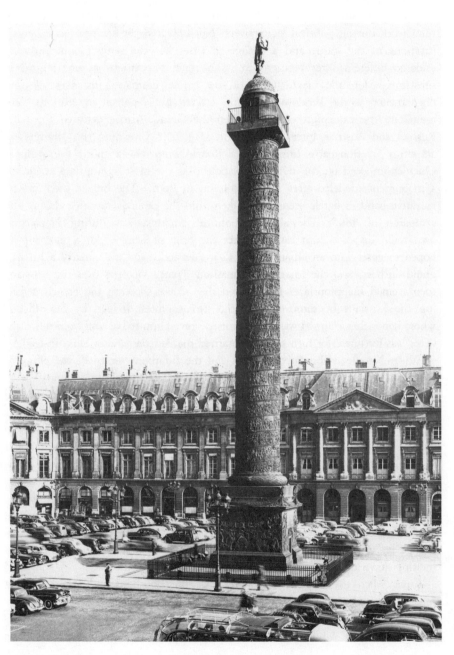

Fig. 2. The Vendôme Column topped by statue of Napoleon by Augustin-Alexandre Dumont after Chaudet, 1862–63. Caisse Nationale des Monuments Historiques et des Sites, Service photographique, Paris.

Introduction

mode. The pressures on sculptors led to increasing generalization and standardization of the sculptural product, so much so that it became possible with changing governments to use a figure designed for one as a symbol of the other. The interchangeability of sculptural subject is a commonplace in the nineteenth century and derives from the essentially conservative tradition of the sculptural profession.

This interchangeability is further related to the reinterpretation of the sculptural work during political switchovers. Not only can the sculptor accept modifications in the statue and a change in title, but the same monument may undergo different interpretations in its national associations as one regime is substituted for the next. One of the most dramatic instances of this phenomenon is the Vendôme Column, erected by Napoleon in 1810 to commemorate the campaign of 1805 when the Grande-Armée defeated the joint Russian and Austrian forces at Austerlitz (Fig. 2).[10] Crowning the column was an effigy of Bonaparte himself as a Roman emperor—a motif the sculptor Chaudet imposed on the reluctant Napoleon as the most appropriate avatar for a monument modeled after Trajan's column in Rome. The bronze used for the narrative band of battle scenes was taken from the cannons captured during the campaign of 1805. The shifting political circumstances during Napoleon's own reign disposed him early to alter the original scheme: for a moment he hoped to enter into an alliance with Czar Alexander and even marry a Russian grand-duchess, and the imagery of smashing French victories over the Russians then seemed inappropriate. He ordered that scenes showing the French defeating the Russians be removed, but the strong protest lodged by his officers, whose honor they claimed was compromised, forced him to back off from this plan. (This was fortunate for him since he married the Austrian Maria Luisa instead.)

When Napoleon abdicated in 1814 and the Bourbons returned, the effigy of Napoleon was toppled and replaced by the Bourbon white flag decorated with fleurs-de-lys in an elaborate framework. When Napoleon returned from the Isle of Elba for his Hundred Days the flag was removed and an inspired officer tried to recover the monument for the emperor by placing his bust at the foot of the column. This, however, embarrassed Bonaparte in its pettiness and he ordered it withdrawn. When Napoleon was decisively defeated at Waterloo, the Bourbons melted down Chaudet's statue of the emperor to supply the material for the horse of François-Frédéric Lemot's equestrian statue of *King Henri IV,* erected on the Pont Neuf in 1817. The bronze founder had hoped to preserve the Chaudet work as a national monument and even offered to supply in exchange for it an equivalent amount of bronze, but the government insisted on melting down the Napoleon as a political symbol of defeat.

Later, when the July Monarchy replaced the Bourbons and Louis-Philippe made concessions to the popular enthusiasm for Napoleon, the government ordered a new statue of the emperor placed atop the column. This time, however, the regime—which opened a contest for the commission—stipulated that

Bonaparte be shown in his historical costume, as in the winning entry by Seurre (Fig. 3). Article 5 of the competition rules noted that since the figures of the bas-reliefs on the column were clothed in French military costume "the statue ought to be shown similarly in military garb."[11] But David d'Angers, who was a member of the jury deciding the winner, claimed that the government's new conception was strictly political; it wanted to deprive Napoleon of all grandeur rather than "inflame the hearts of the people with an apotheosis."[12]

When the Second Empire was established, however, Napoleon III wanted to revive the concept of a Bonapartist dynasty with symbolic links to the Roman Empire. Hence the image of a transcendent ancestor coincided with his imperial aims and need for legitimacy and he therefore ordered that Seurre's statue be replaced by a replica of Chaudet's original version. Dumont's scrupulous reproduction, with Napoleon holding the globe crowned by an allegory of Victory, was unveiled with maximum publicity and pageantry. The Vendôme Column now promoted the Napoleonic legend in Napoleon III's interests, and each year a special parade and review of the imperial troops were organized in the Place Vendôme. As a result, the Vendôme Column came to incarnate the ideology of the Second Empire and represented a hated target of protest on the part of its opponents. After the Franco-Prussian debacle it hovered over Paris as a sign of a painful past and humiliating present. Embittered by long years of repression, the members of the Commune vented their fury on the Vendôme Column which was toppled in a mass spectacle—like the reverse of the statue's inauguration (Figs. 4, 5). Ironically, the conservative Versailles government which crushed the Commune and then became the Third Republic was bent on restoring the Paris of the pre-Commune days and reinstalled the Vendôme Column during the period 1873–75. The old Roman Bonaparte was restored to the top of the column where he still may be seen today.

The ups and downs—or should we say the rise and fall?—of the Vendôme Column is only one spectacular example of the problem of French sculpture in connection with nineteenth-century politics. This was related to the fact that sculpture, although more conservative than painting in technique and subject, was potentially more political in its official and public associations. While Delacroix's *Liberty Leading the People* was a controversial political painting— kept in storage throughout most of the July Monarchy it was meant to celebrate—no one would have imagined destroying it or scraping off the pigment to paint an imperial or monarchical image. Of course, paintings are housed in an interior with security that defies vandalism. Pictures, moreover, convey more the sense of private possessions than sculpture, which more commonly conveys the sense of the communal and public. Outdoor, official sculpture occupies in actuality a public space and automatically acquires a political character. Even when sculpture appears in an interior it recalls less private ownership than religious or public function. Sculpture, especially monumental sculpture, is manifestly political and once addressed entire communities; it was

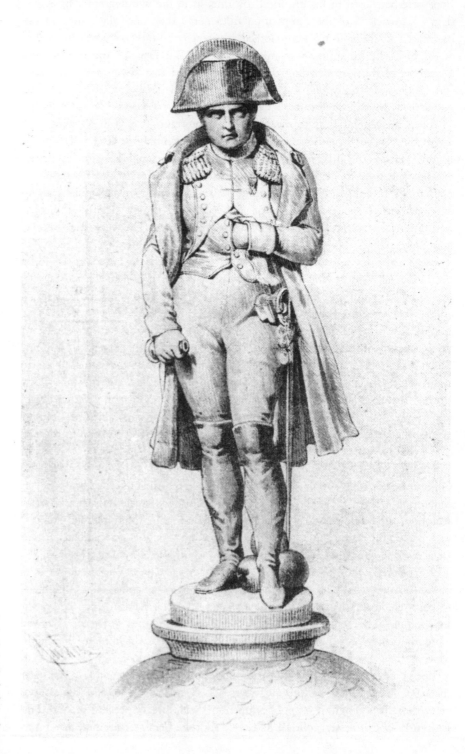

Fig. 3. Charles-Emile-Marie Seurre, *Napoleon I in a Frock Coat*, 1831–33. After a contemporary engraving; original in bronze, now in the Musée de l'Armée, Hôtel National des Invalides, Paris.

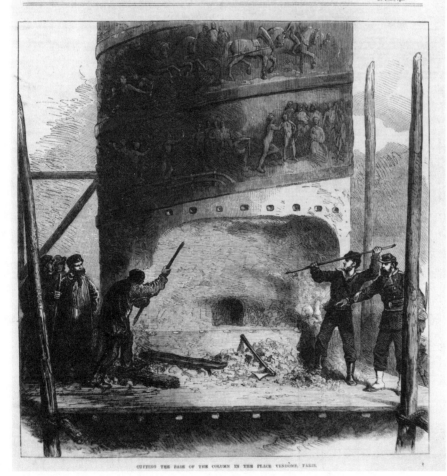

Fig. 4. Communards cutting the base of the Vendôme Column. Wood engraving reproduced in the *Illustrated London News*, 27 May 1871, p. 509.

12

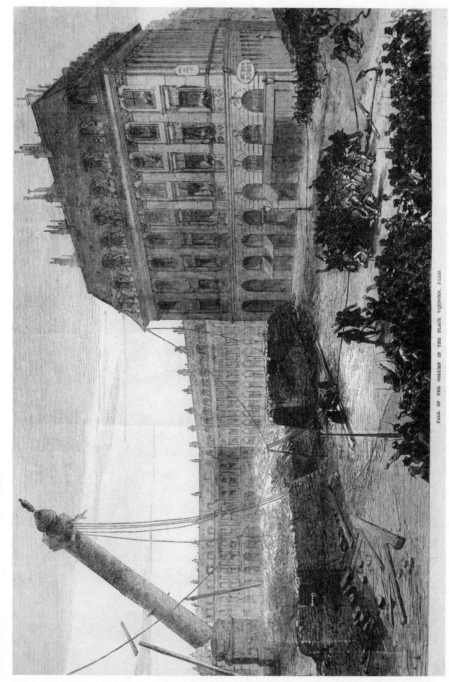

Fig. 5. *The Fall of the Vendôme Column.* Wood engraving reproduced in the *Illustrated London News*, 27 May 1871, pp. 528–29.

FALL OF THE COLUMN IN THE PLACE VENDÔME, PARIS

a landmark, a place to meet, the goal of an afternoon promenade. While today the automobile has diminished the significance of the sculptural monument for the community, in the nineteenth century the monument expressed a group's aspirations and related them to a region or the state. Governing bodies which commissioned public sculpture knew the sense of pride and patriotism it could instill in the community.

The political character of the public monument resides not only in physicality and subject, but even in the decision-making process integral to the financing and erecting of a monument. Around 1820, in the Vendean town of Laval, a monument was planned in memory of the Vendean troops fallen in combat at the Croix-Bataille during Napoleon's Hundred Days. A heated argument developed around the precise choice of location: the prefect wanted it erected at the most elevated spot so that it could be seen from afar, while the ultraroyalists wanted it located on the field of battle itself like a tomb marker. The prefect had a somewhat modern attitude, while the townspeople were motivated more by piety and tradition—typical of many controversies in the nineteenth century.[13] Later, these problems were complicated by public subscriptions when representatives of all economic and political categories could subscribe any amount and thus involve themselves directly into the elevating of a public monument.

The inauguration of a public sculpture was yet another significant political act: it was commonplace to orchestrate the unveiling of a monument at election time or for prominent statesmen to then wax eloquent on patriotism, nationhood, and the achievements of the current government. At the same time, the gathering of the public for such events also furnished the opportunity for mass demonstrations especially in opposition to the spirit of the monument or its presence in a particular geographical area. Even the mere proposal of a bust of Emile Zola in 1908 for his hometown Aix-en-Provence excited wild passions because of the lingering emotions connected with the Dreyfus Affair. The inaugural of Frémiet's *Joan of Arc* witnessed a patriotic outburst from people of Orléans.[14] Whether the work is accepted, defied or rejected, the political potential of sculpture is often more volatile than in painting. Only rarely do we find a painting mutilated or defaced for political reasons, while vandalism against sculpture is legion. Nelson's statue in Dublin has been repeatedly attacked by the IRA, Queen Victoria's effigies were systematically torn down after India's independence, and closer to home Rodin's *Thinker* in front of the Cleveland Museum of Art was mutilated as a symbol of the White Power Structure. Today, the use of the aerosol spray can substitutes increasingly for the physical destruction of monuments but the message remains essentially the same.

Thus while the nineteenth-century sculptural monument in comparison with the painted picture was inherently more conservative in its style, subject, and technique, its physical presence in a civic site promised a more political reaction than

a painting on exhibition. The public, three-dimensional extension of sculpture inevitably charged it with a political mission, although its subject might be of the most uninspired type and its presentation dull by contrast with a *Liberty Leading the People*. Sculpture was, in this sense, *intrinsically depoliticized* and *extrinsically politicized*. Of course, accrual of meaning always occurs independently of the particular ideological aims of artists and/or patrons at the time of execution, but here I wish to argue the case for sculpture's enormous potential to be reinterpreted and to generate new signification in unfolding historical time.

Sculpture not only *represents* something outside itself, but *presents* itself as an object in the universe of things. It simultaneously produces narrative while occupying space like a piece of furniture or natural or sacred object which has to be surmounted or gotten around somehow. This ambiguity in its physical presence and signifying function allows it through time to generate fresh meaning within its public context. Painting on the other hand, hanging innocuously on interior walls, lacks this ambiguity except in the form of the monumental mural. The mural which is directly integrated with a physical structure shares sculpture's double visual and signifying function.

The *intrinsic* conservatism of sculpture in the nineteenth century was directly related to the pedagogical program. We have emphasized the working class and artisanal background of the sculptors as a paradoxical feature of their production; in fact, this explains why the theory of the "immutable ideal" proved more enduring in their profession than in painting. Most sculptors were poorly educated in comparison with painters and were far less secure in society. They were socialized in the Beaux-Arts program, with the Academy at Rome serving as a kind of finishing school. The Villa Medici as an artistic center was the point of contact for influential members of the French colony in Rome, and the sculptors profited from these contacts which helped them to make their way in society. But it also made them susceptible to elitist standards. Their training took place in the artisanal world of the Petite Ecole and they had to work hard to acquire the cultural polish appropriate to the social life in which they now participated. Less secure than the painters, it was easier for them to accept the philosophy of the "ideal" associated with sculpture.

An example of how this operated may be seen in the experience of Simart, an ex-pupil at the Petite Ecole, as a Prix de Rome candidate at the Ecole des Beaux-Arts. Simart entered the 1833 Prix de Rome competition, the subject of which was La Fontaine's fable "The Old Man and his Sons." Simart, whose father was a carpenter and supporter of the July Revolution, wanted to give his version a political meaning. He put into his sketch an agricultural laborer, a warrior, and a magistrate to emphasize the idea of a union of all classes in society. While the veteran sculptor at the Ecole, Pradier, liked the idea, Simart's master Ingres dismissed it as "pretentious," and above all Simart's protector, Marcotte, receiver-general of the Department of Aube, told him that the Prix de Rome competition was meant to demonstrate "savoir" rather than

political insight. Since the projected allegory would not allow for the use of the nude body, this ultimately would be detrimental to the jury's estimation of Simart's project. Marcotte continued: "Your political idea, could, as I see it, seduce many people, but this idea is already implicit in the original fable; it has no need of being developed further and you would do well to abandon it." In the end, Simart followed the advice of Ingres and his aristocratic patron and won the contest. But it came at the expense of his immediate "political preoccupations," and this undoubtedly was a commonplace experience.[15]

A closer investigation of the politics of sculpture in nineteenth-century France begins with the Revolution of 1789 which inaugurated the modern era and was the first to issue a decree dealing with public monuments whose content contradicted present political reality. As early as September 1789 radicals in the National Assembly proposed to destroy the statue of Louis XIII and with its debris raise a work to the defenders of liberty and *la patrie.* On 19 June 1790 the National Assembly initiated a series of iconoclastic measures, with one member moving that all monuments recalling either the domestic or foreign oppression of the old feudal order be smashed. He especially pinpointed the group in the Place des Victoires erected by Louis XIV to commemorate his military victories and showing a ring of chained slaves around its base.

This motion also provided an occasion to give symbolic form to the assembly's repudiation of old regime foreign policy, a controversial issue since May when debate opened over Louis XVI's alliances and capacity to wage war. The motion was adopted, but the resulting decree forbade wholesale destruction of private property and consigned actual execution of the iconoclasm to 14 July to link it to a legitimate time of celebration. But the legitimation of iconoclasm was bound to set in motion uncontrollable events, and in the wake of insurrection on 10 August 1792 an angry crowd vented their frustrations by crashing to the ground several royal monuments in Paris including Bouchardon's Louis XV.[16]

Naturally, the Restoration did everything possible to redress the revolutionary and Napoleonic purge of Bourbon icons. It may be recalled that the emperor's statue had been taken down from the Vendôme Column and melted down for the horse of Henri IV restored on the Pont Neuf. At Napoleon's downfall, the sculptor Lemot hastily executed a plaster reproduction of the destroyed original to greet Louis XVIII on his return to Paris. In 1816 the king further ordered that all vandalized statues of famous individuals of the ancien régime be repaired, and he made a list of twelve glorious heroes whose monumental statues were destined to decorate the Pont Louis XVI (now the Place de la Concorde). Most of these celebrities, like du Guesclin and the Grand Condé, were great military heroes who had been loyal servants of the Bourbons. Everywhere there was a campaign to restore the statues of kings demolished or broken by the Revolution: when the Municipal Council of Caen in 1816 demanded credit to erect a statue to Malherbe, the prefect answered that the restoration of the statue of Louis XIV had more priority. Louis XIV was finally reinstated in 1828 while Malherbe had to wait until 1845. The significance of the sculptural program for Louis XVIII is seen in the fact that he decreed in 1816 that no public monument by either military or civil institution could be erected without preliminary authorization from the Court. The Crown manifestly gave public monuments top priority and wanted exclusive control over the choices to be made.[1]

One of the important sculptors to emerge in this period was David d'Angers, one of France's most outstanding sculptors in the first half of the century. While he is considered a life-long republican, he in fact began as a sculptor under the new Restoration sculptural program. It was the Restoration's need for artistic propaganda that launched David d'Angers's career. His moderate republicanism emerged during the July Monarchy and was probably stimulated by the controversy surrounding his Panthéon commission. But his first major commission served to aggrandize the Bourbon dynasty as part of its new program.

Among the heroes the government wanted statufied was the Grand Condé, the brilliant military chief of the seventeenth century. The Grand Condé stemmed from a collateral branch of the Bourbons and made his reputation during the epoch when France established itself as the most powerful nation in Europe. He performed brilliantly at the Battle of Rocroi against the Spanish in 1643 and the following year at Freiberg when his troops were vastly outnumbered by the Bavarians. The Bavarians were well dug in, and legend has it that the Grand Condé dismounted from his horse, hurled his officer's baton at the trenches, and marched like a common foot soldier at the head of his army. While the anecdote had never been substantiated, it was the moment the sculptor chose to represent. David d'Angers's *Grand Condé* rears back like an Olympic athlete to fling his baton at the entrenched enemy, and one can almost hear the passionate strains of a Beethoven piece as the cloak is thrust back by the motion (Fig. 6). Although displaying an affinity with Bernini's *David,* the dramatic,

17

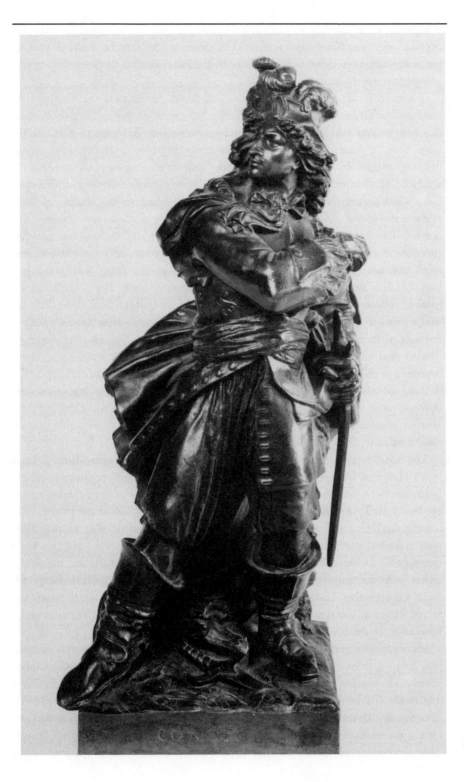

Fig. 6. David d'Angers, *The Grand Condé*. Bronze version, 1827. Musée du Louvre, Paris.

The Restoration

energetic pose was widely seen as a novel departure from the neoclassic statuary still popular under the Napoleonic regime. Thus what is considered a pioneering example of Romantic sculpture was motivated by the government's propaganda program to exalt the newly returned Bourbons.

It should be emphasized that the *Grand Condé* represented the Restoration's attempt to create a counterrevolutionary, counter-Bonapartist Bourbon military hero to supplant in the public mind the souvenirs of the recent past. At the same time, it wanted to preserve the sense of patriotism engendered by French military might by transferring patriotic zeal from one set of symbols to another. Another example of this type is Guérin's painted *Portrait of Henri de La Rochejacquelein* (Fig. 7), which was also exhibited in the Salon of 1817 along with David d'Angers's half-size plaster model of the *Grand Condé*. This portrait formed part of an important series of portraits of Vendean generals commissioned in 1816, around the same time that the *Condé* commission was originally assigned to David's master Roland. (Roland's death that same year provided his disciple with his first official opportunity.)[2] The Vendée region turned counterrevolutionary during the Jacobin republic and defended the throne; this led to bitter internal strife at almost the same time France's foreign enemies were advancing on the frontier. The need to suppress the domestic conflict was one of the root causes of the Terror. But ever after, the Vendée became a symbol of Bourbon pride and hope. La Rochejacquelein was especially dear to the royalists; he refused to emigrate like the majority of his aristocratic *confrères*, and despite his youth was named commander-in-chief of the Vendean insurrection. He was killed by republicans in 1794 after having fought valiantly in several key encounters.

The name even had more recent implications for the Restoration: during Napoleon's Hundred Days a brother of La Rochejacquelein, Louis, organized another insurrection in the Vendée called the Royal Volunteers of La Rochejacquelein. He was killed on 4 June 1815, and his portrait was also included in the 1816 commission. Guérin's Vendean hero is framed by the white flag of the Bourbons inscribed with the counterrevolutionary slogan "Vive le roi," and he wears the insignia of the cult of the Sacred Heart, newly resurfaced during the Restoration and the emblem under which the Vendean counterrevolutionaries rallied. Conservative Catholics in the postrevolutionary period understood the Sacred Heart as the symbol of the triumph of the Church over its enemies and a restoration of the union of throne and altar.

Ironically, the prototype for the counterrevolutionary images of the Restoration derived from Napoleon's favorite painters David and Gros. Gros's dashing portrait of *Napoleon at Arcole* (1799) clearly served as the model for both David d'Angers's *Grand Condé* and Guérin's *La Rochejacquelein*. While substituting Bourbon for Bonapartist heroes, the Restoration art program clearly wanted to exploit the sense of patriotism and military glory engendered by their predecessors. That the Napoleonic prototype should have served as the basis of a counterimage

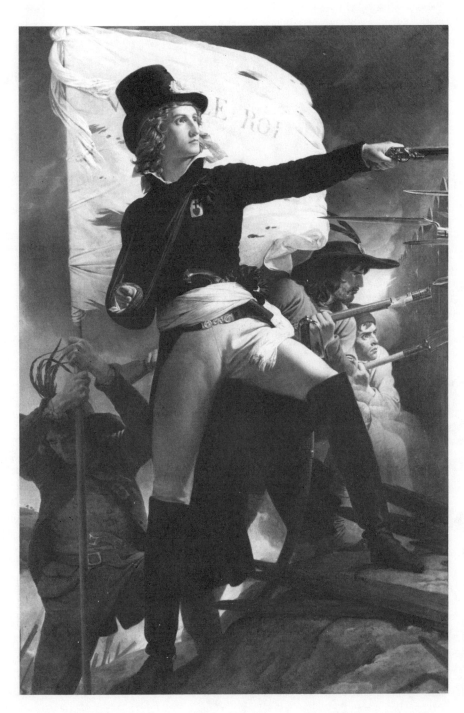

Fig. 7. Pierre-Narcisse Guérin, *Portrait of Henri de La Rochejaquelein*. Oil on canvas, 1817. Musée Municipal, Cholet.

20

Fig. 8. David d'Angers, *The Death of General Bonchamps*. Plaster model, 1819. Musée des Beaux-Arts, Angers.

is consistent with the developments connected with the effigy atop the Vendôme Column. Another feature of this connection is that the Grand Condé was the first of the line to use the title the duc d'Enghien, a name which had bitter implications in the ideological conflict between royalists and Bonapartists. In 1804 Napoleon ordered the young noble with this title executed for conspiring against him, and the royalists never forgot this assassination of one of their own. But plans for a public statue of the duc d'Enghien were rejected by the Restoration government because the hero was of too recent memory, and it is likely that the *Condé* also fulfilled the purpose of revanche.

The primary function of the series of commissions for Bourbon military heroes was to serve the martial propaganda of the new regime. The Restoration abolished the hated military conscription laws and established a system of voluntary enlistment. But this proved ineffective and the government was forced to pass new laws in 1817 to provide an adequate number of troops to fill the military quota. The statufication of Bourbon adventurers coincides with the recruiting campaign, and one can understand the dramatic presentation of David d'Angers's figure as an image declaiming: "The Grand Condé wants you!"

The sculptor did a number of works glorifying Bourbons, and one of these was the monument to yet another Vendean hero, General Bonchamps (Fig. 8).[3] This commission was authorized in 1817 although David did not actually receive it until two years later. Bonchamps, like La Rochejacquelein, earned his fame for generosity to his republican enemies as well as for his courage under fire. According to a popular story, five thousand republican prisoners incarcerated in the church of Saint-Florent were about to be massacred by their Vendean captors when Bonchamps, himself fatally wounded, ordered with his last breath: "Grace for the prisoners, I wish it, I order it!" While there was evidence to contradict the possibility of Bonchamps being present at this scene, this is the subject portrayed by the sculptor. Here the example of the classical nude—modeled after the *Dying Gladiator* (or Gaul) (ca. 230–220 B.C.)—is invoked for elevating the modern hero.

Yet the effect is more like that of an expiring Christian martyr, and in fact the work is steeped in religious sentiment. The monument to Bonchamps, who was revered for his Catholic piety, is complemented by two bas-reliefs depicting allegorical personifications of Religion and France in attitudes of maternal grief. David d'Angers's monument was inaugurated as part of a solemn religious ceremony: it was installed in the same church where the prisoners were incarcerated and the Abbé Gourdon, himself a Vendean, pronounced the rites. Vendean veterans and their families were present, and their courageous fidelity to "Throne and Altar" was recalled. Curiously, however, at the time of this ceremony the Vendée could no longer be counted upon as a bastion of ultra-royalism: two years earlier it had elected to the Chamber of Deputies the liberal Manuel who consistently opposed the reactionary policies of the Restoration government including its intervention in Spain. The pomp and ceremony of

The Restoration

the inauguration of David d'Angers's statue may have reflected a conscious attempt on the part of the government to fix the attention of the populace on the glorious souvenirs of its conservative past.

Years later the sculptor had to apologize to his republican friends for this monument, claiming that he paid off a debt to Bonchamps because his father had been one of the republican prisoners pardoned by him. David even declared that he refused other offers to depict Vendean heroes. But this is after the fact: his notable work in this period clearly manifested the ideology of the Restoration regime. He received the Légion d'honneur from Charles X in 1825 and the following year was elected to the Academy. At the Salon of 1827 he exhibited a plaster relief for his commission for the Arc de Triomphe du Carrousel, *Reception of the Duke of Angoulême at the Tuileries after the Spanish War,* celebrating the successful suppression by the French of the Spanish insurrection in 1823. He could hardly have been called a rebel in this period.

One seeming exception is his *Memorial to Marco Botsaris,* also shown at the Salon of 1827 (Fig. 9).[4] The subject of his monument was a hero of the Greek War of Independence killed at Missolonghi in 1823, and its execution would seem to locate David d'Angers among Romantic sympathizers with the Greek cause such as Delacroix who did related themes in the 1820s. But what has not been generally understood is that French support for the embattled Greeks—unlike that for Spain—was not confined to opposition liberals but embraced most of the French people. All Christendom sympathized with the revolt against the infidel oppression. Even Charles X championed the Greek insurgents and found himself in agreement with the liberals on this point, and his ultimate intervention in Greece was in accord with widespread popular sentiment. The French fleet, together with the Russian and British task forces, destroyed the Turkish and Egyptian navies at Navarino in the very year that David's work was exhibited at the Salon.

The government refused to commission this work, however, and the sculptor had to finance it himself. He tried to interest the Administration in the project to commemorate the Greek hero before the fall of Missolonghi in 1826, but only the minister Martignac, a moderate royalist, showed interest. At the highest level, there was little enthusiasm due to the then-current political policy. The government was slow to action in Greece because it was influenced by Metternich's counsel not to widen the conflict for fear of disturbing the balance of power in the East. European governments were especially afraid that Russia would seize the occasion to expand its territory at the expense of the Ottoman Empire. But if the king could not sanction the commission officially, the subject would not have been alien to his sympathies. In his capacity as "Most Christian King," Charles X was favorable from the start to armed intervention which savored of a crusade.[5]

In addition, David's final project is hardly a testament to heroic insurgence, a theme which probably discomfited the most enlightened of monarchs in this

Fig. 9. David d'Angers, *Memorial to Marco Botsaris*. Plaster model, 1825. Musée des Beaux-Arts, Angers.

period. He depicted a pubescent nude girl reclining on top of Botsaris's tomb; analogous to antique *vota* figures, she traces the name of the hero in what is supposed to be a layer of sand. David claimed that her nudeness symbolized the Greek warriors and stood as a metaphor as well for the nascent Greek nation to inspire its young heroes to future deeds of valor. Such a figure, however, is as ambiguous as Delacroix's allegorical *Greece Expiring on the Ruins of Missolonghi* of 1826. Delacroix's female personification hovers uncertainly between a phoenix-like gesture of resurrection and a gesture of total surrender. Similarly, David's young girl is an image of passivity and resignation, far removed from the reality of Botsaris's revolutionary commitment. Indeed, the combination of eroticism and resignation in the motif suggests another interpretation: in 1826 Chateaubriand protested before the Chamber of Peers against the "white slave trade," referring to Greek women seized by the Turks and transported and sold as slaves in the Ottoman Empire. This notion, intimately associated with the Greek war for independence, fired the imagination of French artists, as is evident in Delacroix's *Massacre at Scios* (1824) and *Greece Expiring*. Moderate conservatives could more easily deal with the issue of white slave traffic than with black slave traffic, a topic identified with the liberal opposition. Thus the pubescent girl in Botsaris's tomb has the character of the passive harem slave or concubine with all of the attendant erotic associations. Not surprisingly, David declared in his explanation of the motif that henceforth the Greeks would never again be slaves.

He hoped that his monument would attract a new generation of Greeks seeking fresh inspiration from Botsaris's career, and he wanted them to identify the mausoleum designed for it with the French nation as a sign of its solidarity with the Greek cause. Thus he was bitterly disappointed to discover during a trip to Greece several years later that graffiti had been scrawled on the back of the figure and that its extremities had been vandalized. He now perceived the Greeks as hoodlums and vandals, unappreciative of high art and incapable of patriotic feeling.[6] But it is clear that David's incongruous motif all but mocks the Greek hero who sacrificed himself for his people.

Thus David's work of the Restoration cannot be construed as more "liberal" than the regime under which he worked. While his views began to change in the late 1820s, this development he shared in common with a growing sector of the middle class who perceived their immediate interests threatened by the repressive domestic policies of Charles X. It is true that after the Revolution of July David continued to move to the left, and he was one of those who marched in the funeral cortège of the radical deputy General Lamarque which sparked the bloody uprising of June 1832. But he continued to enjoy the support of the government which awarded him the highly coveted commission for the pediment of the Pantheon on 16 November 1830.

The story of the Pantheon is another case of reinterpretation brought on by political change: the Revolution of 1789 made it the Temple of Great Men where Rousseau, Voltaire, and Marat were interred; Napoleon's decree of 1806 restored it to a church, but Louis-Philippe, in the wake of the anticlericalism at the outbreak of his regime, made it a national temple again for the country's heroes. This was the subject of David d'Angers's commission, France's Great Men, a favorite theme which also linked him to the doctrinaire critics of the Restoration who held the reins of power under the July Monarchy.[1] The inscription just below the pediment identifies the theme "AUX GRANDS HOMMES LA PATRIE RECONNAISSANTE" (Fig. 10). The allegorical personification of Patrie distributes the laurel crowns to the Great Men—including Voltaire, Rousseau, Laplace, Mirabeau, Napoleon—that Liberty, seated on her right, hands to her in the center of the pediment. On the left of Patrie, History personified inscribes the names of the worthy on a tablet. The two halves of the pediment are divided left and right by intellectuals and "Men of Action," respectively. Liberty is shown seated on the side of the thinkers, statesmen, and artists: in the thought of the sculptor, Liberty should appear in combat only when the land is menaced; after the hour of triumph her place is among the conquerors of the mind. This notion already shows the ideological shift of those who overthrew Charles X and assumed power under Louis-Philippe—especially evident when it is contrasted with Delacroix's concept of *Liberty Leading the People*. David has reworked the aggressive emblem-manifesto of the new regime—Phrygian bonnet and all—into an image of passivity. Gustave Planche's review of the project after its completion in 1837 declared that while not negating the souvenirs of the French revolutionary tradition, David's Liberty "has nothing tumultuous about it."[2] Like the July Monarchy itself, it spurns the forces of revolution that made its existence possible and asserts an alternative ideology for its shrine of great men.

The Men of Action, moreover, are almost all anonymous: except for Napoleon, who reaches out for one of the laurel crowns, and Etienne, the heroic drummer boy of Arcole, this group comprises symbolic military types. David d'Angers commented that the army incarnates not the individual warrior but "the people" who have sacrificed themselves for their country. Thus "the people"—originally the popular classes who fought on the barricades of July 1830—are now defined out of existence in favor of a broader interpretation, and only celebrated aristocrats and intellectuals merit identification for immortality. Napoleon himself, shown as the general of the revolution rather than as emperor, makes the only real reference to the Revolution of 1789 to which Louis-Philippe so ardently attached himself in August 1830.

Naturally, the meaning of a shrine of heroes is ultimately bound to the representative selection. Within the limits of his conception David d'Angers incorporated those whom he perceived to be progressive symbols. The presence of Voltaire and Rousseau on the front of a shrine formerly dedicated to Sainte-

26

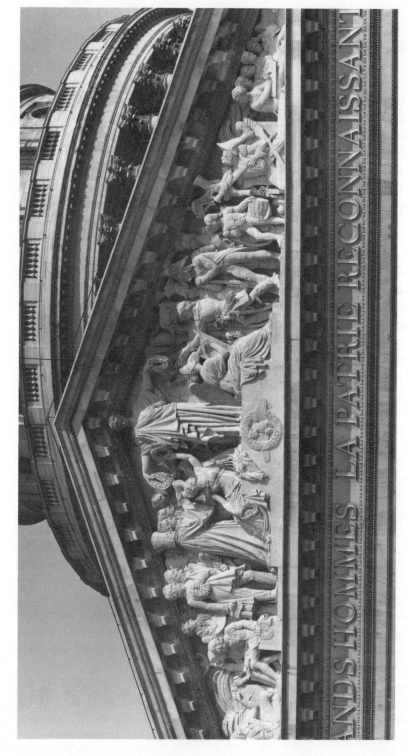

Fig. 10. David d'Angers, *Pediment of the Pantheon*. Limestone, 1830–37. Caisse Nationale des Monuments Historiques et des Sites, Service photographique, Paris.

Geneviève aroused the indignation of conservative Catholics, while contro-versial political heroes threatened the government. Behind the figure of Malesherbes stands the liberal deputy Manuel who was expelled from the Chamber of Deputies in 1823 for his opposition to royal intervention in Spain. Behind him, in a group comprising Jacques-Louis David the painter and Cuvier the naturalist, rests David d'Angers's special hero, Lafayette. Every-body's favorite in 1830, Lafayette had since moved to the benches of the opposition. The increasing authoritarianism of the regime is reflected in the attempt of the comte d'Argout, minister of the interior under the Soult administration, to block the project during the period 1832–34. When David d'Angers presented his sketch for the project in 1834, d'Argout's successor, Thiers, also pressured David d'Angers to modify his concept. But the sculptor, whose original program had been authorized by Guizot, remained firm and the Administration capitulated. Nevertheless, the government refused to allow the monument to be unveiled in time for the celebration of the July Days in 1837 and postponed the event to September.

Planche intimated that the work lacked even the slightest suggestion of dis-sent and claimed that it judged the past "not with the passions of the French revolution, but with the impartiality of the present generation."[3] This is the language of *juste milieu* ideology, and in the end it is this ideology manifested in the pediment. Although by this time—since he had marched in General Lamarque's funeral cortège—David d'Angers stood left of the regime, and his indoctrination in the aesthetics of sculpture and the outlook of the government profoundly affected his work.

Indeed, David d'Angers incarnated the type of progressive-minded citizen whose very métier blocked his potential to express ideas in sculpture consonant with his actual political position. According to him, sculpture should be "pure and virginal," be committed to "lofty thoughts," and convey the look of eternity. In a letter to Humbert de Superville in 1832 he decried the debasing effect of modern dress "invented by the stupid brain of a tailor." Sculpture functioned optimally as apotheosis not as documentation, revealing the soul of a famous person or "the most remarkable deeds of nations." Thus David's aesthetics of sculpture had a political role in propagating for eternity a privi-leged class and their memorable exploits. He even believed that truly great sculpture, despite its universal appeal, could only inspire "a person of the elite." He admitted that sculpture was undemocratic, that it depicted magi-sterial men, colossal and ideally nude, and projected a realm beyond mortal space. He mused that Plato had no need to banish sculptors from the Republic; in real life they were rarely subversive and even cursed the political opposition that threatened the source of their official commissions.[4]

The conservative political character of post-Napoleonic art in this period is often submerged beneath its thematic and metaphorical content. A striking

case of this is seen in the general acceptance of its medieval themes as a homogeneous subset of romanticism, when in fact these themes most often stress the aspirations of a courtly and aristocratic society. One example is the so-called "Troubador Style," a body of cultural products particularly associated with the Restoration and the early years of the July Monarchy. The general form of this medievalism agitated in behalf of the conservative and especially the religious antibourgeois. At the same time that Charles X and his court sought to translate the Gothic revival into a justification and glorification of absolutism, its appeal trickled down to the young generation of painters and sculptors reacting against classicism and bourgeois values. They were generously received at the official Salons, including a minority who paradoxically revealed a strain of what may be called "left-wing medievalism" in their emphasis on folklore and populace rather than on feudalism and Catholic order.

Félicie de Fauveau, a female sculptor, typified the conservative medievalist. She was born into an old Breton family known for its loyalty to the Bourbons, and she distinguished herself in the service of Charles X whom she deeply admired.[5] She traveled in ultraroyalist circles where she became close to the duchesse de Berry, daughter of the king of the Two Sicilies, daughter-in-law of Charles X, and niece of Louis-Philippe. Not surprisingly, Fauveau's work celebrates medieval scenes often set into Gothic frameworks.

At the Salon of 1827 she exhibited two works, *Subject based on Sir Walter Scott's novel, The Abbey* (the Waverley novels were basic reading for the conservatives) and a relief of *Queen Christina of Sweden Refusing to Spare the Life of Her Equerry Monaldeschi* (Fig. 11). The subject of the second concerned the political intrigues of the Swedish, French, and one faction of the Neapolitan governments. Monaldeschi, from a patrician family in Orvieto, became the queen's court favorite and served her as riding master and confidante. She made him privy to her plans to seize the throne of Naples with French support, but he evidently betrayed the plot to the Spanish. While Christina and Monaldeschi were guests at the Château of Fontainebleau in 1657, she ordered his summary execution.

Many elements in the narrative suggested allusions to Fauveau's political circle. Marie-Caroline, the duchesse de Berry, was born in Naples and looked forward to being queen of France one day. (The 1820 assassination of her husband, heir to the French throne, permanently altered the course of her ambition.) Louis Blanc noted her "Neapolitan temperament" and her predilection for intrigue.[6] She shared with her friend Fauveau a love of Walter Scott and an admiration for militant female rulers like Christina and Mary Stuart. More importantly, the work projects the need for an assertive sovereign capable of decisive action when the royal prerogatives are impugned. During the year 1827, Charles X, rapidly losing popularity, was depicted by the opposition as a compliant tool of the reactionary elements in church and state. That year the duchesse de Berry was stopped in her carriage by a hostile crowd comprising

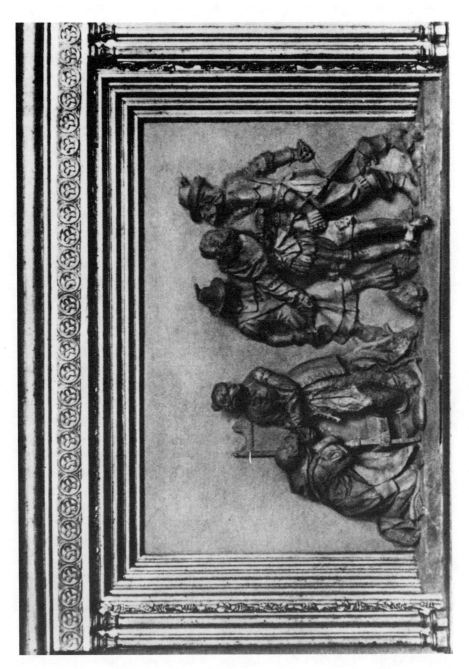

Fig. 11. Félicie de Faveau, *The Queen Christina of Sweden Refusing to Spare the Life of Her Equerry Monaldeschi, etc. ca.* 1827. Low relief plaster, etc. ca. 1827. Musée des Beaux-Arts, Louviers.

several National Guardsmen who called her a "Jesuitess." She immediately formed a pressure group around the king, advising him to punish the National Guard and the opposition press. Against his better judgment, he disbanded the one and censored the other.

Later, the duchesse de Berry was outraged by the July Revolution. She fled into exile with the king and was appointed regent over the exiled court. She now plotted (in emulation of Christina?) a counterrevolution against her uncle Louis-Philippe, "the usurper." Her plan was to inspire the populace of the Vendée to take up arms as in 1793 and then march on Paris to join forces with the local royalists. She imagined herself the rallying point for a new crusade, but the attempt at insurrection in June 1832 proved to be a fiasco. The Vendeans were no longer the idealists of 1793, and she failed to muster the numbers needed for a right-wing coup.

Two of her faithful adepts were the wife of Auguste de La Rochejaquelein and Félicie de Fauveau. Blanc called the sculptor "one of her most trusted followers," and indeed Fauveau had taken up arms in the service of the insurrection.[7] She was arrested early on, imprisoned and acquitted, but later fled to Belgium. Fauveau remained a fervent partisan of the duchesse de Berry who was eventually captured and incarcerated; as late as 1842 she submitted to the Salon a *Judith and Holophernes* modeled upon the features of the duchess and Louis-Philippe.

Left-wing medievalism centered on the personality and work of Victor Hugo, who was politicized by the oppressive ordonnances of Charles X and the July Revolution. *Notre-Dame de Paris* (begun on 30 July 1830 and published the next year) paints a dreadful picture of an aristocrat and a priest while heroizing the deformed Quasimodo and the gypsy girl Esmeralda. Like Delacroix's *Liberty Leading the People* (which also celebrates Notre-Dame), the novel depicts lively street scenes, swarming crowds, and even the marginal types inhabiting the Cour des Miracles. A group of Hugo's admirers organized the Jeunes-France which included Gautier, O'Neddy, Borel, and the sculptor Jean Duseigneur. They proclaimed the spirit of the Middle Ages, fantasized about chivalric romance and troubador themes, while at the same time opposing the Academy and bourgeois ideals in their journal *La Liberté*. Several of them affected medieval-style names; the sculptor Duseigneur called himself Jehan DuSeigneur.[8] In the 1833 Salon he exhibited a bust of Hugo and also a plaster group based on a scene of *Notre-Dame de Paris* in which Esmeralda brings water to the pilloried Quasimodo.

But the work for which Duseigneur is most remembered is *Roland furieux,* (Fig. 12), first shown at the Salon of 1831. Based on Canto 39 of Ariosto's *Orlando furioso,* it shows the moment when the frenzied Orlando struggles to get free of the bonds fastened on him by Olivero and his friends. Deeply admired by the Jeunes-France, the original poem stemmed from the *Chanson de Roland* and the historical figures of Charlemagne and his nephew Roland

(Orlando). It also drew upon Arthurian legend and chivalric romance. The episode Duseigneur depicts is the prelude to Orlando's recovering of his former heroic self, when the crazed knight enters the camp of the paladins and disrupts their siege of North Africa. Orlando's jealous passion for Angelica has destroyed his reason, thus leading him to neglect his duty to France and contribute to the Christians' defeat by the Moors, Saracens, and Blacks in North Africa. Indeed, a main theme of the poem involves the struggle between Christendom and Pagandom (represented by Islam), first on French soil and then in Africa.

It may be recalled that Charles X perceived the showdown between the allied powers and the Ottoman Empire over Greece in precisely these terms. Following the successful participation of France in this struggle against the Turks, he embarked on an even more ambitious crusade in North Africa, the invasion of Algiers. Charles X's avowed excuse for the invasion included his understanding that the expedition would work "to the advantage of all Christendom."[9] The work of conquest and administration took place in the closing days of his reign, but not without opposition from the liberals who viewed the episode as a tactic to divert attention away from the domestic situation. The process of colonization, however, was extended and completed during the first years of the July Monarchy, and this regime also inherited the opposition. When the French expedition became bogged down in Africa during the period from September 1830 to February 1831 and Arab leaders were proclaiming a jihad against the French nation, people at home were concerned about the loss of French lives and wasted money. The chambers became bitterly divided over the issue, and a violent controversy erupted over it both in parliament and the press. General Bugeaud, who later assumed command of the expedition, recalled that the July Monarchy's invasion was opposed by a sizable portion of the nation. Thus the appearance of *Roland furieux* at the Salon of 1831 and its association with the struggle between Christians and Arabs on North African territory cannot have been fortuitous. The text accompanying the Salon entry ends with Roland's immobility, "despite his useless efforts to defend himself."[10] Duseigneur's work symbolizes France's political dilemma, in which the twists and knots of the protagonist bind more tightly in the struggle to get free. The sculptor's writhing form did break with academic convention, however, attesting to both his heightened political and aesthetic awareness.

In the Salon of 1834 Duseigneur exhibited *Satan Vanquished by the Archangel Saint Michael, Announcing God's Reign.* The fascination in this period for satanic themes springs from a reaction to the orthodoxism of Charles X and to the narrow-mindedness of Louis-Philippe. In the same Salon the most significant example of this type was Jean-Jacques Feuchère's statuette of *Satan* seated in the traditional pose of Melancholy and enclosed within batlike wings (Fig. 13). While Satan's enraged expression suggests the bitter outcast, the fact that he assumes the position identified with stultified genius adds a note of glamour to

32

Fig. 12. Jean-Bernard Duseigneur, *Roland furieux* (1831). Bronze, 1867. Musée de Louvre, Paris.

his character. Satan represented the counterimage to the missions, processions, and pilgrimages which covered France during the Restoration, and could be associated with the anticlerical attacks of the opening years of the July Monarchy. Feuchère's friend Michelet claimed that Satan stood for the people's protection against total domination by the Church. All scientific and individual progress that grew up despite canonical authority to the contrary was "the work of Satan."[11]

Feuchère belonged to liberal circles: his friends included Daumier, Préault, Michelet, and Baudelaire.[12] He was a pioneer of pedagogical reform and a leading industrial designer; he opposed the fetishization of art and hoped to bring about a union of art and industry for the production of well-designed but socially useful objects. His statuette of Satan certainly carried symbolic political associations. Its connection with Hugo lies in its close resemblance to the famous gargoyle figure on Notre-Dame, later restored by Viollet-le-Duc and recorded in a popular etching by Charles Méryon. Above all, the statuette was identified with the Knights of Templar, a secret society originally dedicated to the overthrow of the Bourbons but which formed part of the opposition movement during the July Monarchy. In Paris the chapel-headquarters of the group was located in the Cour des Miracles, the site of one of Hugo's dramatic scenes in *Notre-Dame de Paris*. Here gathered all the denizens of the underworld, the medieval *lumpenproletariat,* a kingdom which seemed to the character Gringoire to have been ruled by Satan himself. One member of the Knights of Templar was Raimond Bonheur, Rosa Bonheur's father, a dedicated Saint-Simonist then in favor of a republican regime. Wishing to indoctrinate his daughter in the ideas of the order he obtained special permission for her to be initiated. A photograph of the period shows her in the Templar's costume, seated next to a table on which sits a replica of Feuchère's *Satan* (Fig. 14). Its prominence in the picture demonstrates its symbolic importance for the group.[13] Curiously, Louis-Philippe himself identified the republic with Satan, which he felt should be understood "as a malevolent being who must be flattered and treated with consideration, but never opposed."[14] Not surprisingly, Feuchère warmly received the Republic of 1848 and participated in the contest for an allegorical image of the new government.

Despite his republican sentiments, however, Feuchère followed the general tendency of sculptors to rely on government and aristocratic patrons for support. In addition to the duc d'Orléans, Count Demidoff, and the duc de Luynes, he could count upon the Sèvres porcelain works for commissions.[15] Feuchère was also among those commissioned by Louis-Philippe's government to work for one of its single most significant artistic undertakings, the completion of the Arc de Triomphe. Thiers especially admired the sculptor and ordered him to execute for the monument the relief of *Napoleon Crossing the Pont d'Arcole*. But Feuchère failed to win one of the coveted stone reliefs for the massive pillars commemorating the Bonapartist era eventually awarded to Etex, Rude, and Cortot.

34

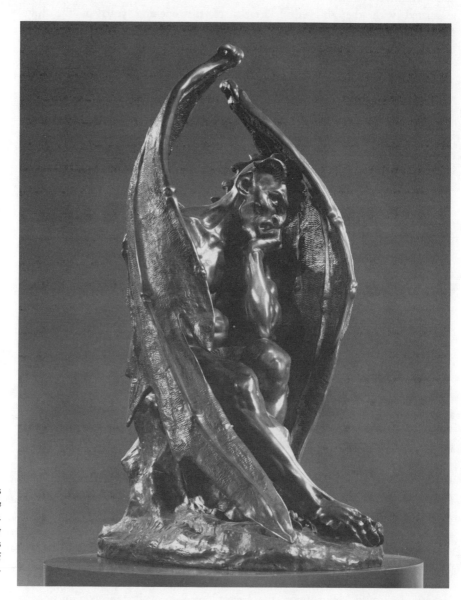

Fig. 13. Jean-Jacques Feuchère, *Satan* (1834). Bronze, 1850. Los Angeles County Museum of Art, Los Angeles. Courtesy of Times Mirror Foundation.

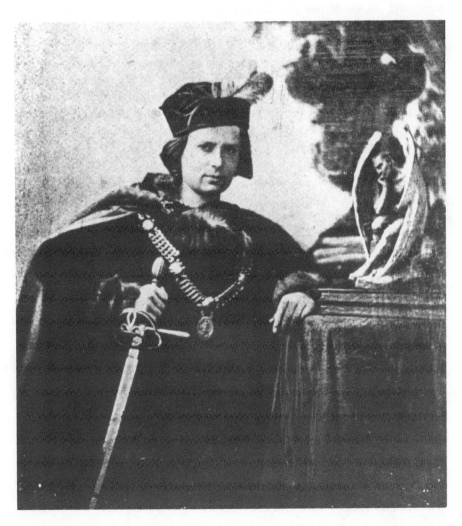

Fig. 14. Photograph of Rosa Bonheur in her Templar costume, ca. 1834. Reproduced in A. Klumpke, *Rosa Bonheur* (Paris: Flammarion, 1908), 159.

The July Monarchy

The strange parallelism of medieval and Napoleonic iconography is rooted in Louis-Philippe's shaky hold on power. The July Monarchy assimilated the Restoration's medieval ideology through its historicist program which rationalized the reign of Louis-Philippe. It established the definitive rules for the Ecole de Chartes—founded under the previous regime to train students to read and interpret medieval texts—and organized the preservation and restoration of major Gothic monuments including Notre-Dame. The Revolution of 1830 brought historians like Guizot to power, who organized the collection of *Documents inédits de l'Histoire de France* which comprised one of the principle sources for the history of the Middle Ages. It was the same government which acquired the Hôtel de Cluny and its famous collection of artifacts from the Middle Ages and Renaissance amassed by Alexandre du Sommerard. Finally, the founding of the Commission des Monuments Historiques for the classification and inspection of medieval French monuments, and the recruiting of talents like Ludovic Vitet and Viollet-le-Duc in the service of this commission, definitively committed the July Monarchy to a program totally at odds with the anticlerical mood of the popular classes immediately following the fall of Charles X.

Their anticlericalism and enthusiasm for Bonapartism induced the new regime to act swiftly to deflect popular sentiment into safe channels of expression. This took the form of much pro-Bonapartist rhetoric from the government and an attempt to raise or refurbish imposing and spectacular memorials to the revised image of Napoleon. Perhaps the most important of these was the Arc de Triomphe. Inaugurated on 29 July 1836, the Arc de Triomphe represents still another outstanding case study of the politics of sculpture. Begun in 1806, it was meant, like the Vendôme Column, to celebrate the Grande-Armée. Its colossal proportions aimed at intimidating the masses, present and future, with the awesome power of Bonaparte. The choice of location related to its heroic prospect from the Palais des Tuileries, the symbolic center of France. Its location at the Etoile (the threshold between Paris and Neuilly), an important entrance to the city and a spacious site frequented by promenaders, guaranteed a commanding and imposing presence near the heart of Paris. Napoleon would pass under it regularly since he had to cross the Etoile going to Malmaison, Saint-Germain, Saint-Cloud, and Versailles.[16]

The Arc de Triomphe was abandoned in an incomplete state in 1814—literally a monumental pile of masonry at the top of the Champs-Elysées—and the returning Bourbons were horrified by the spectacle. But Goust, the architect then in charge, persuaded the new regime to overlook the original intention of the monument and consecrate it anew to the glory of the Bourbons. It was decided that images of the successful intervention of France in Spain under the leadership of the duc d'Angoulême would decorate it. When Charles X took the throne the project was again reviewed and a new program suggested, including a wraparound frieze with the east facade representing the king surrounded by his military chiefs and the west the dauphin receiving civil and military authorities.

The advent of the July Monarchy put an end to this project as well, with the new regime requiring a program suitable to its ideology. It was certainly in the interest of Louis-Philippe to attach himself to the souvenirs of Napoleon.[17] Every time a demonstration occurred during the early phase of the regime the name invariably invoked would be that of Napoleon. Even before the 1830 revolution, republicans, liberals, and Bonapartists all exploited the name of Napoleon; during the three glorious days it became a password and often was joined to cries of liberty. On the anniversary of the death of the emperor in 1831 and 1832 there were almost riots in front of the Vendôme Column. There could be no doubt that Louis-Philippe exploited Napoleon's image to bask in his glory and shore up his shaky regime. The inauguration of the arch took place on 29 July 1836, the sixth anniversary of the July Revolution, and a coin was struck for the event showing the king's profile superimposed on that of Napoleon.

In addition to the commissioning of Seurre's effigy for the Vendôme Column, the most important example of the Napoleonic revival is the commitment to the completion of the Arc de Triomphe. Plans for the monument got underway by 1832; however, it no longer celebrated exclusively the Grande-Armée but "the glory of all the French armies since 1792."[18] Various programs were considered for the sculpture, especially for the immense front and back wall surfaces, but it was not until Thiers became minister of commerce and public works in 1833 that the program assumed its definitive shape. Thiers, a historian-statesman who helped engineer Louis-Philippe's rise to power, was a specialist in Napoleon whose *Histoire du Consulate et de l'Empire* (1845–62) would contribute to the later phase of the Bonapartist revival. He understood fully the meaning of Bonapartist sympathy and how to exploit it, and acted to keep this surge of popularity tied to the historic past rather than encourage it as a call to action in the present. Having survived the insurrection of 1832 sparked by the funeral of the Bonapartist Deputy Lamarque, the government, through its spokesman Guizot, could declare that "the revolutionary spirit, a spirit of blind faction, which seemed for a while to have gripped the entire nation, is dead." But the opposition—still invoking the Bonapartist symbol—continued, and in December Louis-Philippe warned that "an increasing vigilance is still necessary; insensate passions and culpable maneuvers are still at work to undermine the foundations of the social order."[19] Carried to power by revolution, Louis-Philippe was deathly afraid of another and aimed to promote the sense of domestic stability and peace abroad as the hallmarks of his regime. He used culture to establish himself as the inevitable outcome of prior French history, as the summation of all that was just and stabilizing in the recent political upheavals. His ideal was personified by Pradier's two figures of *Public Order* and *Liberty* (1832) for the Chamber of Deputies, with "Liberty" alluding to the prerogatives of a privileged minority and not to the "rabble" who carried out their dirty work.[20]

Thiers commissioned Rude, Cortot, and Etex to do the colossal sculptures on the four pillars of the Arc de l'Etoile; the choice of Rude and Etex, artists not

belonging to the Academy, was distinctly political and declared Thiers's intention to broaden the government's support of the art community. Rude and Etex conformed to the rule, however; both were sons of artisans (Rude's father was a stove-maker and Etex's an ornamental sculptor), perceived themselves as moderate republicans, were politically ambitious, and wound up in the service of all regimes willing to grant them commissions. Rude's Bonapartist predilection dated from his work on the reliefs of the Vendôme Column, but he eagerly embraced the opportunity to work for the Restoration when it planned to use the Arc de Triomphe for its own political ends. Rude in fact helped organize the team of fourteen sculptors assigned to the arch into a kind of union to bargain for higher wages, but their petition stressed that all were anxious to "attach their names to a monument full of glory for France, the King, the princes and the Army."[21]

Thiers's final program emphasizes defeat of Napoleonic France and the "shameful" peace imposed upon it from without. But the defeatist message is submerged beneath scenes of valor and courage in the face of surrender. The one positive image of Napoleon is also the dullest, Cortot's *Triumph of Napoleon I* on the Paris side which shows a medieval image of the emperor packed in among an accumulation of allegories (Fig. 15). Fame blasts her trumpet overhead, Victory crowns the emperor, History registers his mighty deeds in her book, and a Conquered City kneels at his feet. Napoleon's topical appeal is all but entombed in this pictorial sepulchre.

Rude's *Departure of the Volunteers of 1792* projects a more heroic aspect, referring to a specific episode of the Revolution of 1789, when the Convention signaled "the country in danger" to its volunteer army for the march against the Prussians and Austrians advancing on the French frontier (Fig. 16). Ironically, however, the energy of this work is centered in the ferocious allegory of War hovering overhead and utterly dominating the volunteers. She bellows with primeval force and her splayed arms and legs propel her forward. She occupies over one-half of the compositional space, while down below a motley crew of soldiers clad in antique costume try to muster sufficient energy to follow her. None, however, reflect her zeal and dynamism; they twist and turn in all directions, and, except for father and son in the center, practically fall over themselves in their effort to assemble. While Rude's War (now known as "Liberty") is far more revolutionary in intent than Cortot's Fame which is its complement, both serve similarly to congeal the past in an allegorical mould. The real dynamic of the compositions comes through in allegories, while actual people are reduced to inaction or ineffective attitudes. The Genius of War's acceptance by the regime in the first place is probably related to the very violence she implies: restricted to the allegorically abstract she signals a warning to the middle class now frightened about the prospect of further revolution. Rude's disappointment in the final result and the sense of his having compromised his original conception is clear from the recollections of his wife: "I never

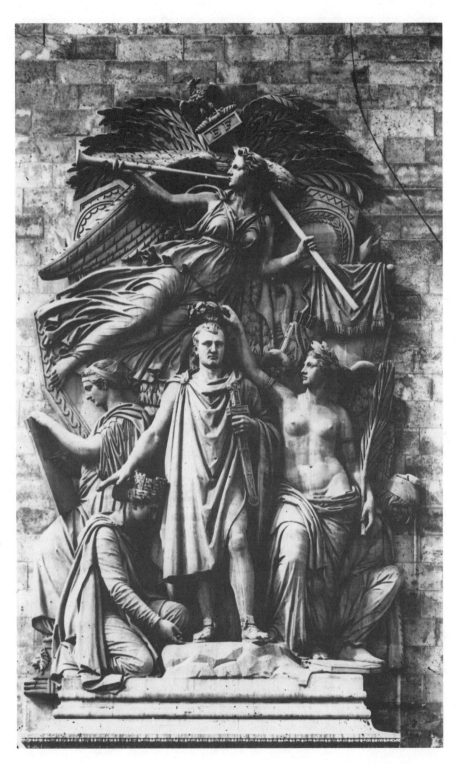

Fig. 15. Jean-Pierre Cortot, *Triumph of Napoleon I (1810)*. Limestone, 1833–36. Arc de Triomphe de l'Etoile, Paris. Caisse Nationale des Monuments Historiques et des Sites, Service photographique, Paris.

The July Monarchy

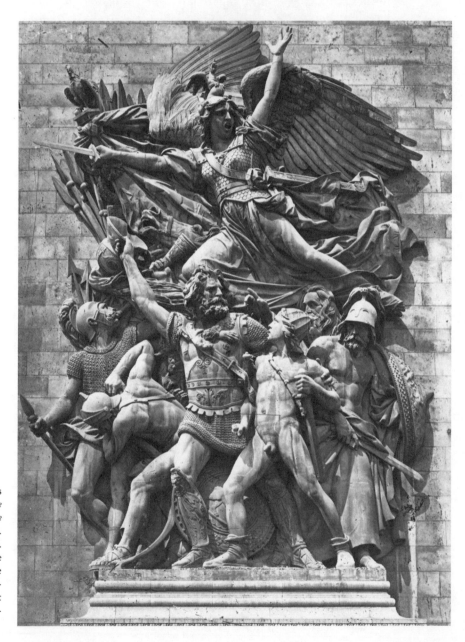

40

Fig. 16. François
Rude, *The Marseillaise
(The Departure of the
Volunteers of 1792).*
Limestone, 1833–36.
Arc de Triomphe de
l'Etoile, Paris. Caisse
Nationale des Monu-
ments Historiques et
des Sites, Service pho-
tographique, Paris.

saw him so tormented. . . . The Arc de Triomphe attracted him invincibly, and he kept repeating to me in such a sad voice while walking on the Champs-Elysées: 'It would be too beautiful to be capable of rendering what one really felt! That's the only desirable thing. Nothing else counts. . . .' "[22]

Thiers manipulated significant chronological benchmarks to justify the origins of Louis-Philippe's regime. For the Neuilly side of the monument Thiers commissioned the young Etex to execute *1814 (Resistance)* and *1815 (Peace)* (Figs. 17, 18). Etex held radical convictions and was at first perturbed at having to depict moments of defeat and humiliation. But Thiers insisted on the importance of 1814 for his program ("I need 1814 as a date"), and flattered Etex with promises of fame and fortune. Not about to relinquish the opportunity, the sculptor resolved the conflict for himself by emphasizing the heroic defense of Parisians against the allied invasion. Etex, however, makes it clear in his *Souvenirs* that 1814 and 1815 were miserable childhood memories, when French people acted cowardly and selfishly and his only consolation were high-flown fantasies about conquering heroes on horseback. His idea for *1814* does not present confrontation between opposing armies but a civil arena where citizens ("all of humanity") defend the soil of the fatherland. A youth aged twenty-five to thirty years old (Etex's age at the time) stands in the center protecting the land against the foreigner, shielding from harm his wounded father and his wife and child. Behind him a warrior is struck fatally on his horse, and at the apex of the group is the personification of Resistance, functioning compositionally like Rude's Liberty, but in this case frontal and immobile. If *1814* follows roughly the design of Rude, *1815* resembles the Cortot in the stacking up of symbolical personifications. The youth has now sheathed his sword and is surrounded by his family pursuing their labors in the field. His father yokes an ox, another member cuts the wheat, the wife fondles their newborn infant, and the figure of Minerva overshadows them.[23]

Thus Thiers makes the culminating episode *Peace,* the humbling of Napoleonic armies and the restoration of the Bourbons. The revolutionary origins of the July Monarchy are safely tucked away by inference in the presentation of *1792* which is shown to have been snuffed out and finally pacified by European kingship. It is upon this *peace* that Louis-Philippe intends to build and which his predecessor evidently neglected. Etex seems to have assimilated the spirit of Thiers's program, even claiming that popular reception for his works exceeded those of Rude and Cortot, being more humane and comprehensible.[24] Thiers had previously criticized Etex's first sketch for the *Resistance,* claiming that the projected Genius of the Future evoked thoughts of rebellion. His request that the sculptor tone this figure down along with the overly conspicuous horse throwing the rider was carried out in the next set of sketches.

The work that brought Etex to the attention of the Administration was his *Cain,* the plaster model of which enjoyed an enthusiastic reception at the Salon of 1833 (Fig. 19). The origin of this work dates from his trip to Italy which the

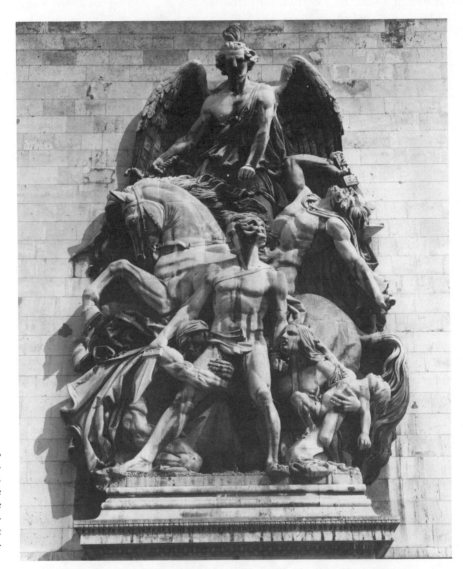

Fig. 17. Antoine Etex, *1814 (Resistance).* Limestone, 1833–36. Arc de Triomphe de l'Etoile, Paris. Caisse Nationale des Monuments Historiques et des Sites, Service photographique, Paris.

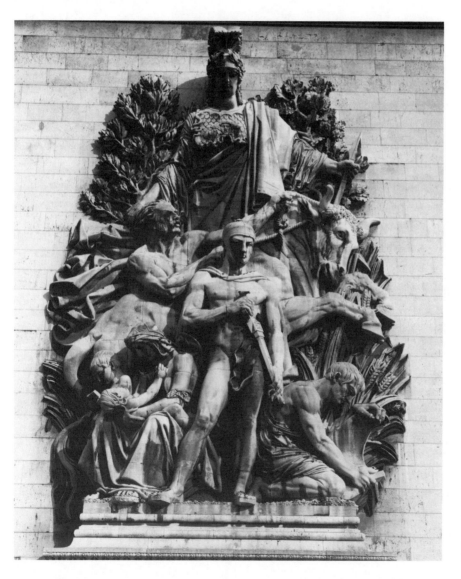

Fig. 18. Antoine Etex, *1815 (Peace)*. Limestone, 1833–36. Arc de Triomphe de l'Etoile, Paris. Caisse Nationale des Monuments Historiques et des Sites, Service photographique, Paris.

The July Monarchy

44

Fig. 19. Antoine Etex,
*Cain and His Race Ac-
cursed of God.* Bronze,
ca. 1832. The Arthur
M. Sackler Collection,
Washington, D.C.

government financed as a result of his heroic participation on the barricades and his help in the guarding of the Louvre's treasures during the July Revolution. While in Italy Etex was moved by the national struggle of the Italian and Polish peoples, set into motion by the events in France. He responded bitterly to the suppression of these insurrections, and in the same period he came into contact with the progressive ideas of Saint-Simon whose slogan "From each according to his capacity, to each according to his needs," offered for him a solution to contemporary social ills.[25]

It was in this context that he first conceived *Cain*, showing the slumping figure of the cursed son of Adam and his grieving family suffering the impact of their ostracism. Marked out from the community, they represent the primal outcasts. The full title was *Cain and His Race Accursed of God,* implying a meaning beyond Cain's immediate family. Jean Reynaud, a Saint-Simonist writer, noted that this particular Cain was not in revolt against God but expressed the very human feeling of having been abandoned by God and suffering the loss of spiritual mooring.[26] Thus Cain deserved sympathy, a view related to Byron's *Cain* of 1821 which made the biblical villain a duped victim of Lucifer who kills his brother accidentally.

Six years later, when the marble version showed at the Salon, the moderate liberal newspaper, *Le Constitutionnel,* rejected the idea that *Cain* was the symbol of resignation and brutishness and asked: "Is it not the symbol of protestation and struggle? Is not the worker Cain represented in the tradition with incessant ardor and the genius of action?" Etex himself must have accepted this interpretation, for when he ran as deputy from the Seine-et-Oise region in 1848 he noted in his placards: "Let us elect the great sculptor Etex, who, in his depiction of Cain, wished to embody the miseries of the proletariat." The critic Maxime du Camp, who recalled this poster, ridiculed the thought, affirming that the murderer Cain, an older brother, could not stand as a symbol of the oppressed.[27] But Etex employed as his models indigent Italians whose poverty touched him, and his use of this type is analogous to the left-wing use of Satan. Here the conventional villain and outcast are converted into symbols of revolutionary protest against established authority.

At the same time, the need to couch the image of the proletariat in these allegorical terms demonstrates the conservatism of sculptural tradition as well as Etex's own political ambivalence. He took up arms against the insurgents of 1848, and he even advised General Cavaignac, commander-in-chief of the government's troops, to post this warning on the walls of Paris: "Anyone caught touching a paving stone will be shot."[28] Etex was certainly more progressive than most of his peers, running on a Republican platform, preaching the need to break down the barriers between high and industrial art, and attempting to simplify and demystify pedagogical methods for the benefit of workers. He was always further to the left than the existing government, but the gap between his rhetorical and working creed is reflected in his frustration and constant need to

justify himself. He seizes every opportunity to hold himself up as a model of integrity and the victim of jealous intrigues and political prejudice.

Finally, however, the results speak for themselves; there is little evidence of his creed in his work: he was constantly at the beck and call of the July Monarchy, and one of his works, *Sainte-Geneviève,* was given as a bribe by the government to Dupin, president of the Chamber of Deputies, when the ex-mouthpiece for the regime began to criticize some of the ministers and jockeyed for personal power. Etex's claim to uncompromising integrity is also contradicted by the fact that in 1842 at the behest of the Administration he changed the title of a statue from *Poland in Chains Beseeching Its Liberators* to *Olympia Abandoned in the Hebrides Islands,* exhibited at the Salon of that year.[29] The regime was embarrassed by the allusion to its failure to aid Poland, a major issue of the liberal opposition during the years 1830–31.

When Etex did work expressing his solidarity with the downtrodden he usually represented them as victims, classically illustrated in his *Paris Imploring God for the Victims of the Cholera in 1832* (1840). The cholera took its heaviest toll in the working quarters of Paris (the rich moved to their country homes or rented rooms in the suburbs), and the poor believed that the government spread the disease to eliminate them. Republicans blamed the regime for willful neglect of proper hygiene and sewage disposal, and a hatred developed against physicans and others suspected of poisoning the working population. The tensions that eventually erupted into full-scale insurrection in June 1832 sprang in part from the decimation of the poor during the cholera epidemic. Etex's work, executed in 1840 but not shown until 1852, typically portrays passive victims rather than struggling peoples, and this made it acceptable to the regime of Louis-Napoleon in the aftermath of the coup d'état.

Auguste Préault was yet another important sculptor of the July Monarchy whose development reveals the artist caught in the crossfire of personal political convictions and the demands of his profession and his government.[30] Like Rude, his father was a metal worker and in this artisanal ambience he developed strong republican sympathies. He studied under David d'Angers, and in spite of a falling out they probably shared mutual political beliefs.[31] In the Salon of 1833 he exhibited three works: *Two Poor Women*, *Mendicity* ("a family of proletariats ignored through injustice"), and a bust of the noted Fourierist critic Gabriel Laviron.[32] As in the case of Etex's *Cain* (which *Two Poor Women* resembles formally), Préault demonstrated his concern for the oppression of the working population and his solidarity with the militant Left, but he, too, chose to express his convictions through images of the poor as casualties and martyrs.

But in 1834 Préault changed course with the showing of his plaster relief, *Tuerie* [*Slaughter*], a work whose immediacy makes it truly exceptional in nineteenth-century French sculpture (Fig. 20). The close-up violence and fragmented presentation of human butchery again emphasize victims, but this

Fig. 20. Antoine-Augustin Préault, *La tuerie* (1834). Bronze, 1850. Musée des Beaux-Arts, Chartres. Courtesy of Photographie Bulloz, Paris.

time in the context of a civil struggle. A shrieking woman holds her mortally wounded husband with one hand and her infant child in the other; at the left, a person described as a black strangles the life out of a struggling female, while a soldier wearing a medieval helmet looks on. The frenzy of the central woman so strongly recalls Rude's Genius of War that it may be presupposed that Préault managed to see the sketches approved by Thiers the previous year. Ironically, the acceptance of this work by the Salon jury probably reflected Thiers's attitude toward the Rude; Cortot (who did the Triumph of Napoleon on the arch), one of the jury members, insisted that it be hung in the Salon "as a criminal would be hung on the scaffold."[33] This has been taken to imply a warning to artists and public alike of the foolhardy course taken by the Romantic school. But Cortot's remarks have a political meaning as well, referring to the militant rebels harassing the regime. Préault's Tuerie, in its suggestion of ruthless reprisal, was a warning not simply against innovative artistic trends but to those who would seek radical transformation in the social sphere as well. His systematic exclusion from the jury after this Salon reflects the more authoritarian character of the regime in the wake of the uprisings in Lyons and Paris that year.

There can be no doubt about Préault's republican credentials in this period; a close friend of Daumier and Michelet and a member of the left-wing medieval circle, he also admired the utopian reformers Fourier and Saint-Simon. When David d'Angers recommended Préault for the execution of the statue of General Marceau, a gallant officer of the First Republic, he stressed that he was well qualified to "understand the character of the republican hero." Given the sculptor's political affiliations in this period, his subject becomes a topical political statement akin to Daumier's Rue Transnonain, executed shortly after Préault's bas-relief. That some form of clash was already deemed inevitable seems clear in retrospect, and Préault, always close to the events, embodied the tensions culminating with 14 April.[34] (Not surprisingly, Préault showed the relief again, cast in bronze, at the Salon of 1850–51 where it figured among a number of works inspired by the civil insurrection of June 1848, including Meissonier's blood-curdling scene of the barricades entitled Recollection of Civil War.)

From the moment Louis-Philippe took office the regime was threatened by forces on both the Left and the Right. His ascent to the throne coincided with an economically depressed period, and after the initial euphoria sparked by the revolution a series of strikes menaced the otherwise smooth political transition. At the Salon of 1834, Pillet, the critic for the government's newspaper, praised Vernet's L'arrivée du duc d'Orléans au Palais-Royal le 30 juillet 1830 for its fidelity to details such as the ominous expression on the face of one of the spectators, "one of these intriguers always ready to profit from a revolution to sway it from its course and plunge us all into anarchy." He was clearly responding to the same fearful climate captured in Préault's sculpture. On 8 January 1834 Dupin spoke in the Chamber of Deputies about the evils of universal

suffrage which could only lead to anarchy and violence "which would drench the fatherland in blood." He baited the left-wing organization, the Société des Droits de l'Homme, who would wreak their vengeance only to be devoured in turn like their "ancestors of 1794"—"these heroes of carnage." The trial against the Société, which was accused of a "conspiracy against the internal security of the state," took place in December 1833 amid a McCarthy-like atmosphere.[35]

Much of this had to do with the insurrection of 5 and 6 June 1832 which broke out during the funeral procession for General Lamarque, a Bonapartist liberal who formed part of the liberal opposition in the Chamber of Deputies. For a time it looked as if July 1830 would occur all over again, but the National Guard ruthlessly suppressed the insurrection. The Right was suspected of having armed the rebels and thus forming a "monstrous alliance." The Saint-Simonists were prosecuted two months later for outrages against public morality, and systematic persecution of the Left followed soon afterwards.

But after being inactive for nearly a year, the revolutionaries suddenly entered the arena once more, mainly through the press and pamphlets. The liberal *Tribune,* under the direction of Marrast, was prosecuted and fined 114 times between 1830 and 1834. In January 1834 the minister of justice introduced a bill requiring vendors of printed materials to have a revokable license. Until then, leftists had been able to exploit a loophole in the press laws by hawking cheap pamphlets in the streets like newspapers. The mood of the ruling bourgeoisie, however, was to stifle revolutionary activities once and for all. On Sunday, 23 February 1834, while popular prints against the government were being distributed in the square of the Bourse, police agents in workmen's costume and armed with clubs rushed on the crowd, trampling women and children and striking down peaceful bystanders. The indiscriminate violence outraged even moderates.

Meanwhile, the general strike staged at Lyons in February revived memories of November 1831 when the silk workers, attempting to resist their proletarianization, staged a successful insurrection and briefly took over the city. Since then Lyons had been the site of an oppressive army garrison. The laws against street hawking and the crisis in the silk industry culminated in a work stoppage on 12 February; two days later almost all twenty-five thousand looms in Lyons and its suburbs halted. Fright spread throughout the city; everyone geared for the worst and the tension was pervasive. Several manufacturers hastened to the countryside searching for asylum, but order was temporarily resumed on 22 February 1834. Three days later the Chamber of Deputies brought out the text of a law requiring all associations, even those with fewer than twenty members, to obtain a revokable authorization or be subject to heavy fines and imprisonment. Already announced the previous fall, the law on associations was an act of political hysteria introduced and debated in the wake of the general strike staged at Lyons. It was clear from the opening of the legis-

lative session of 1834 that repression was to be its keynote, and this attitude actually induced the situation it meant to prevent by solidifying the relationship between secret societies and workers' organizations.[36]

In opening the 1834 session of the Chamber of Deputies, Louis-Philippe warned of illegal plots across the land. Now the cumulative effect of workers' strikes during 1833, the public hawkers episode, the February general strike, and the trials of the republicans in December 1833 motivated the Chamber to suspend liberties which the most conservative representatives would not have touched two years earlier. A climate of potential violence now existed and needed only a triggering incident to transform demonstrations into full-scale insurrection. As the unfolding discussion on the law of associations revealed the government's imminent legislative victory, the organizations of the journeyman weavers felt threatened and engaged in renewed outbreak on 9 April 1834. Unlike November 1831 this civil war ended in a massacre, with women, children, and old men slaughtered in the streets by government and municipal troops. The terrible atrocities of Lyons were repeated in Paris on 14 April when the barricades were thrown up once again. The erection of one barricade in the Rue Transnonain was urged on by infiltrating police and *agents provocateurs*. Here on 15 April occurred the horrible scene captured by Daumier in his well-known lithograph. Troops rushed into the house located at 12, Rue Transnonain, suspected of harboring a sniper, and shot and bayoneted almost all of the unarmed inhabitants including old men, women, and children.[37]

Préault's *Tuerie* ("Fragment épisodique d'un grand bas-relief") was shown at the Salon of 1834 which opened on 1 March.[38] It therefore could not have represented the Rue Transnonain episode of 15 April, but it does give utterance to the prevailing climate of tension and potential violence existing since the beginning of the year and culminating with that tragic event. Anyone associated with the republican faction would have geared for some form of clash and Préault, close to the protagonists, expressed the fears and unbearable stress of this period.

It is astonishing to juxtapose Préault's work with his friend Daumier's lithograph of *Rue Transnonain* (Fig. 21). While the first registers the outburst and the second the grim aftermath of violence, both respond to the same repressive climate. Another contemporary image of the Rue Transnonain by an anonymous graphic artist reveals the same victims as Préault: the youth with exposed torso revealing a bayonet thrust, the terrified mother holding her infant, soldiers sporting the walrus mustache then in vogue (Fig. 22).[39]

Although Préault's political sympathies were manifested in this work, at the same time another feature shows the constraints upon his political convictions in this period. On the left, a figure contemporaries described as a black man brutally snuffs out the life of a female victim. Overseeing this act is the soldier in a medieval helmet and visor. The close proximity of these two figures whose roles are clear symbolically links the proponents of law and order with

Fig. 21. Honoré Daumier, *Rue Transnonain*. Lithograph, 1834. Rosenwald Collection, National Gallery of Art, Washington, D.C.

The July Monarchy

52

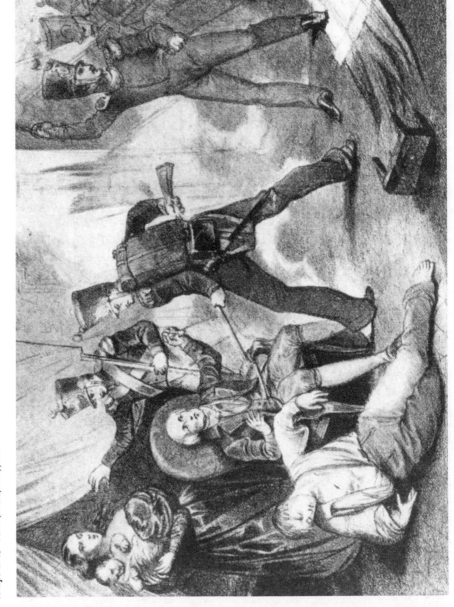

Fig. 22. *Une scène de la rue Transnonain.* Lithograph, 1834. Reproduced in A. Dayot, *Histoire contemporaine par l'image d'après les documents du temps 1789–1872* (Paris, n.d.), 228.

"barbarism." The black is seen here as the metaphorical equivalent of savagery. The identification of the black man with barbarity betrays Préault's socialization in racist Europe; his political awareness could encompass the oppression of urban "slaves" with whom he identified, but it is blind to the oppression of plantation slaves in the colonies and southern United States who harvested the cotton for textile manufacturers of Lyons. The racism of even radicals and liberals in this period is clear: Blanc recalled an incident in the November 1831 uprising in Lyons when one Negro journeyman, named Stanislas, shot down government troops, "expressing his joy in expressive gestures and savage shouts." Etex expressed the most unenlightened views on black people in Algeria and in the United States. While in Algeria during the early 1830s he sketched several black women, and once a frightened group shouted at him, crying and gesticulating "like real monkeys." On another occasion he was invited into a household where a young black woman agreed to pose for him. When he approached her to adjust her drapery with "all respect possible," she was transformed from a woman into "a ferocious beast, a tigress whose mouth issued streams of saliva, and who uttered horrible cries coming from the depth of her gullet."[40] Of course, Etex was unprepared to deal with a non-subservient black—he would never have touched a white woman in similar circumstances without asking permission.

Significantly, contemporaries generally associated blacks with savagery, as revealed in this statement by Saint-Marc Girardin in the *Journal des débats* shortly after the termination of the November 1831 uprising in Lyons: "Every manufacturer lives in his factory like the colonial planters in the midst of their slaves, one against a hundred, and the subversion of Lyons is a sort of insurrection of San Domingo. . . . The barbarians who menace society are neither in the Caucasus nor in the steppes of Tartary; they are in the suburbs of our industrial cities. . . . The middle class must clearly recognize the nature of the situation; it must know where it stands."[41] Here a conservative expressly identified the working class with plantation slaves menacing society with violent insurrection. While the liberal Préault correctly perceived the source of violence in the monarchy which betrayed its promises, he, too, used the black to symbolize the barbaric threat.

The events in Lyons were represented more untypically in the work of Barye, perhaps the most famous sculptor of the July Monarchy. His animal imagery has long exemplified a fundamental character of popular bourgeois taste in the nineteenth century. Barye was more conservative than either Etex or Préault, and was closely identified with the regime in its early years. His popular *Lion Crushing a Serpent* of 1833 (Fig. 23) incarnated the ideals of the July Monarchy which awarded him the Légion d'honneur that year. Sullen and taciturn, Barye felt more at home with animals than human subjects, and this suited the regime's taste as well. Subjects of animal combat and the "struggle for survival" were stimulated by the research of the outstanding French naturalists Cuvier

Fig. 23. Antoine-Louis
Barye, *Lion Crushing
a Serpent*. Bronze
model, 1833. Musée du
Louvre, Paris.

and Geoffroy St.-Hilaire, but they could also contain political allusions to the party strife which the government was anxious to suppress in the name of law and order. The *Lion* enjoyed a real success at the Salon of 1833, the turning point in the sculptor's career. The plaster model was purchased by the state and cast into bronze and installed in the gardens of the Palais des Tuileries. The entire Orléans family supported him, including Princess Marie (a sculptor in her own right) and the duc d'Orléans who commissioned him to do an elaborate table decoration ensemble. As his American friend and biographer wrote: "Luckily for Barye and the world the government bought his *Lion Crushing a Serpent,* those responsible for the purchase thinking to themselves, it may be, that here was a symbolical group in which their party was the lion, the malcontents the serpent."[42]

There were no "maybes" about it. The lion, perennial symbol of royalty, was putting down the perennial serpent of anarchy, the most bandied about metaphor for the regime's opponents during the turbulent years 1831–33. Moreover, around 1833 Barye used beasts as metaphors for nation-states in his unrealized project for the top of the Arc de Triomphe, where a colossal Napoleonic eagle grasped in its claws various animals representing Napoleon's defeated enemies. Additionally, the use of animal allegory fit well with Louis-Philippe's predilection for impersonal monuments. His doubts about his role as usurper and historical illegitimacy instilled in him a fear of effigies that could be effaced, mutilated, and destroyed. He especially loved the obelisk dedicated to him in the Place de la Concorde because it embodied in abstract form the royal virtues and authority and could therefore better survive the vagaries of political fortune. A caricature of the period makes the obelisk the nose of Louis-Philippe's face turned upward, and it terminates with the familiar pear-shaped head at the apex.[43] The meaning of the obelisk for the king was clear to the contemporary public.

Thirdly, the king projected himself as a constitutional monarch along the lines of the revered English model. As the British symbol of royalty, the lion would have served him well in his campaign of propaganda. More specifically, the link between the lion and the July Monarchy occurred in astrology. The revolutionary days, 27, 28, 29 July, coincided with a time when the sun lay between the constellations of Leo and Hydra.[44] The government was well aware of this, as is demonstrated in Barye's design for the pedestal of the July Column, the funerary monument installed in the Place de la Bastille to commemorate the victims of the July Revolution. Official documents actually refer to Barye's lion, surrounded by stars, as representing "the seventh sign of the zodiac."[45] While Hydra is not in the zodiac, the star charts of the time used for celestial navigation showed the adjacent constellations of Leo and Hydra in the forms of a lion and a serpent.

The most important topical implication of this group, however, was the Lyons uprising of November 1831. It may be recalled that the community of

silk workers, masters, and journeymen, frustrated in their attempts to regulate the price of their product, chose to defy the municipal government which sided with the merchants. While traditionally the merchants held the master weavers at their mercy, the July Days encouraged the weavers' hope and reminded them of their potential power. When in November 1831 their successful demand for a tariff had been thwarted by the merchants, the *canuts* (nickname for the weavers) rose in rebellion, drove out the garrison, and unexpectedly found themselves in control of the city. They presented a frightening spectacle to the representatives of the *juste milieu*. The minister of war, Maréchal Soult, and the duc d'Orléans led an army to Lyons, but when they arrived the rebellion had ended. The insurgents, seeing that they were outnumbered and without adequate arms, did not offer resistance.[46]

The repercussions of this event, already discussed, sent shock waves through the ruling classes. The shadow of insurrection haunted the *juste milieu*, and the near-success of the insurgents so soon after the Revolution of July was devastating. The king was now anxious to insure that no repetition of this could occur and to project the sense of total control. The prefect was recalled and replaced, garrisons were installed, the population disarmed, and many persons arrested.

The importance of this event for Louis-Philippe and the critical role of the duc d'Orléans in its resolution could not have failed to affect Barye. Barye's family had originated from Lyons, fleeing to Paris during the turmoil of 1793 when the Jacobins waged war on the aristocrats and conservative bourgeois who made up 64 percent of the two thousand people executed. The memories of this event still haunted the family, and they may have worried about relatives in this period. Given these facts, Barye's group now becomes a meaningful political statement about control: the lion here refers specifically to the city of Lyons, whose coat-of-arms bears a rampant lion with snarling muzzle below a zone of the royal fleur-de-lys. Thus Barye's sculpture, begun in 1832, allegorically shows the forces of state and municipal government crushing the serpent of anarchy and insurrection which dared to raise its ugly head in November of the previous year.

Following the ruthless suppression in 1834 there was no further major outbreak of civil disturbance until the insurrection of February 1848 which toppled the July Monarchy. At that moment, a faltering economy added to the intense political pressure for a more liberal and representative regime. The government's intransigence pushed the Paris crowds to revolution, and on 24 February the Second Republic was declared from the Hôtel de Ville. For a while the moderates and radicals in the provisional government compromised with some skill, adopting universal male suffrage—allowed in no other large nation—declaring the citizen's right to work a principle of government, and abolishing slavery in the colonies and the death penalty at home.

But the heightening of the social issues exposed the disagreements between the two groups as well as the wider social divisions between Paris and the countryside and between middle class and workers. The moderate majority of the new assembly were satisfied with what the Republic had already achieved and drew a line at further social advances and threatened disorders. Workers on the other hand found conditions little improved by the new government and continued to agitate for a more radical social program. Frightened, the government disbanded the national workshops, established to provide useful work for the unemployed. Only a shadow of the concept advocated by Louis Blanc, the workshops in fact offered more welfare than employment. Nevertheless, the moderates saw in them a dangerous principle while the underclasses looked to them as a symbol of hope. On news of their breakup, barricades went up in the workingmen's quarters of Paris, and the poor fought with great courage against the National Guard led by Cavaignac. After three days of fighting, 24–26 June, the government troops triumphed. More than a thousand people died, and thousands more workers were sent to prison or into exile.

By the end of the year, the forces of order had regained control. Nationwide elections in December selected Louis-Napoleon Bonaparte as president of the French republic. He had the support of the Catholic church and the monarchists, and his name attracted the rest. In 1850, with constitutional monarchists a majority in the Chamber of Deputies, the Second Republic was ruled by its opponents. When, in the third year of Louis-Napoleon's four-year term, the Chamber rejected a constitutional amendment that would have permitted him a second term, he decided to launch a coup d'état. Exactly one year later, the Second Republic was transformed into the Second Empire under Napoleon III.

Cultural producers in this period actively engaged the dominant political issues. The young Second Republic's promises of a more egalitarian society lifted the hopes of the painters and sculptors. The utopian dreams involving the artist's constructive social role now seemed on the verge of fulfillment. The artists were encouraged by the exuberant administration of fine arts which developed grandiose plans for monumental public undertakings which they planned to carry out through open competitions and democratically selected juries.

The first and most important of these was for the painted and sculpted Symbolic Figure of the Republic; the regime was plagued with ideological conflicts and needed some kind of general allegorical identification to provisionally embrace the various ideals in a coherent, emblematic image.[1] But the judgment for the painted figure, which took place on 23 October 1848, was doomed from the start. The finalists presented such a motley group of republics that an indignant jury not only voted against awarding the prize but also vetoed the idea of a new contest. This outcome was vigorously protested by the radical press, and it seems clear that the decision to scotch the contest sprang from conservative reaction in the wake of the June insurrection which totally altered the social climate of the Second Republic. The conflicting parties could not agree on an appropriate symbol because the entries reflected the political attitudes expressed before the showdown between workers and bourgeois. Undoubtedly, it was the utopian, visionary character that most frightened the moderates. The right-wing press ridiculed the entries, one journal asking which Republic is to be represented in the symbols, "the Republic of June?"[2]

In view of the failure of the painted Republic it is doubly significant that the sculptural competition for an appropriate allegorical motif had the opposite outcome. For this contest ten finalists submitted plaster models two-and-one-third meters high. The judgment took place in January 1849 when the forces of reaction were in control under the presidency of Louis-Napoleon.[3] Soitoux, a pupil of David d'Angers and Feuchère, also a finalist in the contest, was declared the winner. Clad in classical costume, his figure of the Republic holds a sword and is surrounded by many of the same kind of utopian accessories found in the paintings (Fig. 24). But it radiated the impersonal look of eternity and of antiquity emphasized by Soitoux's master David d'Angers. Here is a "classic" example of how the essentially conservative tradition of sculpture could be made to fit the ideals of a conservative regime nominally labeled a "republic."

Later, Soitoux claimed that Nieuwerkerke, head of the fine arts establishment during the Second Empire, counseled him to transform his Republic into a figure of Justice or Liberty.[4] This was not an unusual request in this period since Nieuwerkerke spent much of his time inducing artists with well-known republican sentiments to bring their work in line with the ideology of the new regime in return for rich rewards. Soitoux refused to play this nominalist game, but in retrospect, he could easily have made the alteration without compromising his integrity in the formal sense. Like the Vendôme Column, Soitoux's Republic was an empty vessel waiting to be filled with new government wine whenever political circumstances dictated.

Other examples of this problem were Roguet's *Republic*, done for the same contest, and Feuchère's *Constitution*. Roguet's work, which earned an honorable mention, was stripped of its republican attributes and shipped to Orléans as a personification of the city. A crown was substituted for the Phrygian bonnet

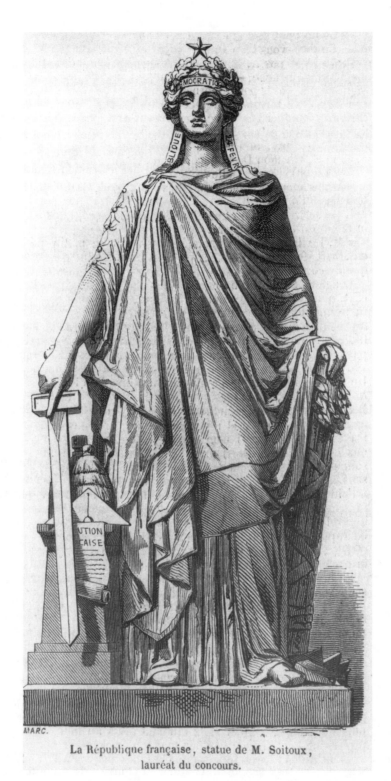

La République française, statue de M. Soitoux,
lauréat du concours.

Fig. 24. Jean-François Soitoux, *Figure of the Republic* (1848–50). Wood engraving of model reproduced in *L'Illustration* 12 (27 January 1849): 352.

and its other accessories were altered in accordance with local traditions.[5] Feuchère's statue of *Constitution* symbolizing the republican instrument had been commissioned for the Place de l'Assemblée Nationale, but he completed it only in 1852 after the coup d'état and it was therefore no longer politically relevant. Nevertheless, the chief of Beaux-Arts under Nieuwerkerke claimed that in principle nothing opposed its use by the Second Empire. The Administration could simply call it "The Law," and install it in its original location, now the Palais du Corps Législatif. Only the inscription would be changed to protect the guilty: "FELICITER—REGNANTE NAPOLEONE III FRANCORUM IMPERATORE ANNO MDCCCLIV."[6]

We have seen how the July Monarchy, in its exploitation of Napoleon's name and deeds, prepared the ground for Napoleon III. Louis-Napoleon tried early on to capitalize on this heritage, not only championing the works of art dedicated to his glorious uncle (as will be seen in the case of Noisot's monument executed by Rude), but actually taking advantage of the Bonapartist popularity to undermine the government. His attempts at insurrection miscarried, but the art served him better. One such monument actually bridges the July Monarchy and the Second Empire, Napoleon's tomb in the Invalides. The Invalides was, of course, political dynamite during the July Monarchy; it sheltered mainly ex-officers and veterans of Napoleon's armies who comprised a formidable liberal bloc, and they overwhelmingly endorsed the Return of the Ashes from Saint-Helena.

The monumental red porphyry sarcophagus designed for the remains of Napoleon was to be located in an excavated circular crypt below the dome of the Church of the Invalides (Fig. 25). The architect, Louis-Tullius-Joachim Visconti, set out his plans for the sculptural decor in 1843, but progress was interrupted by the Revolution of 1848. Work resumed in 1850 during the presidency of Louis-Napoleon and was completed only in 1861 after he had become emperor. Six large white marble bas-reliefs on the walls of the gallery designed by Simart recalled the significant civil achievements of Napoleon.[7] Their compositional format is similar: Napoleon stands or sits in the center in ancient garb, while around him are grouped allegorical personages of the Arts, Science, Religion, and Justice, over which he extends his protection. A little chamber serving as a reliquary houses Simart's colossal statue of Napoleon in coronation robes. The emperor's right hand holds the royal scepter surmounted by a bronze eagle, and his left hand holds the globe of the world.

The July Monarchy decided not to expose Napoleon's sepulchre in a public place or amidst a "noisy, heedless crowd." Louis-Philippe's anxiety about vandalism extended to Napoleon's tomb as well. The emperor deserved a special site—not with the ancient kings at St.-Denis—but "where the veterans of France go for rehabilitation and rest and where those who currently defend their country shall go for inspiration." Rémusat, the minister of interior in

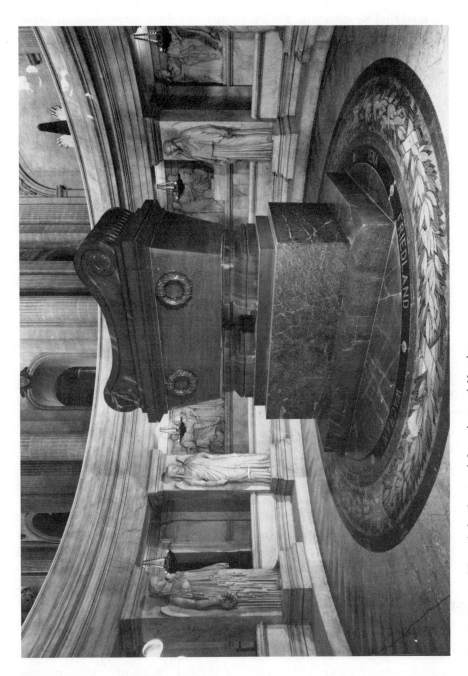

Fig. 25. *Interior View of the Crypt and Sarcophagus of Napoleon,* 1843–61. Musée de l'Armée, Hôtel des Invalides, Paris.

1840, stated in his speech before the Chamber of Deputies: "The Monarchy of 1830 is . . . the unique and legitimate heir of all the souvenirs in which France takes pride. This monarchy, the first to rally all the forces and conciliate all the goals of the French revolution, should have the honor of elevating and celebrating without fear the statue and tomb of a popular hero: for if there is one thing, one thing alone, which does not shrink from comparison with glory, it is liberty."[8] By 1840, when most dissidents were arrested or suppressed, the July Monarchy could bask with security in the "return"; and it expressly emphasized from its secure vantage point that it had no compunction about comparing itself with the popular image of Napoleon. Furthermore, freedom from fear in this narrow sense was equated with the liberty in the repressive political and social realms.

But things were hardly placid: on 12 May the year before, Blanqui and Barbès, two radicals, seized the Palais de Justice and the Hôtel de Ville and tried to secure the bridges to establish contact with the center of the city where barricades were being erected. The insurgents were vastly outnumbered and easily crushed the same day. Then on 6 August 1840 Louis-Napoleon landed from England on the beach at Wimereux near Boulogne, bringing with him a loyal cadre of conspirators. But his attempt to rally the officers of the regiment stationed at Boulogne failed and he was taken prisoner. Tried before the Court of Peers because the government feared the notoriety of a trial by jury, Louis-Napoleon was sentenced to detention for life at the Château de Ham, from where he afterwards escaped.

French foreign policy was also troubled. In April 1839 the Turkish Sultan Mahmoud, urged on by England, renewed the struggle against France's ally Mehemet-Ali, Pasha of Egypt, and invaded Syria; but his troops suffered a severe defeat which was hailed with joy in France for it meant a defeat for England and the restoration of French prestige in the East. England and Austria then proposed to France that they should take concerted action to settle the Turco-Egyptian conflict, and Louis-Philippe accepted. In the end, however, England, Austria, Russia, and Prussia signed the Treaty of London on 15 July 1840 without notifying the French ambassador. This amounted to reviving against France the coalition of 1813 which had brought about the fall of Napoleon. The governing classes in France now assumed a bellicose attitude, and thoughts of Waterloo were revived. But at the last minute the government rejected a military solution, using the opportunity of the Return of the Ashes to channel political and nationalist sentiment peacefully.[9]

Thus the ceremony and pomp surrounding the Return of the Ashes on 15 December 1840 coincided with the immediate political needs of the July Monarchy. French sculptors literally enjoyed a field day. All along the Champs-Elysées were trophies and statues of Victory recalling the Napoleonic

campaigns. A colossal Apotheosis of Napoleon was placed on top of the Arc de Triomphe, and images of the French kings were paraded on the Place de la Concorde and along the quai to the Invalides, again emphasizing a historical succession leading to Louis-Philippe.[10]

Napoleon's tomb extended the ideological implications of this event. Simart's panels reveal Napoleon the Administrator, not the warrior, and celebrate his institutional contributions to social stability, such as the Concordat, Administration (with a crushed hydra representing administrative anarchy), and Pacification of Civil Troubles, with Napoleon again treading anarchy underfoot (Fig. 26). In this plan, the inscription reads: "Disorganizing principles vanish, factions submit, parties blend, wounds close; Creation seems again to have risen from chaos."

There is no passage into the middle of the sepulchre; it is surrounded by a low marble wall, interspersed with huge blocks of white marble which are carved to form twelve colossal statues by Pradier representing the various Napoleonic campaigns—twelve victories supporting the upper gallery of the crypt. Pradier's first idea was to give each figure the native costume of the defeated country, but Visconti rejected this insisting on the uniformity and abstract character of classical models.[11]

Simart's bas-reliefs and Pradier's statues were all but made to order for Louis-Napoleon when he assumed control of France. The tomb was inaugurated in 1853 when he was already Napoleon III, and the commemorative model by Oudiné (like the one struck by Louis-Philippe for the inauguration of the Arc de l'Etoile) showed the emperor's profile superimposed on that of his uncle. The commemorative brochure of that year solemnized the progress of the cult of Napoleon from cradle to tomb, from exile to apotheosis—a destiny clearly traced by the finger of God. Corsica became French at the moment Napoleon was born; the Revolution of 1789 opened a career for him, and in the process of upholding its sane contributions he went from victory to victory until he mastered Europe. After 1815 the imperial fortune seemed to have been depleted; but then a new revolution restored the national flag and revived the memories of his triumphs. The distance between Saint-Helena and Paris was dramatically foreshortened, culminating with the Return of the Ashes. Furthermore, the "tomb prepared by a dynasty alien to the family of Napoleon is now consecrated by the nephew of the Emperor! Protected also by mysterious and invincible destiny, Louis-Napoleon passed from exile to prison, from still another exile to representative in parliament, to the presidential chair, and from thence to the imperial throne! The interval between the two Empires has been effaced, like the distance between the two tombs; the present confounds itself with the past, and the hopes of the country rise to the heights of its memories."[12] Here, in this skillful manipulation of popular sentiment,

64

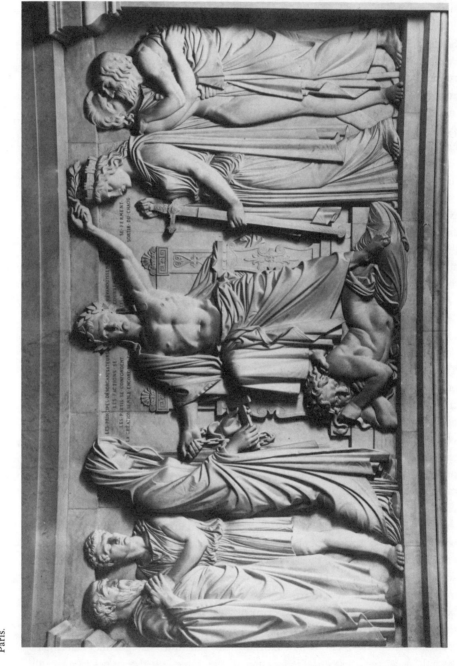

Fig. 26. Pierre-Charles Simart, *Pacification of Civil Troubles*. Marble, ca. 1850–53. Dom des Invalides, Paris, Musée de l'Armée, Hôtel des Invalides, Paris.

Napoleon III buttresses his own illegitimate authority with his personal version of history and reinvests the sculpture planned for the July Monarchy with his own brand of imperial ideology.

Simart's bas-reliefs were conceived and completed during the period 1846–52, with work proceeding rapidly during 1848. In September of that year Simart wrote to a friend about the painful divisions, factions, economic stagnation, and anarchy rife in French society and imagined a Napoleon as the sole answer to these domestic problems.[13] He clearly shared the views of the majority of his countrymen that Louis-Napoleon alone offered a solution to the contemporary dilemma. The bas-reliefs therefore realize a series of institutionalized categories perfectly appropriate to the program of Napoleon III. Simart's pediment for the Pavilion Denon at the Louvre of 1855, *The Awakening of the Arts and of Industry with the advent of Napoleon III,* crowns his aesthetic and political support of the new emperor.

On another level, Simart was disappointed by his colossal gilded statue for the cella of the crypt. Here he felt he had compromised himself: "If I had been free, I would have wished to make this noble form, this heroic figure, tormented by his grandiose vision, by his immense dream which he never realized. . . . I would have wished to print on his noble forehead all the drama of his superhuman existence. Unfortunately, I had to make a statue of convention and by order. . . ." He then retreated, feeling that he perhaps had admitted too much; but he generally felt that his finished work failed to keep pace with his original conception, and that he had need in this instance "to talk about it to a bosom friend."[14]

At the same time, Simart acknowledged that the bas-reliefs could achieve unity in the whole only through antique costume and conventional allegory. Again, sculptural tradition harmonized with conservative politics. At this stage Louis-Napoleon wanted to identify totally with his namesake and encouraged allegory as a means of bridging two time periods. Later he moved toward realism, more consistent with his own epoch and the practical outlook of his regime. But for the years of the coup d'état and his coronation he endorsed Simart's classicism. Like David d'Angers, Simart believed that sculpture should be noble and dignified in line with classical generality and simplicity, and this suited the ideology of Louis-Napoleon during his rise to power in 1848–52.

The revisionist attitude to Bonaparte's legacy during the July Monarchy was exploited in the private domain as well, especially by those who hoped to organize a party around Louis-Napoleon. One neo-Bonapartist was Claude Noisot, a veteran officer of Napoleon's grenadiers in the Imperial Guard who owned an estate at Fixin, about six miles south of Dijon. Noisot had been personally chosen by the former emperor to accompany him in his first exile to the Isle of Elba. Noisot stayed with his idol during the Hundred Days, and after Waterloo he was dishonorably discharged from the army. Later, after several years of persecution, he entered the ranks of the opposition in the Chamber of Deputies. Noisot took an active part in the Revolution of 1830,

leading a unit of Napoleonic veterans on the barricades dressed in his old uniform of the Imperial Guard with a tricolor cockade pinned to his hat. He remained steadfastly loyal to the memory of his former chief, and was ecstatic over Louis-Napoleon's attempted coup d'état at Boulogne and the Return of the Ashes the same year. Noisot and his fellow veterans were assigned a place in the procession, but they aroused some consternation when they deemed their position unworthy of their historical role and moved to the head of the cortège.[15]

It was in this period that Noisot first met François Rude, and shortly afterwards he persuaded the sculptor to undertake a monument to his hero on his property. The result was *Napoleon Awakening to Immortality,* depicting Bonaparte rising from his chains on the rocky pinnacle of Saint-Helena and lifting his burial shroud to greet the light of day (Fig. 27). To the critic Thoré it appeared as "an apotheosis thoroughly endued with conviction, like the promise of a future resurrection."[16] The inauguration that took place on 19 September 1847 assumed all the trappings of a national event. Although the monument was installed on Noisot's private lands, the inaugural ceremony was attended by local and departmental officials and a military cortège consisting of two artillery units and the National Guard and fire brigade of Dijon.

Rude and Noisot joined to create a sacred site, Noisot paying for all material expenses and donating the site and Rude supplying his labor for free. The collaborative project has for its inscription, "To Napoleon, Noisot, grenadier on the Isle of Elba, and Rude, sculptor." This joint dedication and the inaugural solemnities would have scant meaning unless they are seen as part of a larger Bonapartist strategy taking shape in the aftermath of Louis-Napoleon's escape from prison the previous year. While Louis-Napoleon was in London at the time of the ceremonies, the event played a significant role in his propaganda campaign. We know that Rude voted for Louis-Napoleon in the elections of 10 December 1848, and later the prince-president invited both Rude and Noisot to a Bonapartist gathering at Paris to congratulate them on their monument.[17] In 1851 Louis-Napoleon seized the opportunity just prior to the coup d'état to make a pilgrimage to Fixin and pay homage to Noisot. Rude's "awakening" Napoleon may now be seen as a forecast of the Bonapartist pretender.

The reign of Napoleon III witnessed great prosperity for the French nation which enabled the emperor, a political upstart, to remain in power for over twenty years. But this prosperity depended upon imperialism abroad and repression at home. An expert in manipulative techniques, he used his control of the popular media to reconcile the contradictions of his regime. (His propagandistic approach is already caricatured in Daumier's *Ratapoil* [ca. 1850–51], a left-wing critique of Louis-Napoleon done before the coup d'état.) He embarked on a monumental program of public works to provide full employment for the working classes, reduce the possiblites of insurrection, and alter Paris in the imperial image. Under his rule, realism in art gained importance as he

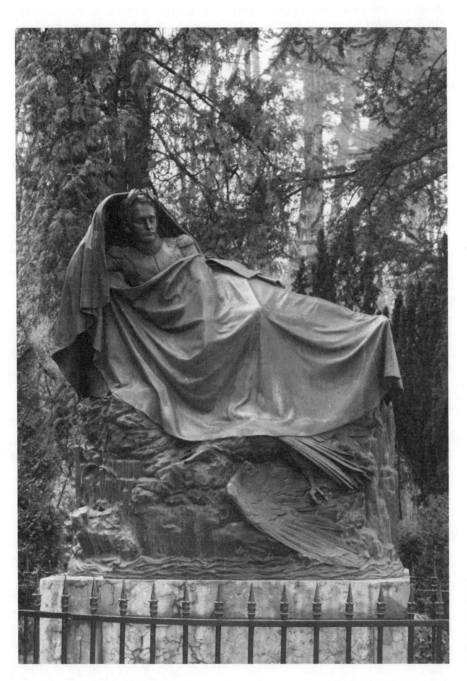

Fig. 27. François Rude, *Napoleon Awakening to Immortality*. Bronze, 1845–47. Parc Noisot, Fixin. Courtesy Bernard Sonnet.

Revolution and Counterrevolution

gradually embraced this style to depict scenes of industry, public works, diplomatic and military victories, and social life in rural areas which were the bulwark of his electoral support. At the same time, the legality of his authority—based on subversion of the constitution and his sworn oath—was always questionable, and he used images to create a veneer of historical legitimacy. Mingled among the realist representations of the regime are medieval motifs which portray him among the heads of former French dynasties, including the Capetians, Charlemagne, and François I. To demonstrate that his reign was securely tied to the historical progress of the French throne, he had himself linked with the great national heroes of the past: monuments to Vercingetorix and Charlemagne abound, but so do sculptures of François I, Henri IV, and, of course, the ubiquitous Napoleon I.

In the end, he exploited the image of his Napoleonic ancestor to such an extent that even friendly critics charged him with using it as a crutch. This motivated him to champion realism further at the peak of his power, but he reverted to the older imagery during the closing years of his empire. This iconological shift is indicated in the work of one of his favorite sculptors, Carrier-Belleuse, who could do ruthlessly realistic portraits of the emperor on the one hand, and on the other, execute in 1869 the mythological theme of *Hebe* sheltered by the wing of a colossal eagle as the avatar of Jupiter—clear allusion to a vulnerable France under Napoleonic protection at a time when the regime was tottering and real confidence was no longer there.[18] Carpeaux's frenzied *Danse* for the Opéra, with its abandonment of "reason" and the grand style, represented the other side of the imperial coin during the regime's final days.

The Opéra, with its ornate and abundant sculpture, was central to Napoleon III's building program in promoting the image of wealth and magnitude of imperial power.[19] Charles Garnier, the architect, regimented his decorators, painters, and sculptors to create a totality expressive of the global impact of the Second Empire. His demand to his laborers to surrender their individuality to the ponderous architectural scheme was the visual equivalent of the government's attempt to bring under its control all the loose ends of the social order. The amount of sculpture on facades, in public places, and new churches now became massive as compared with previous regimes. The imperious Haussmann, who orchestrated the overall building program, met the increased demand for public sculpture by often ordering directly from the sculptors himself. They in turn required a coordinated army of assistants to carry out the work, and this generated their deep concern for training methods. It is no coincidence that contemporary artistic pedagogy received its greatest impulse from sculptors, and that their ideas for reform were realized by the highest ranking official in the Beaux-Arts administration, the sculptor Nieuwerkerke. Caillouette, Feuchère, his pupil Klagmann, Rouillard, Etex, Ottin, Carrier-Belleuse, and Guillaume (appointed director of the Ecole des Beaux-Arts in

1864) all devised new methods for training neophyte artists. They further aimed at simplifying artistic pedagogy to make it available to applied as well as fine artists, all agreeing on the urgent necessity to break down barriers between the two groups. Etex's slogan for the unity of all the arts, "l'art synthétique," incarnated their highest ideals, and it was used by government spokespersons in their rhetoric on the arts.[20]

The government enthusiastically backed these efforts to achieve a larger work force for the public works program and enacted the unprecedented Decree of 13 November 1863 which totally revamped the curriculum of the Ecole des Beaux-Arts and wrested it from the Academy's control.[21] The same year it subsidized the Union Centrale des Beaux-Arts appliqués à l'industrie, hoping thereby to make fine artists responsive to the decorative needs of the government and enlist the aid of industrial artists in developing a style appropriate to the imperial taste. The government was also intent on upgrading the quality of French industrial products for the international market and its showcase, the international world fair. Unlike previous regimes, it praised and promoted the efforts of its industrial art schools, the Ecole de dessin and the Ecole de dessin pour des jeunes filles, on a par with the Ecole des Beaux-Arts. Gifted students at these official institutions were told to be proud of being industrial artists and not to think of entering a career in the fine arts. Houssaye, the inspector-general of fine arts, often spoke at the awards ceremonies of these schools, exhorting the students to recall the Renaissance combination of artist-craftsman and to work for the glory of the government. At the Ecole de dessin in 1867 he emphasized the need for France to shine in the industrial arts at the International Exposition of 1867: "It is especially in this year 1867, when France plays host to all the nations of the world, where industrial art has been consecrated once again by Napoleon III for the eyes of the entire world. . . . It is especially in this year . . . that I would wish to see you surpass yourselves again."[22]

Thus attitudes toward art education underwent drastic change during the Second Empire, and this stimulus to the decorative arts encouraged the careers of Carpeaux, Carrier-Belleuse, Dalou, and Rodin, all of whom studied at the Ecole de dessin. The administration could note in an official report on the school in 1859 that many of the young sculptors and ornamentalists decorating the new extensions of the Louvre and other public edifices were graduates of the Ecole de dessin.[23]

One graduate blending the artist-designer to perfection was Carrier-Belleuse who enjoyed a spectacular success during the Second Empire. He supplied designs for major firms like Barbedienne, the bronze founder, Rousseau the ceramicist, and Christofle, the goldsmith and silversmith.[24] He was one of the founder-members of the Union Centrale des Beaux-Arts appliqués à l'industrie and set up a major booth at its first show in 1863. The regime admired his lively decorative style and commissioned him to do all sorts of work including busts of Nieuwerkerke, Fould, and the emperor himself. In response to the

demand for pedagogical reform he collaborated with the Goupil publishing house to produce his album *Etudes de figures appliquées à la décoration.*[25] Additionally, he actively participated in Haussmann's rebuilding campaign, designing groups for the Tribunal de Commerce and the Louvre, as well as for private town houses stimulated by the rezoning of Paris and the thriving real estate speculation. Among his numerous assistants were Falguière, Dalou, and Rodin, all former students of the Ecole de dessin who followed his decorative bent and assimilated in their own style the master's spiraling gestures and succinct designs. Rodin acknowledged Carrier-Belleuse as his master in Salon catalogues, although the contact had to be mainly practical and technical. Rodin's later simplification of form sprang from Carrier-Belleuse's drastic reduction of form and movement for adaptation to decorative commissions.[26]

Jean-Baptiste Carpeaux shared with Carrier-Belleuse the entrepreneurial ambitions that endeared him to the Second Empire. He painted, sculpted, and ran a business studio to produce and sell reproductions of his work in various media including the new process of electrotyping, the use of an electric current to coat an object metallically and produce a negative mold.[27] Carpeaux's audacity, his image as a self-made type, his constant hustling and business instincts epitomize the Second Empire sculptor. He developed a style consonant with the regime's taste, more realist, more dynamic and emotionally charged than ever before, but tempered by its links with the grand tradition.

Carpeaux's father was a master stonemason, his mother a lacemaker, and the youth worked for his father and also executed various odd jobs to supplement the family income. They moved to Paris in 1838 and a few years later Carpeaux entered the Ecole de dessin which he saw as a stepping-stone to the Ecole des Beaux-Arts. After enrolling in the fine arts school he tried several times without success to win the Prix de Rome. But he had the drive and alertness to overcome all obstacles; he left Rude's studio because the elder sculptor was persona non grata at the Institut (whose members juried the Prix de Rome), and enrolled with Duret for the sole purpose of gaining academic respectability.[28]

During his matriculation at the Ecole des Beaux-Arts he maintained close ties with his native Valenciennes which awarded him a stipend for his studies. His dear friend and patron in that town, the lawyer J.-B. Foucart, was a Bonapartist with close connections to the circle of Louis-Napoleon. While Foucart had a falling out with the regime after the coup d'état, his contacts helped Carpeaux gain entrance to the court of the Second Empire. Foucart commissioned Carpeaux's first major work, the *Holy Alliance of the People,* based on a poem by Béranger. Béranger protested the Holy Alliance of the Congress of Vienna which rearranged the map of Europe in the post-Napoleonic period and dictated French policy. The poem was written in 1818 to celebrate the evacuation of the allies from France and calls for a universal brotherhood of European nations represented not by politicians but by the people themselves.

Carpeaux's bas-relief shows an allegorical figure of Peace emerging from the earth, hovering above the prostrate corpse of Napoleon lying on a cannon in the center of the composition. Peace strews the ground with flower petals, and the ground is nourished by the remains of the emperor in this "springtime of the peoples."[29]

Now Béranger was an ardent Bonapartist throughout his life, and his poetry did much to serve the Napoleonic revival. Louis-Napoleon used his poetic souvenirs of the empire to promote his own cause when he ran for election in 1848, and when he became emperor he helped transform Béranger into a venerated saint. Foucart, whose father had fought under Napoleon I, expressly identified with this work in which he and his wife are directly incorporated.[30] Executed in 1848, Carpeaux's first important piece heralds the presidency of Louis-Napoleon.

Carpeaux continued to compete for the Prix de Rome but was convinced that he was being passed over for want of influence. He now set himself the task of gaining recognition from the government by executing a work flattering to the new regime, a bas-relief depicting the emperor granting freedom to the Algerian leader Abd-el-Kader (Fig. 28). Abd-el-Kader had been released from the Château d'Ambroise to come to Paris and sign a treaty making him an exile subsidized for life by the French state. Carpeaux went to considerable lengths to sketch the individuals involved; he scurried to the Opéra to catch a glimpse of the Algerian chieftain and attended reviews of the troops and official ceremonies like the wedding of the emperor and future empress at Notre-Dame. His bas-relief represented the kind of realist propaganda fostered by Napoleon III and shows the liberties that the government could take with the grand style. Tissier's painting of a similar subject (Fig. 29), exhibited at the Salon of 1861 but begun much earlier, undoubtedly influenced Carpeaux's work.[31] Carpeaux shows the emir humbling himself before the emperor, kneeling to kiss his hand in the presence of the military officers who defeated him in battle. The sculptor emphasizes the authority and prestige of the emperor, who gestures magnanimously while the hero who made the Algerian conquest a prolonged affair is totally humiliated. Henceforth, French colonization of Algeria could proceed with a free hand and Napoleon III could boast that he was as much the emperor of the Arabs as he was of the French.

Carpeaux knew he had a sure thing and went about gaining maximum publicity for his masterpiece. His methods were wildly audacious: he first exhibited the relief at the Salon of 1853, but it was hung in an unfortunate position and barely noticed. Meanwhile, Carpeaux sent the surintendant des Beaux-Arts, Nieuwerkerke, a photograph of the work and complained about mistreatment. Carpeaux learned that the emperor was traveling north on an itinerary that would take him to the sculptor's hometown of Valenciennes. Foucart arranged with the mayor to show the work at the top of the staircase of the town hall, but Carpeaux, who planned to greet the imperial couple there,

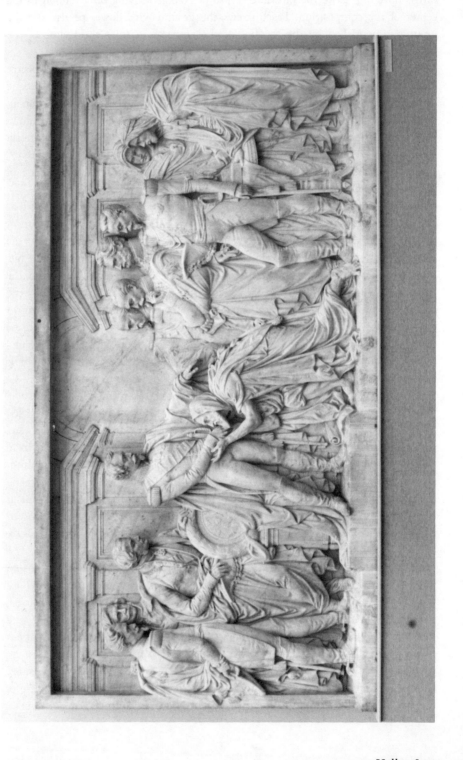

Fig. 28. Jean-Baptiste Carpeaux, *Napoleon III Receiving Abd-el-Kader at Saint Cloud.* Marble, 1853. Musée des Beaux-Arts, Valenciennes.

Fig. 29. Ange-Tissier, *The Submission of Abd-el-Kader*. Oil on canvas, Salon of 1861. Present whereabouts unknown.

Revolution and Counterrevolution

was busy drinking at a pub when the emperor and empress made their visit. Undaunted by this error, he learned that the couple planned to travel to Amiens so he shipped the bas-relief there. His frenetic appearance and breathless excitement led authorities there to suspect that the crate contained an explosive device and that he planned to assassinate the emperor. Finally, with the help of a drawing teacher, the work was shown in an exhibition held at the local lycée where the pair intended to visit, and Carpeaux hid behind a column nearby. When the imperial couple approached the work it struck them as familiar, and at that moment Carpeaux stepped before them and introduced himself as the sculptor. He begged to replicate it in marble or bronze, and the emperor, impressed with his ability and manner, told Carpeaux to contact Minister of State Fould and promised to speak in his behalf after his return to Paris.[32]

Ernest Chesneau, a favorite critic of the regime, wrote the first major biography of Carpeaux and dedicated it to their mutual friend Nieuwerkerke. He noted that it was the surintendant des Beaux-Arts who signed Carpeaux's first official commission, the ordering of the bas-relief of Abd-el-Kader in marble in 1853. The most powerful person in the Beaux-Arts administration, Nieuwerkerke remained a lifelong friend and benefactor of the young sculptor. In 1854 the government architect Lefuel ordered Carpeaux to do a *Génie de la Marine* for the Louvre decorations, and he also received a command to do a bust of the emperor's private secretary, a good friend of Foucart.[33]

It is not surprising to learn that Carpeaux won the Prix de Rome the same year, 1854. His free-standing group of *Hector and His Son Astyanax* harvested lavish praise from all the official critics. The day after the announcement of the award he received a letter from the emperor's secretary congratulating him on his triumph. The secretary wrote that Carpeaux had Napoleon III's good wishes and that the sculptor should immediately send off a note thanking him for his support.[34] The emperor's patronage, backed up by Fould and Nieuwerkerke, was to exempt Carpeaux from many of the rigid regulations of the generally strict atmosphere at the Academy at Rome.

Once in Rome, Carpeaux certainly acted privileged, barely conforming to the standard regulations and fighting constantly with the Director Schnetz over the requirements imposed on the pensioners. Carpeaux's project *Ugolino* sorely tested this relationship, since the number of its figures deviated from the number stipulated in the rules. Schnetz advised him to substitute another subject for his *envoi* (the annual proof of progress required from the pensioners), but Carpeaux refused, and when his fellowship ran out he went over the director's head to the Paris administration which agreed to subsidize the continuation of his project. On his trip to Rome in 1861 Nieuwerkerke enthusiastically praised the piece and predicted that henceforth Carpeaux would be known as the "Ugolino Man." The surintendant hoped to cast it in bronze in time for the London World's Fair of 1862 as an outstanding example of the young French school.[35]

Official pressure and Carpeaux's persistence eventually forced Schnetz over to the young sculptor's side, anticipating the independent position of the administration in matters of fine arts policy and taste. While the members of the Académie des Beaux-Arts received Carpeaux's work from a basically negative perspective, the government purchased the work and a bronze cast of it won a medal of the first-class in the Salon of 1863. This antagonism between the government body and the Académie foreshadowed the explosive enactment by official decree of the pedagogical reforms of 13 November 1863 which gave the government direct control over the fine arts institutions.

Ugolino and His Sons was held up to the public as an example of the type of art encouraged by the government over and against the anachronistic and parochial taste of the Académie. It was overall a controversial work—even for some official critics—with the brooding, contorted image of Ugolino flanked by his dying children and grandchildren in the Tower of the Gualandi (Fig. 30). The subject was based on a passage from Dante's *Inferno*, Canto XXXIII, recounting the tragic climax of the life of the tyrant Count Ugolino della Gherardesca (ca. 1230–89) who held power in Pisa momentarily during a period of bitter factionalization. The two dominant parties, the Guelfs and the Ghibellines, struggled for political ascendancy, with the Guelfs defending the papacy against the Hohenstaufen emperor Friedrich II and his Ghibelline supporters for control of Italy. Membership in one or another party became the prerequisite for holding political office in their respective strongholds, and the terms became attached to specific ideologies which outlived the historic circumstances under which they originated. Ugolino was Ghibelline by family tradition, but he switched parties and rose to power in Pisa as a leader of the Guelfs. His Machiavellian tactics and shifting political alliances cost him dearly; he plotted with the Ghibellines against his Guelf colleagues, and his insecure position led him to commit crimes against his rivals which in turn led to betrayal by his accomplices. The Pisan Ghibellines came to believe that Ugolino had sold them out; they invaded his castle, seized him and his two sons, Gaddo and Ugoccione, and his grandsons, Nino and Anselmuccio, and imprisoned them. They were denied food and all died of starvation, but not before the dying children had offered up their flesh for their father to eat.

This was heady stuff, a subject and context made to order for the mind-set of Second Empire society. Carpeaux's definitive concept came to him during a visit to Florence in August 1858. Between that time and its completion near the end of 1861 the French and Italian peoples became embroiled in a complicated political game. It was the height of Italian nationalism known as the Risorgimento, the main work of which had been accomplished during Carpeaux's fellowship at Rome. The critical chain of events leading to Italian independence and unity all occurred betwen 1859 and 1861, the year the Kingdom of Italy was proclaimed. Napoleon III joined with Piedmont against the Austrians in 1859, thereby alienating the papacy and conservative Catholics at home. His ambition to arbitrate the fate of Europe and weaken the Hapsburgs

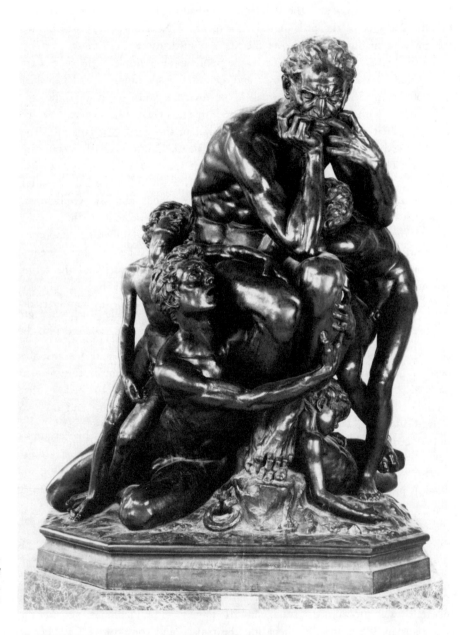

Fig. 30. Jean-Baptiste Carpeaux, *Ugolino and His Sons*. Bronze, 1860. Musée du Louvre, Paris.

put him on a collision course with Pio Nono, formerly the hope of the neo-Guelf movement. This movement had raised expectations since the previous decade that the pope would unite the nation as an alternative to union under Piedmontese rule.

In addition to these historic associations in Carpeaux's work, its theme involved insurrection, usurpation, and political incarceration—material bound to be fascinating to the members of the imperial court which itself rose to power through usurpation and maintained it through ruthless suppression of its opposition. The jails were filled with political captives, including for a time the Italian nationalist Felice Orsini, whose assassination attempt on Napoleon III on 14 January 1858 brought the Italian question directly home to the emperor. As a former conspirator himself, Napoleon III was determined to put an end to all conspiracies in France and neighboring nations. Many of the political prisoners had been incarcerated after the failure of the only major rebellion against the regime at Angers in 1855. The convicted insurgents were deported to Cayenne, Devil's Isle, and several fortified prisons throughout France where large numbers died of malnutrition. Horror stories about the conditions of these prisons circulated in the ensuing years, particularly by escapees who lived in exile. Meanwhile the government was alarmed by the threat of the secret society known as "Marianne" which organized the Angers uprising and sought to systematically uproot its network.[36] The worst period of the search and seizure tactics of the government coincides with the period in which Carpeaux conceived of and developed his *Ugolino,* the archetypal political prisoner wasting away. Some of his preliminary drawings show the group in a confining prison cell, one of which displays a barred window.[37] The final sculpture retains the suggestion of imprisonment in the chains and ring modeled into the base. Ironically, Carpeaux's model for the protagonist was a convict who had to be bailed out on several occasions to allow the sculptor to complete his work.

During the exhibition of Carpeaux's bronze version of the group at the Salon of 1863, at which he also exhibited a bust of Princess Mathilde and the *Neapolitan Fisherboy,* the sculptor wrote a friend that passion was essential for the artistic expression of contemporary life, mentioning among his examples Géricault's *Raft of the Medusa* (1819) and Delacroix's *Massacre at Scios* (1824). Géricault's *Raft* certainly influenced Carpeaux's concept since its brooding old man was long throught to have been an Ugolino-type symbolically referring to the cannibalism aboard the raft. Carpeaux further declared that his sense of the current epoch took the form of "humanity stirred to revolt as if by a squall, hurling generation against generation like wind stirring up the dust." And he ended his letter with a despairing cry of his "hopelessness!" There can be no doubt that Carpeaux manifested in the *Ugolino* the political tensions of his time through the do-or-die confrontation between generations and in society's abandonment of Ugolino and his children.[38]

Why did the administration sponsor this work? One explanation may be that in 1859, needing backing from liberals to make up the loss of church support due to Napoleon III's new Italian policy, the emperor offered amnesty to all persons imprisoned for political crimes or misdemeanors. This was the first domestic move in the direction of the Liberal Empire. At the same time, *Ugolino,* an image of the political prisoner cast into the form of high tragedy, could stand as both a warning to future insurgents and an expression of government recognition of the plight of political prisoners. Carpeaux's final work, profoundly realistic as it appeared to his contemporaries, nevertheless failed to embody the full range of his personal convictions and required the allegorical context to gain official endorsement.

In 1867, the year of the World's Fair, the City of Paris commissioned Carpeaux to execute the monumental Fountain of the Observatory, *The Four Parts of the World* (Fig. 31). Four allegorical women, representing the four quarters of the globe—Europe, Asia, Africa, and America—support the celestial sphere like female Atlases. The globe itself is enclosed within an armillary sphere girdled by the belt of the ecliptic, carrying zodiacal signs. The figures revolve around the sphere in allusion to the diurnal rotation of the earth on its axis (but they erroneously march from east to west). Carpeaux's concept invoked the historic associations between navigation and astronomy and between geographical discovery and imperialist expansion. Here he revealed himself as an ethnographer-sculptor on the order of Charles-Henri-Joseph Cordier, whose busts of ethnic types answered to the colonialist aspirations of the regime.[39] Carpeaux ingeniously translated the cosmic function of the site into an imperialist dream of world domination—a dream actively pursued by the emperor in Mexico, North Africa, Egypt, and Indo-China, and shortly to culminate in the opening of the Suez Canal. Carpeaux's individual studies of a Chinese male and black woman for this group demonstrate his scrupulous attention to ethnic type and were later donated to the Trocadero Museum of Natural History and Ethnography. Chesneau writes of the four personifications: "Europe alone is sure of her power, marches straight ahead with a firm, steady, measured step. Of the four bearers of the cosmic burden, she only, with a noble, easy gesture, sustains the load with both hands for the common good. Apparently, she suffers slightly from this charge; the head is lifted high, but the eyes glance into sidereal space with a mournful look." Chesneau continues that Africa also gazes at the sky, but not in the same way. Her look is impelled by a kind of fierce gratitude for the liberty recently given to her. Does she not carry the ankle clasps of the broken chains left over from the abolished slave trade? He sees similar symbolism in the postures of an overwhelmed Asia and in the serpentine gait of America (represented by a Native American). Chesneau—Carpeaux's close friend and biographer—dramatized Carpeaux's version of the White Woman's Burden.[40]

Chesneau, who described Africa as a "thick-lipped Negress" (Saint-Victor noted disparagingly that the figures were neither male nor female, but "all

Fig. 31. Jean-Baptiste Carpeaux, *The Four Parts of the World*. Plaster, 1867–72. Musée du Louvre, Paris.

negresses"), supported his interpretation of the African woman by referring to
Carpeaux's bust of the model exhibited in the 1869 Salon with the inscription:
"Why be born a slave?" (Fig. 32). Carpeaux portrayed the woman bound with a
rope across her bared breasts and wearing the wild expression of an impetuous
and unbridled personality. His presentation provides the answer to the ques-
tion: like the obverse of Cordier's black household slave in Algerian costume
she embodies fantasies about domination. One critic noted that the group
should be called "The Four Parts of the Demi-Monde," alluding to the suggest-
ive poses of the nudes. The question "Why be born a slave?" is satisfied by
Darwinian logic and echoes European sexual fantasies about subjugated harem
women and vulnerable slaves. The most cursory examination of the reviews of
the abundant "Orientalist" pictures in the 1869 Salon (inspired by the opening
of the Suez Canal that year) demonstrates the link between imperial politics
and sexual politics.[41] It is not surprising that the emperor himself bought the
bust of the black woman for his palace at Saint-Cloud, a veritable repository for
erotic art.

Contemporary male sexism differed from the hitherto standard treatment of
women by having at its service greater psychological and anthropological
sophistication. New theories of evolution and psychology by such thinkers as
Charles Darwin and Auguste Comte provided male artists with pseudoscientific
insights into the social role of modern women, and the ever-increasing threat of
feminism fueled their activity. The imperialism and racism of the period
invariably enters into imagery and is often linked with an antifeminist posi-
tion. The spread of Darwinian theory not only furnished justification for
colonizing "inferior" peoples—peoples presumed to be at an earlier stage in the
evolutionary process—but also suggested that inequality between men and
women, like inequality between the races, was an inevitable fact of nature.

As purely sensual and earthbound beings, women were looked upon as the
primal stuff of the material world. Images of women shown as helpless or
weighted down by oppression (seen or unseen) suggested their availability for
sexual aggression, just as the "uncivilized" races of exotic climes were available
for economic exploitation. The abject helplessness of the females and the inno-
cence of the tribal peoples made them ripe for plucking. Both were born to
serve the European male; their "seductive" allure disallowed his responsibility
for either sexual temptation or colonial intervention.

The intimate association between sexism and racism was further declared in
the pervasiveness of animal metaphors to characterize both modern woman and
tribal man. A critic of the 1869 Salon could write in connection with a picture
of languid Near Eastern women that for Orientals "woman is a gracious animal
to which Allah took good care not to give a mind (âme)"—ostensibly examin-
ing another culture but actually drooling over the French painter's representa-
tion.[42] This is also seen in the increasing appearance in Salon art of nude
women with obvious sexual appetites and in a playful mood—a formula carried

Fig. 32. Jean-Baptiste Carpeaux, *Why Be Born a Slave?* Plaster, ca. 1870. Musée des Beaux-Arts, Valenciennes.

Revolution and Counterrevolution

Fig. 33. Jean-Baptiste
Carpeaux, *La danse.*
Limestone, 1868–69.
Musée du Louvre,
Paris.

to its extreme in the fin-de-siècle sexism of Rodin. Cloaked only in a thin classical disguise, the Salon nude was often shown together with a wild animal or hybrid woodland creature. Carpeaux's own allegory of Africa displays this association in the wild animal skin draped over her left shoulder, the paw of which ironically wraps around her thigh and covers her pudendum. It is woman's apparent eagerness to mate and to play with forest creatures that betrays her atavistic animal instincts. Darwin himself suggested that the presence in some women of multiple breasts hinted at their link with our primal ancestors, thus providing "scientific" evidence for the aesthetic treatment of women as inherently animal-like.

The classic case of this type of presentation in Second Empire sculpture is Carpeaux's *La Danse* (Fig. 33), a work commissioned by the government to decorate the facade of the new Opéra. The flamboyant and opulent Opéra formed the architectural centerpiece of the Second Empire's project for the transformation of Paris. Physically it focused the diagonal Avenue Napoléon (now Avenue de l'Opéra) and symbolically it went right to the heart of Second Empire culture. Its analogy to the Arc de Triomphe de l'Etoile escaped no one: indeed, Carpeaux was expressly requested to do a work "in the spirit of the Arc de Triomphe."[43] The Opéra and its decorations were meant to declaim in loud stentorian terms the modernity and cultural hegemony of neo-Bonapartism.

Carpeaux's life-sized group of frenetic bacchanalian dancers was unveiled in July 1869, the same year as the exhibition of *Negress* carrying the inscription "Why be born a slave?" But its combination of exuberant energy and lifelike rendering of naked flesh touched off a storm of protest against indecent exposure, and because of the building's intimate association with the regime (and Napoleon III's admiration for the work) the event assumed the configuration of a major political as well as cultural scandal. Someone even threw a well-aimed bottle of ink at the figures, evidently a violent reaction to its obscene realism but seen by conservative critics as a rebuke to Second Empire's licentiousness and the new "liberalism." This event inspired a wild round of caricatures and bad puns on the word *encrier* (inkwell), one sheet of which brought together topical associations of the sculpture with prostitutes at the Bal Mabille (a popular outdoor ball), the imperial pageantry for the Suez Canal, and the political fallout of the statue as manifested in the responses of the various factions, with the Right exclaiming with relief that with the ink blotch "One can at least look at it!" (Fig. 34). Spokesmen for the government condemned the act as the vicious work of its cultural and political enemies. They rationalized it as an outbreak of iconoclastic opposition to the work's extraordinary realism and suggested that this iconoclasm only verified Carpeaux's success.[44] But even liberals such as Emile Zola agreed with the conservatives who identified the sculptural group with the venality and vulgarity of Napoleon III's regime. Both the work's admirers and detractors emphasized its realism and generally interpreted it as a sign of a degenerate society. The aesthetic discourse and the political discourse were conspicuously entangled in the reception of Carpeaux's *Danse*.

Fig. 34. Detail from Bertall, "Revue du mois," *L'Illustration*, 25 September 1869, p. 205.

Like Zola, many of the critics perceived the freely whirling and swinging women in the *Danse* as drunk and disorderly. (This perception was backed by eyewitness testimony to Carpeaux's administering of wine to his models to get them in the appropriate mood.) The reviewer of the government newspaper, *Le Moniteur Universel,* wrote while breathing hard: "Quivering, feverish, exhausted, these drunken women whirl uncontrollably, laughing with a lascivious, stupefied air." Another critic summed up *Danse* as "a madwoman, drunk and in heat."[45] Clearly the wild abandon of Carpeaux's dancers conjured up the typical bacchantes and nymphs of Salon art. As the intoxicated sex-starved creature of antiquity, the bacchante/nymph was generally associated with animals or hybrid satyrs and fauns. Satyrs were part human and part goat, passionately devoted to riotous dancing, and it was perfectly consistent with Salon art that Carpeaux included the head of a satyr among the dancers. The atavistic hybrid creature, still frozen in the evolutionary chain, joined forces with the sensual naked woman to create a bourgeois male fantasy. The idea of uninhibited sexual pleasure answered conveniently to the sex-starved male who could not be faulted for being seduced by an insatiable bacchante or nymph. Indeed, it is just about this time that the term "nymphomaniac" becomes commonplace in the lexicon of drawing-room and barroom conversation.[46]

But if Carpeaux's group was the living, breathing incarnation of this fantasy, why was it so universally attacked? After all, it was seen in numerous avatars in the Salons of the 1860s and was hardly surprising as an expression of contemporary masculine ideology which viewed woman as either housewife or harlot. Carpeaux set into the center of his group a male "genius" (or spirit) who rises nobly above the fray and at whose signal the women begin their jig. Carpeaux was close to such notorious male chauvinists as Alexandre Dumas fils, Edmond de Goncourt, and Jean-Léon Gérôme, and his attitude to his prospective wife (whom he married three months before *La Danse* was unveiled) fits the stereotypical pattern. Amélie-Clotilde de Montfort was of noble ancestry and Carpeaux literally set her on a pedestal in his *La Fiancée* (1869), where he depicts her adorned in virginal flowers. He envisioned her as "the angel that God sent me to sustain me in my struggles."[47] Carpeaux clearly preferred a resident angel to a woodland nymph as wife and mother, but free sensual love had to be located in the image of the unchaste bacchante who relished the flesh for its own sake and asked for nothing in return. And it was precisely the failure of Carpeaux's sculpture to *represent* meaning beyond its surface eroticism that so outraged his contemporaries and at the same time opened the floodgates to political interpretation.

Where Salon painting could disguise the sexual fantasy in mythical trappings, its astonishingly realistic appearance in three-dimensional public sculpture proved to be a stumbling block for its audiences. Parisians were set to view *La Danse* as another female allegory, a feminized ideal akin to Justice and Liberty. Its absence of the standard impersonality and its verisimilitude over-

flowed the boundaries of restraint called for in bourgeois decorum. The lack of stylized or formalized transcendence which alone could have justified its utility eroticized the sculpture as an act of public defiance.

Charles Blanc, writing for *Le Temps*, complained that Carpeaux's work turned its back on tradition by trying to become "a painting in stone." For him the liberty granted the painter showed up in this work in the form of "lascivious movements" and "twitching nudities." He could not separate the naturalness and the eroticism which gave the figures the character "of undressed women rather than nude women." This violated the laws of sculpture which was deliberately mounted on a pedestal "to forbid us from approaching it familiarly." And he argued that these conventions should remain sacred because "they make the image of man appear more imposing and more venerable in marble than in nature, because [sculpture's] reality is a mirage, because its eloquence is mute, its movement immobile, and not being alive, it is immortal."[48]

Once sculpture failed to be consistent with its aims it could no longer project the fiction of everlastingness and was reduced to the status of an erotic postcard. When viewed against the backdrop of the Opéra's showy pomposity and costly ornamentation it pointedly signaled the wasteful self-indulgence of the empire. Thus if the patriarchal system inadvertently allowed Carpeaux to expose the underside of its gender bias, it simultaneously exposed itself to political attack. This had been facilitated by the spring elections of 1869 which gave ample opportunity for popular opinion to express its hostility to the empire. The government weakened in the face of moderate criticism backed up by working-class discontent. All that summer strikes broke out and their report became a regular feature in some newspapers. The situation looked so promising to Marx that he made a special trip to Paris the month Carpeaux's group was unveiled. Both the Right and the Left seized upon the indecency of the sculpture as an indictment of the government: the first saw it as an example of capitulation to liberal ideas and pressures, while the second perceived it as a sign of the corruption which needed to be rooted out by radical social reform.

The protest demonstrated the capacity of sculpture to embody political values beyond mere surface or narrative features. Carpeaux's *Danse* was especially attacked in the Catholic press; the reactionary Louis-François Veuillot, editor of *L'Univers,* wrote a virulent diatribe against the monument and used it as a pretext to discredit the regime. Other religious groups staged a massive write-in campaign, constituting a kind of "Moral Majority" under the name of "Enemies of Debauchery." The immediate basis for these attacks against the well-known immorality of the regime was the liberal direction it took in the 1860s which infuriated its right-wing supporters, especially the early backers of the coup d'état. These included the clerical party, for whom during the first decade of his reign Napoleon III executed a number of decrees which strengthened the position of the Church particularly in the realm of education. Above all, the

emperor's earlier favorable policy toward Rome had shifted a decade later in favor of the nationalist movement against the Austrians. This cost him a good deal of Catholic support and partly inspired the pope's promulgation of the Syllabus of Errors in 1864, which condemned liberalism in all forms. Hostilities to Napoleon III's Italian policy were fed by Monseigneur Dupanloup, the outspoken bishop of Orléans who delivered a stinging challenge to the emperor.[49] This same bishop also joined the chorus of protesters against Carpeaux's *Danse*. Both he and Veuillot, although bitter enemies, joined the vociferous Catholic protest against the Liberal Empire.[50]

Little over a year after the group's unveiling the Second Empire was in ruins. It had been totally devastated by the Prussians, and when the catastrophic news of the French capitulation reached Paris the opposition deputies took control and proclaimed the Republic on 4 September 1870. But the moderates could not hold out against the tide of intense conservatism which was revealed by the savage reaction to the Commune in Paris. The aim of the dominant elite in 1871 remained what it had been when the Second Empire was set up, to preserve the fabric of society with minimum reform. The puritanical response of Catholic conservatives to Carpeaux's *Danse* expressed hostility to materialism and liberalism as the key to France's troubles. Their position was reinforced by the Vatican Council of 1869–70 which proclaimed the dogma of papal infallibility. This event affirmed the solidarity of Catholics in the face of new dangers. The conservatives dominated the new National Assembly of the Third Republic, and they still preferred a monarch to a president. As against Carpeaux's lewd dancers, they asserted the image of a militant and pious Joan of Arc.

The Third Republic shifted back and forth between conservative and liberal phases, but throughout the remainder of the century the allegorical image of the Republic—with minor variations—could satisfy the ideological needs of the various ministries. In addition to this pervasive icon, conservatives and liberals sponsored their own characteristic sculptural motifs: for the first group it was Joan of Arc and for the second it was the allegory of Work. When the new government organized itself under Thiers following Napoleon III's capitulation to the Prussians at Sedan and the bloody civil war known as the Commune, the National Assembly was dominated by a majority of Orléanists and Legitimists. It was a monarchy in all but its head, and these two groups tried to organize a "fusion" of the claims of the rival dynasties.[1] According to their arrangement, the comte de Chambord, grandson of Charles X, had first claim to the crown but he would be succeeded by the comte de Paris, the eldest grandson of Louis-Philippe, as the nearest male heir (the comte de Chambord was childless). But Chambord was a diehard reactionary and religious zealot and refused to enter into any arrangement that would mean rejecting the white Bourbon flag and retaining the tri-color flag, the symbol of revolution.

One ardent proponent of the fusion was Bishop Dupanloup of Orléans who had strong political and social ties to the House of Orléans. He was elected member of the Assembly in 1871 and used his political and clerical positions to try to restore the monarchical system. He early implored the comte de Chambord to modify his position on the flag and continued to do so as late as January 1873 when it began to appear that the conservative Republic could become a lasting reality.[2]

But if the monarchy did not materialize, the religious disposition of the comte de Chambord prevailed among the social elite who wanted a revival of the *Monarchie chrétienne*. All over France pilgrimages were made to famous shrines and the Church now preached a veritable crusade.[3] The Assembly voted on 24 July 1873 to erect a great basilica of the Sacred Heart on Montmartre in expiation of the sins of the nation. France had to atone for its frivolous life under the Second Empire, now seen as a modern Babylon whose disorders attracted the fires of heaven, that is, the Commune. Expiation, repentance, and atonement colored all piety during the 1870s, and this stimulated a fighting Catholicism, militant and military.

The personification of this outlook for the elite was Joan of Arc, symbol of both the militant church and the martyred victim.[4] While she became the darling of the right wing, she could embody for all factions their longing for social stability, unanimity, and reconciliation. She was the Third Republic's answer to Carpeaux's male genius of the *Danse*, and certainly to the failed male hero at Sedan. A striking example of this attitude in poetry is Victor de Laparade's "A Jeanne d'Arc," which captures the mood of the conservatives in the wake of foreign and domestic upheaval. It addresses itself to French women—"sisters of Joan"—admonishing them to raise a new generation of males devoted to France

and ready to engage in illustrious combats in their mothers' honor. Joan is the model of this exalted patriotism:

> No, you do not suffer vainly for our France!
> You and your sweet Lord will come to save it.
> O Joan! we await another deliverance:
> The race from whence you came is not yet ready to perish.[5]

The sexism of the poem explains the rush to celebrate Joan: the threat of actual women voting and soldiering in the wake of the Commune (in which they were particularly active) needed to be neutralized and displaced onto a transcendental sign which essentially safeguarded the male hierarchy. At the very moment when Joan was championed, real women's rights and feminist agitation for those rights were aggressively squelched.

It is not coincidental that the individual who did most to promote Joan of Arc as a cult figure in this period was Bishop Dupanloup who had attacked Carpeaux's group for its indecency. He became known as the *évêque de Jeanne d'Arc,* advertising Joan as a Christian and monarchical symbol who spoke for the ideological preoccupations of the "fusionists."[6] When the moderate republicans finally gained a majority in the Chamber of Deputies and sponsored a national festival for Voltaire in 1878, Dupanloup countered them with a Joan of Arc festival. Nearly ten years earlier, Dupanloup had assembled the bishops of all the dioceses where Joan had passed and addressed a letter to the pope demanding the initiation of the process of her beatification. Thereafter he kept up demands for the process leading to canonization. Guillemin's preface to *Jeanne d'Arc: l'épée de Dieu,* one of many books devoted to her in the period 1874–96, stated the hope that the book would contribute to realizing Dupanloup's project and satisfy the ardent wish of every French Catholic.[7]

During the 1870s images of Joan of Arc could be seen everywhere. Perhaps the most famous of all was the equestrian version by the sculptor Emmanuel Frémiet inaugurated in 1874 (Fig. 35). Depicting Joan as the militant Christian, it soon became a cult object; in 1878 Dupanloup suggested that Catholic women should assemble and lay flowers at the foot of the statue as a reply to the hundredth anniversary of Voltaire's death. Voltaire had satirized Joan mercilessly in *La Pucelle d'Orléans* (1755), and conservatives seized the occasion of the Republic's celebration of the centenary to organize a counterdemonstration at Frémiet's statue. The silent protest took place on 30 May in rain, and confirmed the powerful effect of the *extrinsic* signification of public sculpture (Fig. 36).[8] By this time Joan stood as the symbol of French national resistance to the enemy, of military strength and national order, and of Catholic fervor and mysticism.

Frémiet, a devout Catholic who worshipped Joan of Arc, is one of the most fascinating sculptors of this period. A relative of Rude, he enjoyed under the Second Empire the warm support of both Napoleon III and Nieuwerkerke. Frémiet collaborated with Carpeaux on the Fountain of the Observatory, executing the charging horses and tortoises below. Two types of subjects dominate his

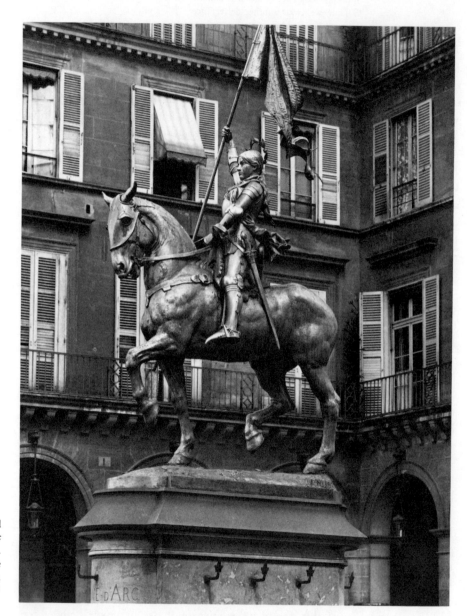

Fig. 35. Emmanuel
Frémiet, *Joan of Arc
on Horseback* (1874).
Bronze, 1899. Place
des Pyramides, Paris.
Courtesy of Alinari/
Art Resource.

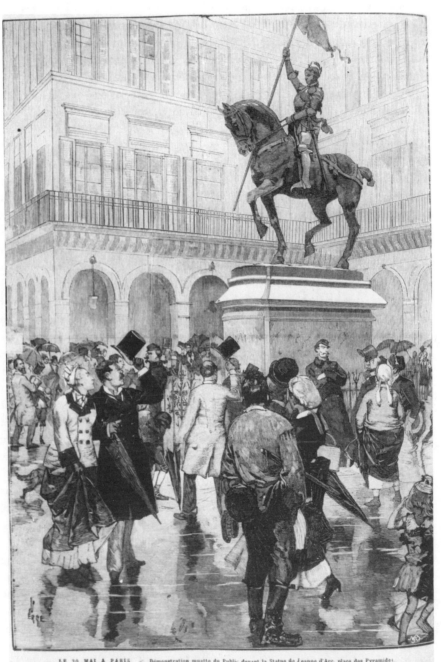

LE 30 MAI A PARIS. — Démonstration muette du Public devant la Statue de Jeanne d'Arc, place des Pyramides.

(Dessin de M. Vierge.)

Fig. 36. *Le 30 Mai à Paris*. Drawing by Daniel Urrabieta Ortiz y Vierge. Wood engraving in *Le monde illustré*, 8 June 1878, p. 368.

The Third Republic

production: medieval heroes and saints, and animals. These will be studied below as antitheses and are in fact dialectically related. By the time of the Third Republic Frémiet was a partisan of the fusionist ideology, backed by Orléanists like the duc d'Aumale who purchased his equestrian figure of the *Grand Condé* in 1881. His religious fervor manifested itself in the creation of one of his best known pieces, *Credo* (1889), a statuette of a crusader holding a scroll with the inscription of commitment to the Catholic faith. Thus there can be no doubt that his Joan of Arc, commissioned by the government at the end of 1872, embodied the contemporary ideology of the dominant elite in France.[9]

Erected on the Place des Pyramides near the site where the heroine was wounded during a battle against English invaders, the *Joan of Arc* was a political statement from the moment of its inauguration on 20 February 1874. The ceremony was deliberately held in a low key, without fanfare and the conventional address by an official of the regime. Nevertheless, the crowd of between 50 and 150 was restless. It included several outspoken critics like the nationalist Paul Déroulède who bewailed the loss of the Alsace-Lorraine provinces. Indeed, the desire for the recovery of Alsace-Lorraine after 1870 and the hope for revanche were the main props of French patriotism in this period and immediately politicized Joan of Arc, whose native region was Lorraine.[10] At the same time, memories of the Provisional Republic's poor handling of the defense of Orléans during the Prussian siege also caused ill feeling at the time of the inauguration. But the real cause of the uproar which broke out at the inauguration was the notorious Orléans scandal for which Dupanloup was blamed. This event involved the commemorative service of 16 December 1873 held in the Orléans Cathedral for the war dead and as a benefit for the Red Cross. The nave had been decorated with tri-color banners exclusively; on the pretense of maintaining political neutrality, the request by one member of the Comité Catholique who wanted to display the white flag of the papal Zouaves with the Sacred Heart was rejected. Dupanloup's loyalty to the House of Orléans made this a politically suspect gesture of its own, and the right-wing press enjoyed attacking his motives. Responding to the persistent attacks of the ultramontanistic *Univers*, Dupanloup wrote a letter on 6 January 1874, published in *Le Français* on 8 January, accusing its editor Veuillot of trying to wreck the hopes of the fusionists.[11] The reverberations of the Orléans scandal continued to be felt through February and placed *Joan of Arc*, the Maid of Orléans, at the center of the fusionist controversy.

Joan of Arc was literally the saint of the clerical party and the right wing who saw her as the embodiment of their aspirations. This same group responded with horror to the Commune and blamed foreign-born or non-French peoples as scapegoats for current troubles. Joan's protection was meant for a privileged group and did not embrace all national or ethnic groups. The right wing understood the Darwinist, materialist thought associated with the Second Empire as antithetical to the purity, spirituality, and chivalry of Joan of Arc. Frémiet's use of wild animals and primitive people in other works incarnates

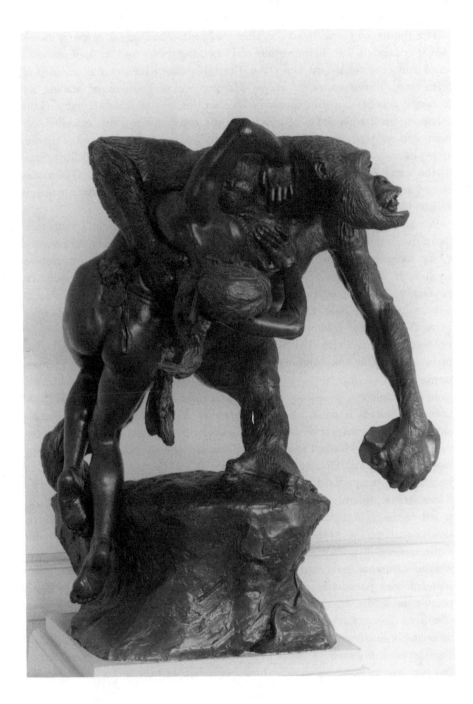

Fig. 37. Emmanuel Frémiet, *Gorilla Carrying off a Human Female*. Plaster, 1887. Musée des Beaux-Arts, Nantes.

the bestiality and materialism of these "outside" groups, referring to a state of mind not yet exalted by, or inaccessible to, Christian belief.[12] Frémiet wished to place "uncivilized" human and wild animal on an equal footing and thus justify Western encroachment on "pagan" terrain. While his first version of the famous *Gorilla Carrying off a Human Female* was refused for the regular Salon of 1859,[13] his version of 1887 enjoyed an enormous success (Fig. 37).

The impact of *Gorilla* (and the later *Orang-utan Strangling a Native of Borneo* [1895]) related to the dissemination of Darwinian theory and its application to social and political theory under the Third Republic. During the ministry of Jules Ferry, France embarked on an extensive colonial enterprise, mainly for economic benefits but also to compensate for the loss of Alsace-Lorraine. This enterprise involved a series of treaties in the early 1880s which extended the West African territory of Gabon, pinpointed by Frémiet's biographer as the native habitat of the gorilla. He also described the animal as cannibalistic, that is, the female victim is meant to be devoured rather than ravaged. Gabon was known at the time for its cannibalistic tribes and the literature often compared African blacks to apes.[14]

We have already seen that the ethnography—the description of tribal or "primitive" communities—of sculptors like Cordier and Carpeaux contained a strong racist component. While physical anthropology automatically involved the concept of race, this did not in itself imply any belief in racial inequality or superiority. But it could imply this when linked to the study of the evolution of humans on the basis of the prehistoric fossil record, another expression of Frémiet's sculptural interests. Clearly the human's earliest identifiable ancestors—notably Neanderthal Man—were both more apelike and culturally inferior to their discoverers. Now if some existing races could be shown to be closer to the apes than others, would this not prove their inferiority? Thus Darwin could be exploited to show that existing races were inferior because they typified an earlier stage of biological evolution or of sociocultural evolution or both. The poor were poor because they were biologically inferior and conversely, if citizens belonged to the "lower" races it is no wonder that they stayed poor and backward. Frémiet often expressed this attitude in connection with the peasantry, comparing their coarseness to that of monkeys, "nos cousins."[15]

Frémiet's sculptural polarities (characterized by de Biez as moving from the far left to the far right) demonstrate to what extent he embraced the concept of superior and inferior races. It is significant that he repeated the *Gorilla* in the 1880s, a time of intense colonial activity and right-wing patriotism. In 1886 Edouard Drumont published his virulent, anti-Semitic book, *La France juive*. Drumont was profoundly racist, writing in another place that "our soldiers struggle heroically in the pestilential swamps of Dahomey against Negroes with faces like monkeys. . . ."[16] *La France juive* declares that guileless French Christians of modest means have been systematically ripped off by racially inferior people comprising a worldwide network aiming at global domination. This was one result of the Prussian defeat which forced the influx of ungrateful

foreigners and Alsatian Jews, aided by the cupidity of some French people. Drumont generally attacked the Republic for having benefited the diabolical trinity of Jews, Freemasons, and Protestants. Not surprisingly, his book prepared the ground for the Dreyfus Affair, and it was he who first broke the story in his newspaper, *La libre parole*.

Much of Drumont's polemic revolves around the contrast between Aryan and Semite, between a glorious medieval past and a corrupt, materialist present. The Aryan is chivalrous, poetic, military; the Jew is materialistic and scheming. The Aryan is like Parsifal braving a million dangers in the conquest of the Holy Grail. Throughout his writings Drumont identifies the true Frenchman, that is, the Aryan, with heroic crusaders and knights-errant, and the Jew with traitorous rebels, cosmopolitans, modernists, anticlericalists, republicans, and iconoclasts. Not surprisingly, Drumont's Aryan heroes are the very subjects of Frémiet's Christian sculpture: Joan of Arc (whom Drumont refers to frequently and lovingly), du Guesclin, Saint Louis, Saint Gregory, François I, Charles V, Saint Michael, and the Grand Condé. Often Drumont applauds these medieval people for having suppressed Jewish monsters, Satan's creatures—in effect setting up antitheses similar to Frémiet.[17]

Two of Drumont's favorite culture heroes were Joan of Arc and Bishop Dupanloup, the latter affectionately called *l'évêque de Jeanne d'Arc*. For Drumont, Joan was a Celt who saved the country by expelling traitors and calling the king to her side. France needed a Joan of Arc then despite the opposition to her cult on the part of Jews and Freemasons. Drumont quotes the reactionary huckster Léo Taxil who confirms this view, pointing out that Jews and Freemasons conspired to dishonor her by hiring the notorious Jewish actress Sarah Bernhardt to reenact Joan. While this is leaping ahead to the decade after the inauguration of Frémiet's statue, as early as 1873 the conservative journal *L'Illustration* called the Jews traitors and scavengers who attached themselves to Prussian units to rob the defeated French populace.[18] The same year it published the Salon painting by Juglar entitled the *L'usurier* with an outrageous anti-Semitic description (Fig. 38).[19] Even Bishop Dupanloup wrote a diatribe against Freemasonry in 1875, attacking among others Jews either in the movement or enacting its precepts such as Adolphe Crémieux and Jules Simon.[20] As minister of public instruction in the early 1870s, Simon attempted to laicize education and encountered stiff opposition from Dupanloup. When Thiers's government fell in 1874 Dupanloup led the fight to rescind Simon's laws. Simon also became a *bête noir* for Drumont who used him as an example of Jewish and Masonic influence on republican policy.

Significantly, Jacques de Biez, Frémiet's main biographer for whom the sculptor wrote extensive notes, was the co-founder with Drumont of the Anti-Semitic League in 1889. De Biez and Drumont were close friends and Drumont refers to him often in his work, including de Biez's oft-repeated quote from Joan of Arc that good people share the "blood of France." Even more dramatically, Drumont dedicated his *Testament d'un antisémite* to de Biez, "dele-

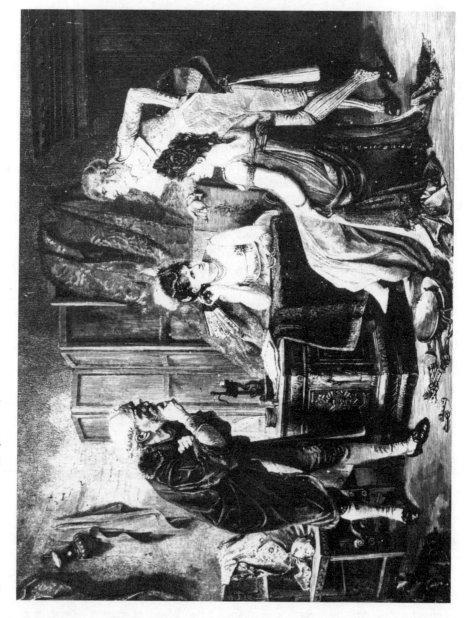

Fig. 38. Victor-Henri Juglar, *Chez l'usurier*. Oil on canvas, Salon of 1873.
Reproduced in *L'Illustration* 61 (21 June 1873): 429.

gate-general to the National Anti-Semitic League of France," and therein he condemned sell-out artists who cater to Jews and Prussians but praised "hommes de coeur" like Puvis de Chavannes, Adolphe Yvon, and Frémiet![21]

While de Biez's prejudice is muted in his 1910 monograph on Frémiet, it shows up blatantly in his series of articles on the sculptor published in *L'Artiste* during the years 1892–95.[22] As in Drumont, Joan of Arc stands in opposition to aliens and Jews. His article of November 1894 referred to the patriotic cry of a Frenchman at the trial of the traitor Alfred Dreyfus—"Vive la patrie!" The Jew Dreyfus had committed an atrocity against French blood, against the native instincts and faculties which distinguish the French from inferior races. Earlier de Biez observed that it is only in Frémiet's studio where a Frenchman can take refuge in the authentic France whose population Joan of Arc called "the people of French blood." When de Biez poses Frémiet's *Gorilla* against the *Credo* and suggests that the first apotheosizes the "monde bestial" and the monstrous system which shapes the human destiny into an animal filiation, there is no doubt that he is talking about monarchist versus republican, Christian versus Jew. Elsewhere he calls the gorilla the "gargoyle of our laicizing society," thus condemning republicanism and Freemasonry in the same breath.[23]

One mediating link between Frémiet's animal subjects and the anti-Semitic movement are the zoological writings of Alphonse Toussenel. De Biez invoked Toussenel's "esprit des bêtes" in characterizing Frémiet's work. Toussenel was a notorious anti-Semite whose book *Les juifs: rois de l'époque* (1845) had a major impact on the growth of anti-Jewish literature in the nineteenth century. He even blended his violent hatred of Jews with his zoology; he compares the mule to the peasant with long ears who votes for Jews and compares the vulture with the traits of a Jewish usurer. Similarly, Frémiet gave the devilish head of the dragon "vanquished" by St. Michael the inevitable hooked nose of the stereotyped Jew.[24]

Drumont also had a profound admiration for Toussenel and did a biographical study of him in his *Les héros et les pitres* (1900). Drumont celebrates Toussenel's patriotism and mentions that France is for him "la doulce France" (the sweet France) of the *Chanson de Roland* and the "gentil pays de France" (play on gentile—gentle France) about which Joan of Arc spoke.[25] It is Toussenel's love of France that spawned his anti-Semitism; Jewish financiers oppose their slogan, "chacun pour soi," to the slogan of the ancient nobility, "noblesse oblige." The equivalent to this in the animal sphere is the baronial eagle versus the usurious vulture. Drumont's medieval interpretation of Toussenel is accompanied by illustrations of a knight carrying a lance, a madonna-like figure blowing out the candles of a menorah, and above all the image of a medieval queen holding a shield decorated with Bourbon lilies and a sword aloft as she chases away a stricken Shylock (Fig. 39).

The Third Republic

Fig. 39. Lucien Metivet, illustration for *Les héros et les pitres* (Paris, 1900), 259.

TOUSSENEL

N a comparé Toussenel à Michelet et sur bien des points, l'auteur de l'*Insecte* et de l'*Oiseau* procédait de l'auteur de l'*Esprit des bêtes* dont il a certainement subi l'influence.

Michelet et Toussenel avaient de commun un amour profond, filial, poétique de la France. Ils aimaient, non seulement son âme, sa grandeur historique, mais ses paysages enchantés, ses fleuves mélancoliques et joyeux, ses forêts majestueuses et riantes, ses eaux claires, coulant à l'ombre des peupliers et des saules.

Lisez les pages admirables que Michelet a consacrées à la description géographique de la France et où il a parlé de ses provinces d'un aspect si

While later in the century all shades of political and religious opinion could find something in the person of Joan of Arc for a weapon against their opposition, she was exploited primarily by conservative and clerical groups. Even when moderate republicans embraced her they did so to neutralize Joan's conservative sponsorship. Gambetta could say, "I have a sufficiently broad mind to be both a disciple of Voltaire and a devotee of Joan of Arc." Generally, however, any publicity for Joan played into the hands of the reactionaries and reinforced their position. An example is Charles Lemire's popular publication in 1891 of *Jeanne d'Arc et le sentiment national* which spoke for a patriotic France still yearning for Alsace-Lorraine and for a colonialist policy to compensate this loss.[26]

For his frontispiece Lemire reproduced Henri Chapu's pious *Joan* listening to the voices, a sculpture which first exhibited at the Salon of 1870 (Fig. 40). While France had not yet suffered defeat at the hands of the Prussians, Chapu's work then manifested the religious criticism of the Second Empire and its materialist proclivities.[27] Chapu was a religious and political conservative, fearing insurrection and relishing his personification of *Security* for the prefect of police. He bitterly despised the Communards and after 1870 became the protégé of the Orléanists and supported their policy of fusionism. The Orléanists commissioned him to execute Bishop Dupanloup's funeral monument for the Cathedral of Orléans in 1877. Designed in the Italian Gothic style celebrated by older medievalists like Félicie de Fauveau, Chapu's project displayed an angel carrying aloft the banner of Joan of Arc, and two other allegorical figures personifying Dupanloup's interests, a knight in armor who bestrides a dead dragon and an old man deep in spiritual meditation. On the back of the altar is a bas-relief showing the bishop surrounded by disciples and benefactors—the entire Orléanist contingent which attempted the fusion of rival dynasties.[28]

Chapu also executed a funeral project for Cardinal Bonnechose, the bishop of Rouen who similarly championed the cause of Joan of Arc. Bonnechose was among the prelates assembled by Dupanloup in 1869 to sign the request for Joan's canonization. He, too, shuddered at the republican preparations for the festival honoring Voltaire in 1878 and that year circulated a letter advocating the immediate construction of a major shrine to Joan's memory. Eventually his efforts culminated in a grandiose monument constructed at Bonsecours near Rouen between 1889 and 1892, for which Louis-Ernest Barrias did his statue of the captive but defiant heroine. Bonnechose and his successor wanted his monument to commemorate the fallen victims of the Franco-Prussian War and the lost territories of Alsace-Lorraine. Bonnechose himself advocated a militant church and temporal power for the pope, often comparing himself to an officer leading a regiment. Like Dupanloup, Bonnechose sat in the Chamber of Deputies and with rare exceptions pleaded the cause of the extreme clerical and monarchist party. Not surprisingly, Chapu's funeral monument for Bonnechose includes an allegory of *La France chrétienne*. When in 1878 the cardinal

Fig. 40. Frontispiece and title page for C. Lemire, *Jeanne d'Arc et le sentiment national* (Paris, 1898).

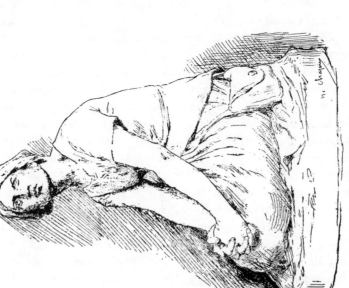

JEANNE D'ARC

ET LE

SENTIMENT NATIONAL

(1412-1431, 1870-18**)

LA FÊTE DE LA PATRIE FRANÇAISE

AVEC UNE CARTE SPÉCIALE ET GRAVURES

par

CHARLES LEMIRE

CHEVALIER DE LA LÉGION D'HONNEUR,

CORRESPONDANT ET OFFICIER DE L'INSTRUCTION PUBLIQUE, LAURÉAT DE L'INSTITUT

ET DE LA SOCIÉTÉ DE GÉOGRAPHIE COMMERCIALE DE PARIS

MEMBRE DE L'ACADÉMIE FRANCO-HISPANO-PORTUGAISE DE TOULOUSE,

AUTEUR D'OUVRAGES COURONNÉS ET ADOPTÉS

PAR LES MINISTÈRES ET LES ÉTABLISSEMENTS D'INSTRUCTION PUBLIQUE

DEUXIÈME ÉDITION

PARIS

ERNEST LEROUX, ÉDITEUR

28, RUE BONAPARTE

1898

JEANNE A DOMRÉMY (Croquis de Chapu).

Hollow Icons

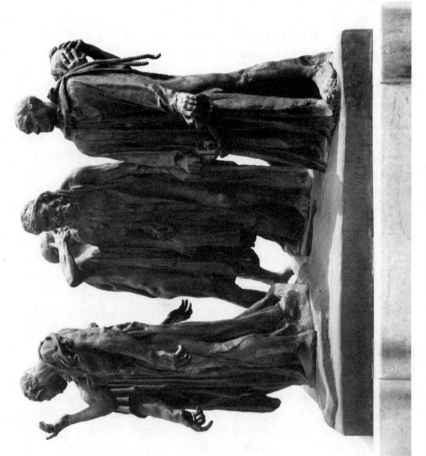

Fig. 41 Auguste Rodin, *The Burghers of Calais*. Bronze, 1885–95. Given to Philadelphia Museum of Art by Jules Mastbaum. Used here by permission.

called for the Joan of Arc shrine he emphasized the urgent need to "instill in the hearts of the younger generation the sentiments of faith and patriotism placed increasingly in jeopardy by contemporary doctrines of materialism and cosmopolitanism. . . ." He envisaged Joan of Arc as a symbolic protest against subversive ideals leading to the demise of "the French nationality." Bonnechose's successor, Monsignor Thomas, assumed this viewpoint in his own sermons, quoting, like de Biez, Joan's phrase for authentic France, "the blood of France."[29]

The evangelical and patriotic fervor of Thomas's sermons in the mid-1880s found their sculptural equivalent in Auguste Rodin's *Burghers of Calais,* conceived during the years 1884–86 (Fig. 41).[30] The subject refers to the heroic Calaisians who in 1347 offered themselves as hostages to England's King Edward III after Calais had been besieged for more than eleven months. Edward agreed to lift the siege if six hostages, wearing sackcloth and halters and carrying the keys of the city, would enter his camp prepared to forfeit their lives. This they did, although their liberty was later granted by the intercession of the king's wife, Queen Philippa.

Ironically, at the time of the unveiling of Rodin's monument, an old controversy erupted over whether Eustache de Saint-Pierre had sold out his country for English favors. The revival of this controversy related to the reverberations of the Franco-Prussian war which still haunted French society. A critic for Drumont's *La libre parole* defended Eustache de Saint-Pierre against what he considered a deliberate "distortion of history" by the real sell-outs—"Judeo-Protestant free-masonry." At the inaugural ceremonies, speakers compared the event to the Siege of Paris and linked the burghers' act of patriotism to the national sentiment of Joan of Arc as critical stages in France's march to nationhood. The souvenir booklet published to commemorate the unveiling of the monument was illustrated with royal and Catholic symbols redolent of the medievalizing fantasies of the political and cultural right wing (Figs. 42, 43). Significantly, Calaisians of the fourteenth century were compared to the population of Alsace-Lorraine in the nineteenth century. The ceremonies were also marked by the praise of French colonialism, with allusions to Calais as a major port for colonial commodities. The government was represented by the minister of colonies who would join in the same speech references to Joan of Arc expelling the invader and to the overseas empire which "today is more extended than ever before."[31]

Rodin's aspirations were nationalist, but more monarchist than republican; he consistently opposed the medieval ideal to the crassness of the modern world. His refusal to sign Albert Clemenceau's petition to appeal the sentence of Dreyfus, and his embarrassment at having too many of Zola's friends among the contributors to the *Balzac* fund attest to the influence of anti-Semitism on his thoughts. Deeply devout, he early contemplated the priesthood for his life's work. In 1877 he systematically visited French cathedrals, a pilgrimage which resulted in his *John the Baptist* of 1880. Rodin romanticized Gothic cathedrals

Fig. 42. Title page of
*Livre d'Or des Bour-
geois de Calais* (Calais,
1895).

The Third Republic

Fig. 43. Illustration from *Livre d'Or des Bourgeois de Calais* (Calais, 1895).

and medieval craftsmen as exemplifying Christian civilization at its best. Akin to his hero Victor Hugo in *Notre-Dame de Paris*, Rodin wanted to imbue the Gothic cathedral with the spirit of nationalism. He claimed that French cathedrals "are born of the French countryside," and that the initiation to Gothic beauty is an initiation "to the truth of our race, of our sky, of our land." Rodin observed that the Jews were proud of their Bible, the Protestants of their morality, the Muslims of their mosque, but French people lacked this fidelity to their cathedrals.[32] In other words, he equated Frenchness with Catholicism, not with Judaism, Islamicism, or Protestantism.

The *Burghers of Calais* embodies Rodin's anxieties which he shared with his clerical-minded contemporaries in the mid-1880s. Like the image of Joan of Arc, *Burghers* pointed to the virtues of national self-sacrifice and patriotic devotion. Rodin searched for the story in the medieval *Chronicles of Froissart* (late fourteenth century; Kervyn de Lettenhoue's complete edition, 1867–77) to imbue his work with the spirit of the Middle Ages. Ironically, the project was made possible in large part by a donation from Alphonse de Rothschild who owned an estate near Calais and wanted to give the community a long-desired monument to Eustache de Saint-Pierre.[33] Rothschild's action occurred just after a major financial collapse for which he and his family were blamed by right-wing nationalists. The corporate investment bank Union Générale was founded by reactionary groups bent on undermining the central position of Rothschild's bank, and its crash in February 1882 touched off a prolonged depression which contributed to the rise of anti-Semitism in this period. Rothschild's funding of this project represented an attempt to improve the image of the House of Rothschild, and by extension, that of Jews in general.[34]

Thus far we have emphasized the influence of the Right during the Third Republic as embodied in the neomedieval imagery of Joan of Arc and the *Burghers of Calais*. The reaction to this from the moderate and left-wing groups is to be found in the image of the male worker—usually bare-chested to invoke the heroic nude of tradition and the pride of class—which proliferates in the last two decades of the century. It corresponds to the growing militancy of the working-class movement and the incapacity of the allegorical image of the Republic to project radical possibilities. Personifications of the Republic had lost all revolutionary implications, having been used in one form or another by liberals and conservatives. Its popular offshoot, the *Statue of Liberty*, was widely recognized as a conservative personification which was heavily clad and substituted the torch of truth for the torch of revolution.[35]

Indeed, so hidebound did the republican allegory become that more progressive forms were developed to answer to the needs of growing class consciousness. Thus even moderates began using the image of the up-to-date bare-chested laborer. While the Left elevated the representation to the status normally reserved for the Republic, the moderates attempted to incorporate it into compositions as an accessory, exemplified by Dalou's motif of the black-

smith in the *Triumph of the Republic* (1879–99). Here conservatives invoked the standard formulas established in a period when the obsession with public sculpture could be characterized by one contemporary critic, Agulhon, as "statuemania." As he has shown, when the main subject of a monument was the Republic or some other abstract personification, the allegory occupied the crowning height while complementary or accessory figures were situated below. If the main subject was an actual person (living or dead), he or she occupied the uppermost position and the allegorical or symbolic modern types relating to the main personage occupied the lower level.[36] This arrangement actually denoted social status, and moderates manipulated this formula to neutralize the sense of a powerful and militant working class.

Both Rodin and Dalou figured among several prominent sculptors who searched for both a topical and larger-than-life image of the worker at the end of the century.[37] Their investigations coincided with the spread of militant trade unions and class-consciousness in the face of the marked trend toward industrial combinations and amalgamations. They were conservative republicans, however, and their struggle to heroize the worker was qualified by their participation in the social hierarchy. Their energetic efforts in behalf of labor most closely reflected the social encyclicals issued by Leo XIII, especially the *Rerum Novarum* of 1891. Pius IX's successor restated Catholic belief in private property, the sanctity of the family, and the social role of religion, but he also recognized the right of workers to their own organizations and to decent living conditions.

Rodin's projected *Tower of Labor* (Fig. 44), a monumental work planned from around 1898 but never realized beyond the model, underscores this attempt to reconcile church views with modern industrial conditions. Based on a Pisa-like, arcaded tower enclosing a column covered with spiraling bas-reliefs, the project stands as a sort of republican riposte to both the Bonapartist Vendôme Column and Rodin's own aristocratic *Gates of Hell*. Rodin arranged the structure so that spectators could view the reliefs while mounting a helical stairway. They would first enter a crypt containing representations of miners and divers—workers whose activities occurred below the earth's surface. Ascending the staircase, visitors would then observe labors that took place above ground arranged in hierarchical order, beginning with the manual trades like carpentry and blacksmithing and culminating with the intellectual work of writers, artists, and philosophers.[38] This ascending order referred not only to physical location but also to a fixed order of importance. At the apex of the tower the viewer would encounter the alighting Benedictions, winged genii descending from heaven "to bless the work of men." The location of the allegory at the top and the workers below demonstrate that Rodin assimilated the standard formulas of the moderate Republic. As in the concept of David d'Angers, it is the great men who continue to be apotheosized. Rodin has simply enlarged upon the meaning of the modern celebrity by interpreting the

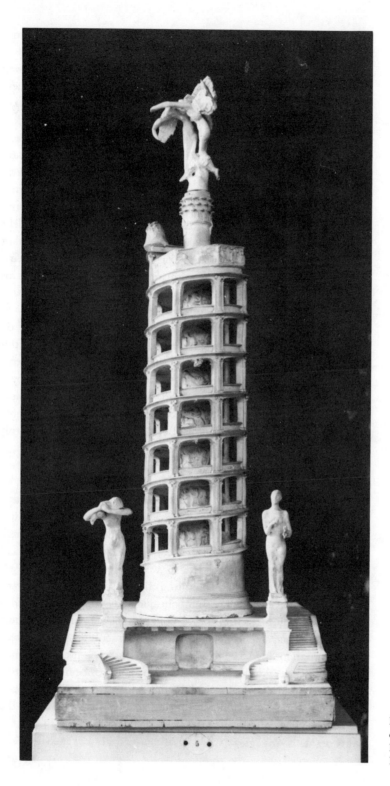

Fig. 44. Auguste Rodin, *Tower of Labor*. Plaster, 1898. Musée Rodin, Meudon.

108

privileged elite as "brain workers" who inhabited the lofty realm of the *Tower* just below the crowning Benedictions.

Rodin's somewhat more liberal friend Dalou often included workers in his monuments, deploying them as accessories to point up the virtues of the state or of private enterprise. He tried to democratize his *Triumph of the Republic* (Place de la Nation, Paris) by introducing a bare-chested blacksmith among other symbolic types who push her chariot forward. In his relief of *Estates General, Meeting of 23 June 1789 (Mirabeau Responding to Dreux-Brézé)* (1883), Dalou incorporated an unprecedented image of a worker in the scene but located him at the extreme left totally outside the main action. The result is an insignificant and almost anachronistic curiosity. Dalou's monument to *Jean-Edme Leclaire,* an entrepreneur in house-painting supplies, celebrates a self-made type who cared enough about his employees to found a profit-sharing policy and a benefit society (Fig. 45). Indeed, in return for their paternalistic program his grateful workers commissioned the monument to his memory.[39] Nevertheless, Dalou depicted the entrepreneur in the standard fashion: the solitary Leclaire occupies the topmost level while an allegorical worker whose homage he graciously acknowledges stands below. The sculptor does give the formula a slightly different twist: he makes Leclaire assist his faithful employee in taking a step upward, thus suggesting that the bridge between them is not immutably fixed. But they are differentiated by dress as well as by position: the house-painter wears the worker's smock and stands amid the tools of his trade, while Leclaire resides in a transcendental realm wearing bourgeois garb complete with fashionable topcoat. Both class and status are sharply defined in this monument.

Dalou's own patronizing attitude toward the worker is aptly manifested in his ambitious concept of the 1890s for the *Monument to Workers.*[40] The project assumed the form of a giant phallus which he thought most appropriate for virile labor (women could thus be conveniently ignored). While the project never went beyond the maquette stage, several detail studies as well as a plaster maquette have survived (Fig. 46). They demonstrate that the monument would have been exclusively consecrated to workers occupying niches encircling the lower portion of the phallic column. Fully six-sevenths of the towering column would have been devoted to symbolic garlands of work tools in relief, while only the remaining fraction would hold the niches. Clearly Dalou, like Rodin, could not emancipate himself from the conservative format developed under the Third Republic which assigned images of workers—even in a monument pretending to their glorification—to a secondary position and status. When we recall, moreover, that Dalou had in mind his own *praticiens, adjusteurs,* casters, and plaster workers, it is not surprising to find that he wanted them confined to a particular social as well as aesthetic niche.

Hollow Icons

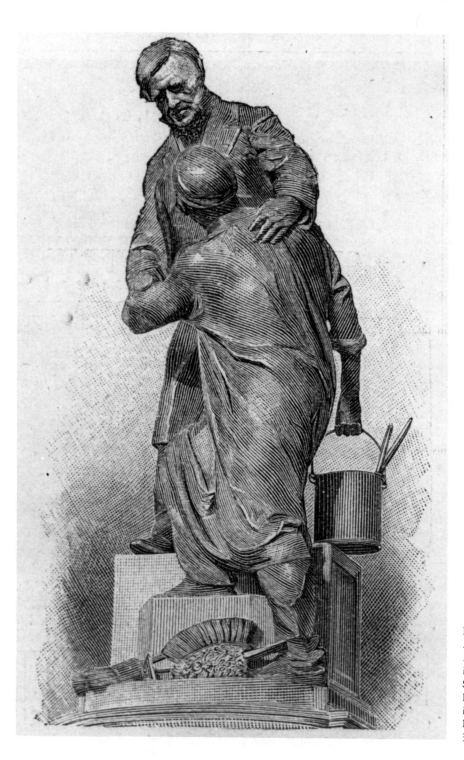

Fig. 45. Jules Dalou, *Monument of Jean-Edme Leclaire.* Bronze, inaugurated 1896. Square des Epinettes, Belleville. Reproduced in *L'Illustration*, 7 November 1896, p. 376.

The Third Republic

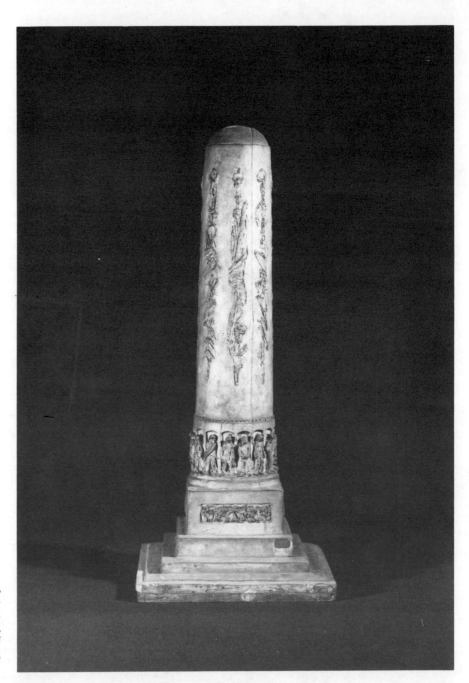

Fig. 46. Jules Dalou, *Monument to Workers*. Plaster, ca. 1898. Musée du Petit Palais, Paris. Courtesy of Photographie Bulloz, Paris.

Consistent with the social role assigned to sculpture in the nineteenth century, the image of work was relegated to subordinate status. Unlike painting, where radical images such as Millet's *Sower* (1850) and Courbet's *Stone-Breakers* (1849) appeared at mid-century, sculptural radicalism evolved more slowly and offered fewer examples. When it did emerge in high art, most notably in the work of Dalou and Rodin, it was revealed in a safe, paternalistic context dominated by symbols of a higher order. Despite the artisanal background of all the major sculptors, the pressures of tradition and of politics weighed heavily on them. Often, these pressures coincided with their own social aspirations or what they perceived to be an enlightened position. In the end, sculptural high art of nineteenth-century France could yield only hints of the class struggle and continued to reinforce the interests of the dominant elite.

Such in broad outline are the main developments of French sculpture in the last century and its relationship to political and social history. It should be clear that the French placed a high value on sculpture in all its forms, often assigning it a prominent role in public spaces and ceremonies. In this way it was infused with a historical coherence and logic that reinforced its instrumental part in transmitting public policy. Much nineteenth-century French sculpture was directly inspired by immediate political circumstances or indirectly determined by various pressure groups responding to social change. The late manifestation of right-wing medievalism points to the baffling p change and represents a sign of resistance to it.

Throughout the century, there were sculptors who were not who committed to the government under which they worked, but they to a visual and formal tradition that fit well the art of political positi regime. More innovative practitioners like Rodin contributed to the tion of the conditions and social relations of the Third Republic by and modernizing the traditional and conventional approaches. Nevertheless, he spoke for the frustrations of social groups that felt most threatened by social change: aristocrats, rural people, and other conservative Catholics. They tried to make patriotism and national strength their battle cry and learned to make use of sculpture for effective mass appeal.

The widespread involvement of the French state in the fine arts overtly and fundamentally politicized cultural practice, forcing opponents of the state at any given time to combat the official ideology with a counterculture equally charged with political significance. The threat from the Left led inevitably to coalitions of moderates and conservatives, and the commemorative sculpture generally displayed a sameness and uniformity whose *extrinsic* meaning thrust itself into political consciousness mainly during a change of government. But a powerful alliance of conservatives and monarchists—united in patriotic indignation against Jews and radicals allegedly conspiring to sell-out France to its enemies—nurtured the medieval revival in the heart of the anticlerical Third Republic.

The spectrum of political sculpture from left to right as presented here was meant to yield fresh insights into the political use of culture. The propaganda of the Napoleonic era gave a decisive turn to the ideological application of art throughout the century, starting with the Restoration's reaction to it, continuing through Louis-Philippe's efforts to co-opt the Bonapartist legacy and thereby setting the stage for the refurbished version of Napoleon III. By the time of the Third Republic sculptors and administrators were so savvy that sculpture's connection with statecraft and party politics was automatically taken for granted.

This should answer the age-old question on the social relevance or meaningfulness of art. The successive visualizations in nineteenth-century French sculpture may have been rhetorically concealed under critical claims to greatness, beauty, spiritual experience, and creative inspiration, but they were nevertheless visualizations of a political, social, and civic order. Naturally, all the art of a dominant elite pretends to universality and timelessness, just as that elite promotes its belief system as not only natural and inevitable but eternal. Sculpture's intimate association with precisely these qualities in French cultural practice insured its fundamental political role right through the century.

Any study of the politics of sculpture in nineteenth-century France must include a discussion of Bartholdi's *Statue of Liberty,* known under its original title of *Liberty Enlightening the World* (Fig. 47).[1] Although it is probably the single most cherished national monument in the United States, its genesis is inevitably bound up with the politics of the donor. Even the begrudging way in which the American elite initially received the gift pointed to the general suspicion of any French export of "liberty." The statue's capacity to be reinterpreted as a personification of North America confirms the thesis set forth earlier in this study. It owes its ongoing vitality as a symbolic image to its intrinsically conservative form and extrinsic political potential as a colossal public monument situated in one of the most strategic sites in the world. *Liberty* is literally an empty vessel—a hollow icon—standing ready to be charged with fresh interpretation, an old bottle perpetually awaiting a refill of new wine.

The transformation of the statue's identity from the conventional French allegorical personification into a popular American icon dramatizes the political possibilities of nineteenth-century French sculpture. The extraordinary diversity of meanings associated with *Liberty,* its seemingly unlimited commercial and ideological potential, all mitigate against an aesthetic interpretation for an appreciation of the potency of public imagery. While the iconographic tradition—the role of allegory and its specific attributes—contributes to the sculpture's appeal, it does not explain *Liberty*'s capacity to survive as a vital allegorical symbol. Bartholdi himself confessed that his statue "cannot be considered as a very great work of art. It is an ordinary statue enlarged and placed on a pedestal."[2]

So much for its intrinsic aesthetic character. The question of its extrinsic meaning centers on the interpretation of "liberty." Whose liberty is implied in the title? The original French title referred to it as a general principle permeating the world, while the vernacular American title takes it as the embodiment of the national ideal. Actually, both suppositions mystify the historical origins of the work: the group responsible for its conception acted in the interests of a specific political program, while at the time of its American inauguration in 1886 various ideologies were competing in the national arena for a particular interpretation of liberty. Neither France nor the United States could claim a national consensus on the meaning of the word.

Hence the statue cannot be understood simply as a gift from France to the people of America, nor as a token of sympathy between sister republics in commemoration of their partnership during the American Revolution. It was a tribute to a particular ideal of republicanism entertained by segments of the dominant elite of the two countries, and on this understanding the field of inquiry expands for a deeper historical evaluation of the statue's odyssey. The mystification of its origins and the various contending claims to a particular liberty should give us pause in the face of its endless exploitation as an image of some generalized "America."

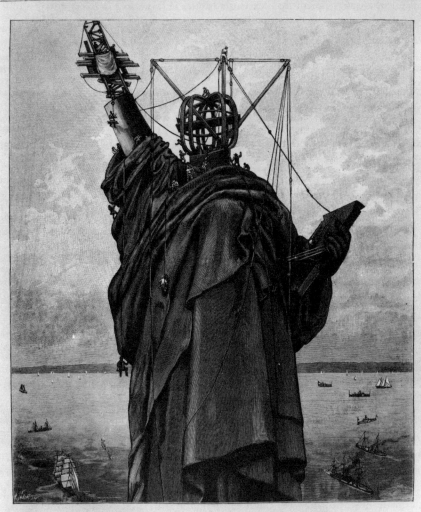

L'ILLUSTRATION

JOURNAL UNIVERSEL

PRIX DU NUMÉRO : **75 CENTIMES**
Collection mensuelle : **3** fr. — Volume semestriel : **18** fr.
Les demandes d'abonnement doivent être affranchies et accompagnées d'un mandat-poste ou d'une valeur à vue sur Paris au nom du Directeur-Gérant.

44ᵉ ANNÉE. — VOL. LXXXVIII. — Nᵒ 2278.
SAMEDI 23 OCTOBRE 1886
BUREAUX : 13, RUE ST-GEORGES, PARIS

PRIX D'ABONNEMENT
PARIS & DÉPARTEMENTS : 3 mois, **9** fr.; **6** mois, **18** fr.; un an, **36** fr.
ÉTRANGER : Pour tous les pays faisant partie de l'Union postale :
3 mois, **11** francs; 6 mois, **22** francs; un an, **44** francs

LA STATUE DE LA LIBERTÉ A NEW-YORK. — LA FIN DU MONTAGE

Fig. 47. Frédéric-Auguste Bartholdi, *The Statue of Liberty*. Wood engraving reproduced as cover illustration of *L'Illustration* 88 (23 October 1886).

Ms. Liberty's image was especially conspicuous in 1986 when the most widely recognized symbol in the United States was being readied after restoration and repair for its fresh unveiling on 4 July 1986. Yet even the centennial of the statue's inauguration falsified history since the original dedication actually occurred on 28 October 1886. The desire to exploit the celebration of Independence Day together with the second coming of the *Statue of Liberty* underscored the organizers' attempt to secure the foreign-born image for the mom-and-apple-pie tradition. Although the spectacular celebration invoked the standard patriotic rhetoric and concentrated on its "immigrant" meanings, the statue predictably resisted the reverential praise and became the focus of symbolic protest—both at home and abroad—against President Ronald Reagan's domestic and foreign policies.

The complexities, then, of *Liberty*'s meanings and its status as a mythical icon need to be unraveled in the light of its history. By so doing, we shall separate fact from fiction and see that this constitutes a clinical case study of sculptural politics. While *Liberty*'s history has been admirably sketched in Marvin Trachtenberg's study of 1976, my concern here is to try to recover the specific significations of the statue from the time of its inception to its final installation on Bedloe's Island. The various meanings attributed to the *Statue of Liberty* concern two distinct but overlapping phenomena: the France which delivered the statue was not the same one that had conceived it, and the work began to have a life of its own independent of the intentions of its creators and original recipients. For conservative French republicans the principle of liberty stood for a new source of sovereign power set up against monarchy on the one hand and anarchy on the other; for the radicals it represented a popular force aimed at the dominant powers in society. As conceived in its definitive form in the 1870s, the *Statue of Liberty* was inevitably the brainchild of certain French conservatives intended for certain American conservatives and destined to serve specific ends. The drama of the *Statue of Liberty* unfolds at the moment of its inauguration, that is, at the moment when the recipients attempt to fix its meaning. The young Cuban revolutionary, José Marti, covering the story for Argentine newspapers, quickly grabbed it for the underdogs: "Irishmen, Poles, Italians, Czechs, Germans freed from tyranny or want—all hail the monument of Liberty because to them it seems to incarnate their own uplifting." He anticipated the attempt of Puerto Rican nationalists less than a century later to take over the *Statue of Liberty* momentarily as the emblem of Puerto Rican independence.

The initial idea for the statue derived from Edouard-René Lefebvre de Laboulaye, an internationally distinguished jurist who specialized in American constitutional law and was professor of comparative law at the Collège de France. According to the sculptor, Frédéric-Auguste Bartholdi, the idea originated in 1865 during an after-dinner discussion at Laboulaye's estate at

Glavigny, near Versailles. The discussion drifted to international relations and the debts that nations owed one another. Citing the example of Italy's hostility to France since their coalition against Austria in 1859, one guest declared that "gratitude could not exist among nations." Laboulaye, however, contradicted him by pointing out the case of the United States which still cherished the memory of Lafayette and other Frenchmen who fought together for the principles of liberty and justice which united them. He then added that "if a monument were to be built in America as a memorial to their independence, I should think it very natural if it were built by the united effort, if it were a common work of both nations."[3] This conversation came back to Bartholdi's memory some five years later when he actually conceived the idea of a monument dedicated to the principle of liberty.

Bartholdi quite rightly credited Laboulaye for the idea which inspired his monument. But it was not the result of an offhand remark. Already in 1863 the jurist praised the example of America as a counterweight to Great Britain, a morally enlightened democracy powerful enough to maintain the independence of the high seas. He looked hopefully to America as a "secure shelter" amid the raging storms where "liberty glows like an inextinguishable lighthouse and casts its rays on the Old Country."[4] In this preface to his philosophical writings, *L'état et ses limites* (1863), Laboulaye anticipated his subsequent liberal use of the United States as a vicarious battleground for protesting against conditions at home. Laboulaye formed part of the mild opposition to the government of Napoleon III under which liberals masked their dissent by passionately embracing the cause of freedom elsewhere. His text is liberally sprinkled with the term "liberty," and he terminated four of his essays with it. But Laboulaye's concept of liberty is narrowly defined as a state somewhere between the two extremes of "anarchy and despotism." He insisted that there was nothing revolutionary in his idea of liberty which respected individual freedom of thought and action and left to representatives "effective control of public affairs."[5] He rejected popular sovereignty and direct elections and made a sharp distinction between liberty and equality: Equality is the promise of socialism, but is is the death of individuality. There was often more liberty in a caste system than in societies without social distinctions, he believed. He celebrated the cult of individuality against the centralized government which transformed "equality" into a "sterile uniformity."

Laboulaye took the United States as the ideal society. He praised its press laws, legal system, educational institutions, and its balance of authority and freedom, always slyly pointing out the contrast with French conditions. Universal suffrage worked there because the people were better educated; teachers received higher wages and were allowed to enter into associations to organize their curricula. The American public was informed because the press

was free; almost anyone could publish a paper whose success or failure would be governed by how well it answered to public opinion. Everything in the United States was bigger, freer, and fairer, with the emphasis more on the individual than on the state.

Laboulaye's idealization of the United States made him fair game for the American Consul-General John Bigelow, who carefully cultivated his friendship in his campaign to persuade the French against recognizing the Confederacy. Bigelow could boast that Laboulaye's pen and influence "were always at our service."[6]

Laboulaye in turn did not enter into this alliance innocently, but did so to help forestall the maritime power of Great Britain. Laboulaye profoundly regretted the lost opportunities of France in America. He noted with sadness the relinquishing of the New World in favor of France's hereditary enemy. France, however, tried to compensate for this loss by enabling the colonies to break from Great Britain's grasp. Later Napoleon extended this support by selling Louisiana to the United States at a cut-rate price and thereby making it a power great enough to check the ambitions of the British Empire. Laboulaye's obsession with English prowess explains his position on the American Civil War, still raging at the time of the first edition of *L'état et ses limites*. Although the head of the French Anti-Slavery Society, Laboulaye was less concerned with the status of slaves than with the possibility of an alliance between the Confederacy and England. He also watched with dismay how the South tried to appeal to France's revolutionary instinct by proclaiming its liberty from the tyrannical North. Laboulaye insisted on the need to maintain neutrality; any European intervention on the side of the South would prolong the war. France had both a commercial and political stake in America, and the shorter the war the shorter the time before the two nations could resume normal relations. For Laboulaye the worst-case scenario was dismemberment of the Union; England would then have recognized the South and stationed its vessels at the port of New Orleans. The American navy would have been weakened at the expense of the British navy, and this would have eliminated the check that Napoleon had cultivated. The triumph of the South would pave the way for the reinstatement of England as a power in the New World and would ultimately undermine the strength of France. Laboulaye held that among nations "the balance of power is the best guarantee of peace."[7]

Laboulaye totally identified France's interests with those of the North and wondered why such little sympathy existed in France for the Union: "What has become of the times when all of France applauded young Lafayette putting his sword in the service of the Americans? Who followed him? Who recalls this glorious event? Have we become so old that we have forgotten everything?" Laboulaye tried to console his American readers with the assurance that France,

the first friend of America, remained its most steadfast ally. He hoped that in those tragic circumstances France would again rise to the occasion and prove its fidelity "to America and to Liberty."[8]

Laboulaye pitched his arguments to American abolitionists then at the peak of their power. He had been in close touch with Charles Sumner whose cause he had promoted in French journals. Laboulaye and his colleagues formed the French Anti-Slavery Society which rallied to the side of the Union when war broke out. It was this group that Bartholdi encountered in 1865 in Laboulaye's conservatory and this group which organized the French-American Union which set forth the plan for the *Statue of Liberty*. The group included noble and bourgeois moderates in the political opposition including Agénor Gasparin, the Christian moralist, Henri Martin, noted historian and grand master of French Freemasonry, Charles de Rémusat, a scholar married to a granddaughter of Lafayette, Hippolyte de Tocqueville, surviving brother of Alexis, Oscar de Lafayette, Jules de Lasteyrie, and Wolowski, the Polish banker-economist. They were all basically conservative, fearing revolution and insurrection, and deeply suspicious of the masses. They firmly opposed revolution against the Second Empire, proclaiming liberty as an abstract principle rather than as a call to arms.

When Bartholdi arrived in 1865 to model Laboulaye's bust, he felt very much at home in this company. They congratulated themselves over the outcome of the American Civil War, and Laboulaye's idea for a monument was meant to be a memorial to the ideological alliance of French and American abolitionists. Laboulaye and his circle understood it as a reminder of a political debt that would at the same time reinforce their position at home. American recognition of Laboulaye's steadfast loyalty to the Union would also constitute an outside affirmation of Laboulaye's position on domestic issues. The idea of a monument for New York had strategic significance not only in its location to European immigrants but as the heart of the Union. It is no wonder that most of the other states considered the gift primarily the responsibility of New York rather than that of the United States as a whole. This would play a major role in the complex problem of raising funds to erect the pedestal, the responsibility of the American side.

The next stage of *Liberty*'s history coincides with the cataclysmic events of the Franco-Prussian War, the downfall of the Second Empire, and the Commune. Bartholdi claimed that it was during the Franco-Prussian War in 1870 that Laboulaye's idea for the monument came back to him. Bartholdi had volunteered for combat and served in the army on the eastern front. At one point he was sent to Bordeaux to pick up a shipment of arms and munitions from the United States, and he was dismayed to overhear a conversation between officers on board about the demonstrations in America in favor of Germany. When the war was over, Bartholdi could not return to his native town Colmar in Alsace. The Prussians had closed off Alsace to the French, and

eventually the entire region, except for Belfort, went to Prussia as part of the peace settlement. This dismemberment of the French nation was a bitter pill to swallow and assured that henceforth enmity between France and Germany would be a central fact of international relations.

Marti wrote at the time of the inauguration of the *Statue of Liberty* that Bartholdi's monument had "come to demand Alsace back for France rather than to illuminate the freedom of the world." There can be no doubt that *Liberty* embodied this meaning for the sculptor; almost all his work of the 1870s carried this reference. In May of 1871, after Alsace became legally Prussian, Bartholdi returned briefly to Colmar to visit his mother prior to his fact-finding tour to the United States on behalf of the *Liberty* project. During his brief stay he executed a sculpture which he entitled *The Curse of Alsace,* depicting a woman kneeling by a fallen soldier, his dead hand clutching a flag, and a child by her side embodying hope in the future. Bartholdi gave the work to Gambetta as a gift from the Alsatians. Bartholdi's famous monument, *The Lion of Belfort* (1880), commemorated the heroic actions of the French defender of the only town in Alsace not ceded to the Prussians. Carved out of red granite, the lion was set into the rocky flanks of the citadel which sustained the heaviest Prussian bombardment. The colossal lion is wounded but still capable of fighting, growling with rage and mighty defiance. Bartholdi's *Liberty,* conceived in this period and incorporating the features of his mother, similarly pays homage to his despoiled mother-fatherland. He wrote to Laboulaye from Colmar just prior to leaving for America: "Trying to glorify the republic and liberty over there, I shall await the day when they may be found here with us. . . ."[9]

The pain of Alsace-Lorraine and the desire to gain worldwide sanction for a policy of revanche commingled with the politics of the *Statue of Liberty.* During the wining and dining events connected with the inauguration of the statue in New York in 1886, Bartholdi and his backers referred repeatedly to Alsace. On one occasion, Bartholdi rose after a toast to declare, "I do not take this reception for myself. I take it for my country—for France and also for Alsace." In another speech honoring the sculptor, the chief spokesperson for the French colony in New York observed that the "great goddess" originated in Colmar. It was in pained reaction to mutilation of French territory that Bartholdi invested the figure with "his regrets, his love, his hopes! He opens the horizon, crosses the mutilated frontier of his country, and then a vision of light, of liberty, of grandeur, breaks on him and he gives it light, puts it into a body of imperishable bronze to be placed at the gate of the country which cherishes and knows France!" This note was struck also in the inaugural parade itself, with one grandiose float sponsored by the French colony carrying several young women wearing the traditional Alsatian costumes.[10]

On his way to America in 1871 Bartholdi did not stop at Versailles to see his friend Laboulaye. At that moment Paris and Versailles were caught up in the bloody civil war known as the Commune. The intense conservatism of French

society in 1871 was revealed by the savage reaction to the Commune of Paris, as it had been in 1848 by the repression of the revolt of the June Days. The aim of the dominant classes in 1871 remained what it had been when the Second Empire was established, to preserve the fabric of society unchanged—not to create a new France but to save the old one. Following Napoleon III's capture at Sedan and the annihilation of the French army, the Second Empire lost its reason for existence. On 4 September 1870 a republic was announced to cheering crowds by the self-appointed Government of National Defense. One of its leaders, Léon Gambetta, organized Paris and other parts of France to hold out against the Prussians. At the end of January 1871, however, Paris capitulated, and the armistice called for elections to establish a government that could ratify the terms of peace. Two-thirds of those elected to the National Assembly that met in February were monarchists, and the rest included a handful of Bonapartists and moderate republicans like Laboulaye. Adolphe Thiers was named chief of the executive power, and it was decided that the assembly should meet next at Versailles rather than at radical Paris. Determined to consolidate his position, Thiers recognized Paris as the greatest threat to the sort of compromise between the monarchists and moderate republicans he represented, and one of his first acts was to disarm the city's National Guard. When troops were dispatched to take the city's cannons, they were met by an angry crowd hardened and politicalized by months of fighting. Faced with insurrection, Thiers withdrew the army to Versailles to await the proper moment to crush the Parisian resistance.

The Municipal Council of Paris declared a Commune which included moderate and radical republicans and socialists, including a few members of the Marxist First International. The civil war between these Parisian democrats and the Assembly at Versailles fed on the distrust and despair that accompanied the French war effort, the siege of Paris, and defeat. The bitter and bloody fighting lasted nearly two months before troops broke into the city in May. Hostages taken by the Communards to win release of some of their captured leaders were killed, but in the end the victors proved far more brutal. Under the watchful gaze of the Prussian armies, tens of thousands of Parisians died in the streets, and summary courts-martial ordered execution, imprisonment, or deportation for tens of thousands more.

While the Commune raised the red specter for the elites throughout Europe, it became a model of the proletarian rising for the Left. Former Communards became the heroes of socialist gatherings for the next generation, and to this day the cemetery where many of them were executed remains a shrine honored by socialists and communists. After 1871 a working-class uprising became a credible possibility to radical and conservative alike, and working-class movements pointed to the martyrs of the Commune as evidence of selfish cruelty of bourgeois rule and of the futility of reformist policies.

The Commune was a horrifying spectacle for Laboulaye and Bartholdi, both of whom stood squarely behind Thiers. It was during the early days of the

Commune that Bartholdi had returned to Laboulaye's estate near Versailles. There was a reunion of the dinner guests of 1865, almost all of them elected to the National Assembly. They stood unflinchingly behind the government's resolve to smash the insurrection and if necessary to reduce Paris to ruins. Around the time of the proposal of the Communards to topple the Vendôme Column, Laboulaye and his cronies advised Bartholdi to visit America and propose to "our friends over there to make with us a monument, . . . in remembrance of the ancient friendship of France and the United States." Laboulaye declared that he and his group would form an organization to raise funds for the monument's construction.[11] This was the germ of the Franco-American Union which provided the backing for Bartholdi's *Liberty*.

Bartholdi carried with him to the United States letters of introduction to the scholarly senator and abolitionist Charles Sumner, the poet Longfellow, President Ulysses S. Grant, Civil War Generals Meade and Sheridan, iron magnate Peter Cooper, and entrepreneur Cyrus Field. Laboulaye's connections enabled Bartholdi to meet with the members of the exclusive Union League Club in New York and in Philadelphia. Hence, Bartholdi's voyage to the United States in the spring of 1871 was aimed at the abolitionists and Northern military and industrial interests who owed most to Laboulaye's spirited defense of their interest in France.

Laboulaye and his circle clearly wanted to seize the opportunity to exploit the American debt and at the same time use for leverage the sympathy of their supporters during the catastrophic events of 1870–71 in France. The need to establish a direct link through a commemorative statue was also aimed at gaining American goodwill to offset the traditional English association and the growing German influence. Laboulaye had his own personal reasons for suggesting this monument: in 1870 he discredited himself by declaring himself in favor of the plebiscite of May which essentially meant maintaining the regime (now known as the "Liberal Empire") he had previously opposed. His attitude was condemned by his followers, and students prevented him from giving his lectures at the Collège de France on 23 and 27 May. He needed a clear indication of his ongoing commitment to the principle of liberty which had been the leit-motif of his writings.

His version of liberty was the one embodied in Bartholdi's monument. In his *L'état et ses limites* he confessed that when one spoke of liberty in France everyone immediately imagines that "savage goddess . . . with the red bonnet on her head and a pike in her fist." This image, however, is entirely opposed to Laboulaye's idea of liberty which has "nothing revolutionary in it." In a fundraising speech at the Opéra in 1876, Laboulaye alluded disparagingly to Delacroix's version of *Liberty* as "the one wearing the red bonnet on her head . . . [who] walks on corpses. . . . "[12] Laboulaye's image of Liberty emphasized a respect for law and order, understandable in his case when we recall that the immediate impulse for the *Statue of Liberty* came during the Commune which

invoked the image of Liberty wearing the red cap and even published a newspaper entitled *Le Bonnet Rouge*.

The red cap, the Phrygian bonnet, was the historic emblem of liberty.[13] Thus, during the decisive years of the Third Republic a clear choice existed for allegorical depictions of this theme. To choose a calm posture instead of a vehement one for the female Liberty, a heavily clad figure instead of partial nudity, and to eliminate the Phrygian bonnet was clearly to signify that emphasis would be placed on the calming power of reason rather than on a fervent call to unceasing battle. The red cap was the most constantly significant symbol of all, both because it was one of the original attributes of Liberty and because historically between 1792 and 1871 it became identified with the unrestrained moments of popular upsurge. Thus, by the time Bartholdi made his voyage to America the question of crowning or not crowning a figure of Liberty with a Phrygian cap posed a clear choice and made a precise political statement.

Indeed, this debate was not confined to France but existed elsewhere in the world including the destination of Bartholdi's monument. The American sculptor, commissioned to decorate the extension of the United States Capitol, Thomas Crawford, originally planned to crown three of his allegorical personifications, including the *Statue of Liberty* (1858–63) for the dome of the U.S. Capitol, with a Phrygian bonnet. At the urging of the secretary of war, however, he omitted it and in the case of the dome allegory replaced it with a helmet decorated with an eagle. This switch was dictated by the secretary's fear that the Phrygian bonnet would be identified with the French revolutions and hence, by extension, interpreted as a statement against southern slavery. It is hardly surprising to learn that the secretary of war was none other than Jefferson Davis, the jingoistic southerner who had become president of the Confederacy by the time the statue was erected. Crawford's final version is a reactionary symbol embodying militaristic rhetoric of Manifest Destiny and Southern aims of expansion into the Caribbean.[14]

The image conceived by Laboulaye and Bartholdi conforms to the ideal of the conservative republicans in the wake of the Franco-Prussian War and Commune. The next stage in the evolution of the statue corresponds to the ambiguous "republic" established by default of the monarchists unable to produce a king. Laboulaye and his colleagues in the National Assembly sat with the Center-Left, at that time an unprogressive group standing solidly behind the policies of Thiers. Laboulaye personally saw the reactionary Thiers as the ideal republican. During the period 1872–74, Laboulaye backed Casimir Perier's monarchist faction of Orléanists and conservative republicans. It may be recalled that the monarchists only reluctantly agreed to a republic as a transition regime pending the decision of the royalist pretenders. Laboulaye's party consistently joined with monarchists in monitoring a possible revival of Bona-

partism. By late 1874 a coalition of Orléanists and conservative republicans took control of the National Assembly. By that time Maréchal MacMahon—the monarchist commander who led the attack against the Communards—was the president of the Republic.

The quarrels among the Legitimists opened the way for the republicans who until then behaved with conspicuous moderation to win over centrist groups. Early in 1875 a motion defining the government of the Republic was only narrowly rejected. On 28 January 1875 Laboulaye made an impassioned speech on a motion to establish a republic and almost carried the National Assembly. The motion was defeated by 359 votes to 336. It was followed on 25 February by the famous *amendement Wallon,* which laid down the method of electing the successors to MacMahon as the head of state, the effect of this was to turn the presidency of the Republic from a temporary expedient into a permanent institution. The amendment was passed by 353 votes to 352, so that the Republic was established by the shaky majority of a single vote. But the conservatives refrained from pushing through a full-fledged constitution for fear of losing the coalition, and in its place passed a series of constitutional laws framed by a committee in which Laboulaye played a leading role. These laws included retrogressive components imposed by a monarchist majority. The president, chosen for seven years and re-eligible, was the next best thing to a king, and the door for easy shifting from republic to monarch was kept open by establishing a simple procedure for constitutional revision. While republican institutions lasted, the conservative interests in society were to be entrenched in an upper chamber, or Senate (which Laboulaye was soon to enter), with powers in theory practically equal to those of the Chamber of Deputies. The natural play of forces insured that the Chamber of Deputies did not commit itself to social experiment.

The National Assembly dissolved itself in December 1875, and the elections of the following year produced a chamber with over 340 republicans against under 200 of the Right, including a sizable Bonapartist group. However, the republicans were constrained over the next three years by the conservative majority in the Senate and above all by the personality of the president, the royalist-minded MacMahon. MacMahon actually asserted his prerogative to dissolve the chamber on 16 May 1877 (the famous *coup de seize mai*), but new elections again returned a republican majority. MacMahon finally resigned in January 1879 and was replaced by a moderate republican, Jules Grévy.

It is no coincidence that the banquet initiating the fund-raising campaign in France for Bartholdi's monument was held on 7 November 1875, shortly before the dissolution of the National Assembly. The originating committee known as the Franco-American Union consisted of several moderate republicans and Orléanists who orchestrated the compromise with the monarchists. It now intended to exploit the statue and the publicity surrounding it to bolster their own tenuous position at home. Neither the Left republicans nor the royalist

Right countenanced the idea or shared the Center-Left's America-worship. It was strictly the gimmick of Laboulaye's group to promote their prestige in France and rally support from abroad. Originally the group had hoped to donate the completed work to the United States in time to commemorate the approaching Centennial of 1776. They would have wished the United States to share in the expenses, thereby directly participating in the Laboulaye-Bartholdi project and insuring it worldwide publicity. Although the timetable was unrealistic, Bartholdi did manage to cast the right hand and torch in time to exhibit at the 1876 Philadelphia Centennial. It was the perfect advertisement for the conservative republicans of the Franco-American Union.

Bartholdi was one of the French Centennial delegates and made a whirlwind trip to New York to renew his American contacts. But this time he approached the wealthy clubmen who hosted him at the Union League, Century, New York, La Palette, and Lotus clubs. Bartholdi lined up support for the pedestal which would represent the American contribution. Shuttling back and forth between New York and Philadelphia, Bartholdi was feted by the elite of the North including the Astors, the Belmonts, and corporate lawyers like William Maxwell Evarts and Frédéric René Coudert, the spokesperson for the French colony in New York. On 2 January 1877 the constituent meeting of the Franco-American Union's American branch took place at the Century Association. Railroad lawyers and businessmen constituted the largest contingent, with publishers like Whitelaw Reid, Parke Godwin, and Charles A. Dana running a close second. The wealthy merchant Henry Foster Spaulding, on the boards of several banks and insurance firms, served as treasurer, and the group included a special legislative subcommittee composed of Evarts, Godwin, former governor of New York Edwin D. Morgan, and two railroad lawyers, Clark Bell of the Union Pacific and James W. Pinchot of the Pennsylvania—all prominent in the Republican party. It was these robber barons and their acolytes to whom Bartholdi sold Laboulaye's scheme, and who in turn persuaded Congress to authorize President Grant to receive and erect the *Statue of Liberty*.

The years 1877 to 1881 witnessed the foundation of the authentic republican regime in France. Not surprisingly, it assumed power with a solid conservative bias. The view held by its leaders Grévy and Ferry was that an unexpected display of blatant republicanism would run the double risk of provoking and alienating the reactionary party and unleashing the revolutionary ambitions of the extreme Left. It makes no difference whether this circumspection was done out of prudence or conservatism, the result was the same. The preferred symbolic and visual mode of this republican group was an effigy of the Republic stripped of revolutionary attributes. Not coincidentally the state seal designed by Barre in 1848 was used for the seal of the fledgling Third Republic (Fig. 48). It heralds the *Statue of Liberty* with its heavily clad figure and crown of solar rays. Oudiné's medal of 1848 was also restruck, showing the Republic as a standing woman, facing forward, her body entirely draped in robes,

her head crowned with the sun's rays and holding in her right hand the Tables of the Constitution (Fig. 49). This is the image of the conciliatory, conservative republic bequeathed to Bartholdi and monumentally projected in *Liberty*.

The Paris World's Fair of 1878 offered the first opportunity to celebrate the victorious Republic and a recuperated France. One of the main attractions was the completed monumental head and torch of the *Statue of Liberty* set between two mere life-sized models of the whole. The giant bust became a center of interest as an example of superior French engineering and industry. The sedate effigy was echoed by Clésinger's colossal temporary statue of the *Republic* set up to greet the crowds at the right of the principal entrance of the Exposition on the Champ-de-Mars. It was a seated, unsmiling figure, the right hand holding a huge sword and the left resting on the Tables of the Constitution of 25 February 1875 (Fig. 50). This solemn *Republic* wore a headdress that was a cross between the Phrygian bonnet and the antique-looking helmet of a contemporary Parisian fireman. The inaugural speech of the minister of interior on 30 May stressed the calm and moderate image of the *Republic*. Although agitated and passionately aroused in the past, the motherland was once again "at peace."[15] This image of a calm republic was the symbol of a united country; the French republic was no longer the effort of a single party but that of France. The revolutionary image of the republic was no longer applicable. Thus the counterrevolutionaries tried to cast their version of the republic in a form unassailable by the Left. At the same time, the conservatives made *Liberty* the logo not just of a particular party but of the state as a whole, "the gift of the French people."

But the radicals of Paris did not accept the image of the calm republic. They detested Clésinger's statue, although they appreciated the idea of the effigy at the Exposition Universelle: "It is an opportune moment to prove to foreigners drawn to Paris by the Exposition Universelle that the Republic, now definitively established, can henceforth display its image in public places."[16] Here the term "public" testifies again to the extrinsically political character of the republic even in its most conservative form. But Clésinger's statue irritated them, and the newly elected Parisian councillors proposed that Soitoux's marble statue of the *Republic* be taken out of storage and exhibited. The same group also debated the attributes that would best define the Republic, with the radical majority insisting that the statue should be wearing a Phrygian cap, "the historic emblem of liberty." Thus neither Clésinger's *Republic* nor Bartholdi's *Liberty* could satisfy the ideals of all the French people.

Above all, the moderates exploited the *Statue of Liberty* as a wedge in their trade relations with the United States, hoping to eclipse their principal overseas rivals in the 1870s, England and Germany. By associating the work with Lafayette on the one hand and Alsace on the other, Bartholdi's backers attempted to win popular sympathy for the French over and against England and Germany. The Franco-American Union on both sides came to be dominated by

126

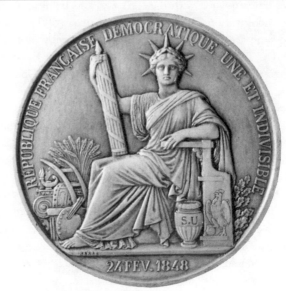

Fig. 48. Jean-Jacques
Barre, Seal of the Re-
public, 1848. Admin-
istration des Mon-
naies et Médailles,
Paris.

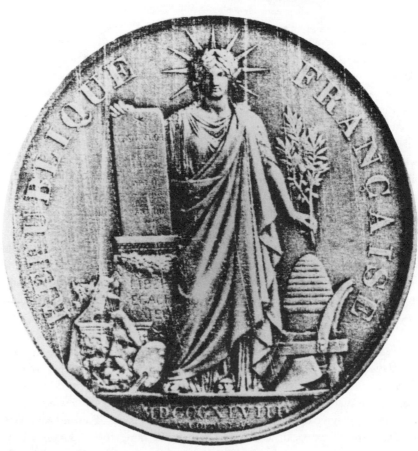

Fig. 49. Eugène-André
Oudiné, Medal of the
Republic, 1848. Ad-
ministration des Mon-
naies et Médailles,
Paris.

Fig. 50. Auguste Clésinger, *Figure of the Republic.* Wood engraving reproduced in *Le monde illustré,* 6 July 1878, p. 16.

business interests, and the note struck at all the banquets emphasized the economic ties between the two countries. The appeal issued to the public in 1875 by the Franco-American Union stressed the location of the statue "at the threshold of that vast continent, full of new life, where arrive all the vessels of the world. . . ." But the clearest evidence of the behind-the-scenes nego- tiations is seen in the excursion of the French delegation to the Produce Exchange in New York the day before the inauguration in 1886. They received an enthusiastic reception from James McGee, president of the Board of Managers, who, welcoming them to these "halls of commerce," announced:

> We cannot but remember that in your delegation there are not only distinguished members of the commercial community, but representatives of science and art. And we are reminded today that the statue—the mystic symbol which is soon to be unveiled—is, indeed, the representative, the key to all true progress, for it is only the enlightenment of Liberty that makes progress possible. We welcome you in the name of commerce—commerce that lights the torch and the flames of liberty, and is the pioneer of civilization.[17]

Both sides seized the occasion of the inauguration to strengthen the political and commercial relations between France and the United States; French dele- gates of the Paris Board of Trade and American hosts representing the U.S. Chamber of Commerce easily grabbed the public attention at the opening ceremonies.

Among Bartholdi's earliest contacts in the United States were Peter Cooper and his son-in-law Abram Hewitt, both magnates in the iron industry[18] with close political connections to Frédéric Coudert. They took an active interest in the project; Hewitt became *Liberty*'s sponsor in Congress and tried to push through a bill covering the expenses of erecting the monument which he saw as "an aid to navigation and to diplomacy."[19] The work, produced in the Parisian workshop of Gaget, Gauthier & Co., certainly brought great publicity to the French metallurgical industry and stimulated a demand for other innovative iron structures. Engineer Gustave Eiffel—shortly to achieve world renown for his thousand-foot tower—designed the complex iron trusswork of the *Liberty* to support the copper sheathing. Eiffel's solutions to the problems of wind resist- ance and foundation design derived from his experience in railway construc- tion, especially in his large-scale station and powerful railway bridges which spanned the deepest gorges in France. Eiffel's combination of practical engineering skills, managerial talents, and creative entrepreneurialism epit- omized the ideal of the elite members of the two branches of the Franco- American Union.

One other international hero of French enterprise figured prominently in the *Liberty* project: Ferdinand de Lesseps, the intrepid canal-builder of Suez and Panama. De Lesseps and Bartholdi first met in 1869 as members of the select delegation attending the inaugural ceremonies for the Suez Canal. Bartholdi had been profoundly moved by the sight of the colossal Egyptian monuments on an early trip to North Africa with the painter Gérôme and others, and he

leaped at the opportunity provided by the completion of the Suez Canal to project a monumental allegory for the entrance to the waterway.[20] His theme, anticipating the *Liberty,* was entitled *Progress* or *Egypt Carrying the Light of Asia* and showed the statue holding a torch aloft. Bartholdi had the backing of the Egyptian khedive, Ismā'īl Pasha, who had allied himself with France in this period in an effort to introduce Second Empire modernizations into his own land. But the project failed to materialize as the English gained diplomatic and economic ground in Egypt, and Bartholdi devoted his energies to the *Liberty* to carry the message of international French achievement and to carve out a symbolic space for France in the New World.

De Lesseps was one of the first subscribers to the *Liberty* campaign. But he did not take an active role until July 1880 when he attended a special banquet of the Franco-American Union organized to notify the Americans formally that they were sure of getting their gift. Thereafter he moved to the foreground of the organization, replacing Laboulaye as chair of the union in 1883. The following year de Lesseps, in a highly publicized ceremony on 4 July, delivered the statue formally to the U.S. minister in France and signed the deed of transfer.

De Lesseps opened his address with an allusion to his project of the Panama Canal, "which is the work of the citizens of the two Republics."[21] It would not be the last time he would link the two schemes. De Lesseps espoused the canal project in 1879 and thereafter he exploited the *Liberty* campaign to publicize the canal. Indeed, the intertwining of the two at this stage in his career coincides with the promotion of the Panama Canal Company and the marketing of its shares. At the same time, neither the administrations of Hayes nor Arthur was sympathetic to the French involvement in the Americas—Arthur entertained his own scheme for Nicaragua but failed to get it past Congress—and de Lesseps viewed the *Liberty* as a means of overcoming American resistance to his project.[22]

But clearly the railroad tycoons and enterprising lawyers of the American branch of the Franco-American Union were not hostile to the French attempt to construct a canal across the Isthmus of Panama and hoped to benefit from the strategic and economic waterway. When de Lesseps arrived in New York to celebrate the unveiling of *Liberty,* he was hosted by some of the leading industrialists and entrepreneurs in the North. A banquet in his honor was organized for major New York businessmen by Cyrus W. Field, promoter of the first transatlantic cable. Field's toast singled out the Suez Canal as demonstrating that de Lesseps "does not belong exclusively to any country, since his works extend all over the world." The New York Chamber of Commerce sponsored another banquet for de Lesseps at fashionable Delmonico's, at which time the French foreign minister rose to state that the occasion of *Liberty* promises to increase trade between "sister Republics" and to "diminish quarrels between capital and labor."[23]

De Lesseps was one of the key speakers at the inauguration of *Liberty,* and could not resist invoking his latest engineering attempt: "Very soon . . . we shall find ourselves together to celebrate another pacific conquest. I say *au revoir* until we meet at Panama, where the thirty-eight stars of North America will soon float at the sides of the banners of the independent states of South America, and will form in the New World, for the benefit of mankind, the peaceful and prolific alliance of the Franco-Latin and Anglo-Saxon races." De Lesseps was far too optimistic in his forecast; the collapse of his project just three years later touched off a financial scandal that would shake the Third Republic to its very foundations. But he expressed in unequivocal terms one of the primary significations of the *Statue of Liberty* in 1886: a "pacific conquest" by France of the American entrepreneurial imagination and a salient demonstration of French savoir faire. De Lesseps lauded American ingenuity and resolution and noted that there was "only one rivalry—that of progress. We accept your inventions as you accept ours—without jealousy."[24] The moment was propitious for de Lesseps; Grover Cleveland, the first Democratic president since the Civil War, was favorable to unrestricted foreign trade and gave the French entrepreneur a proper platform from which to cast his dreams of imperial glory.

Perhaps the most telling involvement in the final stage of the *Liberty*'s development and its connection with state policy is that of Jules Ferry, the French architect of overseas expansion during the Third Republic. It was Ferry, as president of the Council of Ministers, who announced in 1884 that the government of France had decided to sponsor the *Liberty*'s final stage and that the statue "would be transported to New York on a State vessel under the official banner of France."[25] The official deed of presentation was signed by Ferry on 4 July in the name of France.

Ferry's enthusiasm for the *Statue of Liberty* at that moment was inseparable from his insatiable quest for new markets. The experience of the depression that began in France in 1882 had a discouraging effect on trade and commerce. France, having industrialized relatively recently, was behind in the competition for markets. Ferry's solution was colonial expansion which he felt would also meet three distinct political needs of France in the early 1880s: the desire to compensate for past losses such as the Alsace-Lorraine and the Egyptian foothold, the need to regain world esteem, and the economic need for markets and for places to invest.

Ferry looked to the New World and to the Third World for new markets and new consumers. He also feared that the rising power of the United States threatened old French markets and that North America would take from France its South American markets. Ferry supported de Lesseps's Panama Canal project for just this reason: he warned that expansion in exports was the key to France's economic survival in the competition for markets. Ferry did not attend the inauguration ceremony of the *Statue of Liberty* in 1886; he had fallen from power the year before and others stood in to represent his views. In addition to

de Lesseps, one of Ferry's most fervent supporters figured prominently in the French delegation. This was Admiral Jaurès, one of the most decorated veterans of France's imperialist campaigns whose eloquence in the French legislature helped Ferry secure the colony in Southeast Asia which became known as French Indo-China. Perhaps one of the most ironic features of *Liberty*'s history is Bartholdi's replica of the statue erected in 1887 at Hanoi, the capital of the French Protectorate.[26]

Once the *Statue of Liberty* was physically delivered to its recipient its extrinsic political potential took on new significance. The American Committee for *Liberty* tried to insure that the upper crust got credit for the inauguration. They understood the statue as an endorsement of the status quo, as a validation of their existing privileges. Indeed, for the dominant elite it was a symbol far more appropriate for the United States than for France itself:

> It will stand as a perpetual reminder of the realization in America of political ideas of which the origin may fairly be claimed for France, but of which the realization in France itself seems more precarious and less complete. On our shores, and under the tendency of a race less theoretic, less excitable, and less impatient than the French people, the germinal idea has been realized in what all Americans believe to be, with all its imperfections, the most successful and the most hopeful of all the social systems that have grown up in the history of mankind.[27]

Other social groups, however, saw in the monument a promise yet to be fulfilled, and this meant contesting the interpretation of liberty upheld by the members of the American Committee. The dialectical give-and-take of these groups amplified the significations of the statue. The beginnings of this fresh mapping of the field of meaning may be traced to the efforts of Joseph Pulitzer, the editor and publisher of *The New York World*. He saw his opportunity in the American Committee's failure to raise the $250,000 for the pedestal; looking for a way of increasing the circulation of *The World,* he adopted the fund-raising campaign as a crusade in 1885. The irresolution of the predominantly Republican American Committee was due to the unexpected outcome of the 1884 presidential election. Democrats would be the ones to bask in the radiance of *Liberty*'s torch, and the Franco-American Union hesitated to follow through on a project for which their opponents would receive full credit. Pulitzer fervently supported the Democratic party and pretended to speak for "the people" against the Republican "moneybags." During the presidential campaign, he kept hammering away at the connection between Blaine, the Republican candidate, and the wealthy plutocrats of New York. Just prior to the election Blaine was feted by his supporters at Delmonico's, and Pulitzer set the story in lurid headlines and captions that stressed the links between the "mighty money kings" and the Republican party. The seating list of that banquet included practically every tycoon on the American Committee.[28] When Blaine lost to Cleveland, the uncertainty of the Franco-American Union enabled Pulitzer to gain the momentum in the pedestal campaign.

Pulitzer appealed to all Americans for their contributions and promised to publish the name of every donor no matter how small the sum. In his editorial

Excursus on the Statue of Liberty

on 13 March 1885 he began reinterpreting the *Statue of Liberty* in the by now familiar terms: "[The Statue] is not a gift from the millionaires of France to the millionaires of America but a gift of whole people of France to the whole people of America." Pulitzer's message captured the imagination of tens of thousands of readers, including eager school children who sent in their pennies and got to see their names in print. As the movement continued to swell, the American Committee climbed aboard the bandwagon to associate itself with the popular drive. On 23 March, Evarts—his motivation now fueled by presidential aspirations—Butler, and Spaulding signed an "Appeal of Patriotism" asking for donations "in the name of our country." *The World* published this plea together with a statement of its own position: "Let us . . . prevent any syndicate of patriotism among the capitalists. We want the Pedestal built with the dimes of the people, not with the dollars of the rich few."[29]

Between the time of *The World*'s campaign and the unveiling of the statue, *Liberty* became the focus of heated class, ethnic, and gender issues raised by the various groups which adopted it. The ballyhoo and publicity surrounding the occasion provided them the opportunity to register their protest against the inequities and lack of real liberty in the United States. Two major events of 1886 then at the forefront of national discussion centered on dissenting groups and their version of liberty: the independent New York mayoral campaign of Henry George and the Haymarket trial. George—whose best-selling exposé of the contradictions of capitalism, *Progress and Poverty* (1879), made him a hero of Anglo-American labor parties—constituted a real threat to both the Republican elite and Democratic machine in the weeks just preceding the November elections. Running as an Independent candidate for labor, he gathered under his banner the workers and the disenfranchised minorities. His spellbinding oratory and lucid analysis of economic problems attracted large crowds. By late October, journals like *The New York Times* denounced his candidacy and warned of "a red spectre" behind his movement which threatened "the order and stability of the community." George's own critique of contemporary American society ran counter to the patriotic rhetoric of the period: "There can be no true republic under the present social conditions; it is not a true republic in which girls and children are forced to work in the mills; in which thousands of tramps and hundreds of millionaires exist; in which we turn away paupers from our shores. It was once our boast that we could transform the lowest European into a free American citizen. . . . There is wealth enough for all. But the fault lies in the unequal distribution of wealth."[30]

Two weeks before the inaugural ceremony of *Liberty* George took the opportunity to address an audience of French-American citizens preparing to participate in the event. He proclaimed that "The great epoch of the French revolution is about to repeat itself here," and added that the motto of " 'Liberty, Equality, and Fraternity' embodies the aspiration of every workingman in the world today." As reported by *The World,* George's speech failed to

take into account the reality of modern life. The editors wished to see him replace "Fraternity" with "Property" in the old slogan; for them "Liberty" and "Property" were not mutually exclusive terms. The great conservative force in a Republic is property: "If Liberty is its breath, Property is its food."[31]

So inextricably tangled became the rhetoric of the three candidates for mayor and the publicity surrounding the *Statue of Liberty* that *The World* decided to publish an imaginary interview with "Miss Liberty" in order to determine which candidate had the greatest claim to her virtue. She rejected the Republican aspirant, Theodore Roosevelt, for his connections to the party of wealth, and George for being too radical. Her choice was Abram Hewitt, Tammany Hall's candidate and the eventual victor. It may be recalled that Hewitt was *Liberty*'s sponsor in Congress and had close connections to Coudert. Hewitt's line emphasized the moderate political ideal embodied in the statue. But George, who ran a close second to Hewitt, was not about to yield his hold on *Liberty*. Accepting his defeat philosophically, he addressed his labor constituencies with this hopeful idea: "We have lighted a torch whose fire they will not be able to quench." He likened his campaign to "the Bunker Hill of the labor revolution."[32]

The year 1886 culminated a decade of major strikes; several that year—such as the bitter pork-packers strike at Armour & Co.—broke out in Chicago over agitation for the eight-hour day. The most sensational of these and the one that sent shock waves through the world was that of the McCormick Harvester Plant in May. The violent reprisals against workers led to a protest rally in Haymarket Square; this time when the police entered the scene someone tossed a bomb into their midst, killing and wounding several officers.[33] Immediately, the authorities exploited the opportunity to round up anarchist leaders in Chicago whom they blamed for the violence. The trial of the eight anarchists has since been recognized as the most unjust in the annals of American jurisprudence. None of the eight was accused of the bomb-throwing, but they were tried for creating an atmosphere of violence which influenced the bomb-thrower. The controversial trial became the focus for all the stormy passions of the day, since it put to the test the stated aims of the American republic and its capacity to fulfill them. Issues of radicalism, mass immigration, and foreign-born anarchists sparked a campaign of radical-baiting and xenophobia that has rarely if ever been surpassed. The Haymarket trial demonstrated in dramatic form both the inequities of American capitalism and the limitations of American justice. Since this occurred at the very moment when the *Statue of Liberty* was inspiring lavish praise for America as a haven for the oppressed, the issues and principles raised by the trial touched deep-seated emotions. No other case attracted more widespread attention in the period, and it assumed a symbolic signification equal to that of the *Statue of Liberty*.

The theme of liberty was particularly evident in the Haymarket trial, whose defendants were members of a movement which made "liberty" the watchword

of their platform. Anarchists in Boston even titled their journal *Liberty*. The newspaper of the Chicago anarchists, *The Alarm,* devoted practically every other editorial to a definition of "liberty" or "freedom." On 18 April 1885 it provided the following definition of anarchist goals: "Well, in the first place, the second place and the third place, Anarchists want *liberty*—liberty for themselves and for all other human beings. By this is meant the exact reverse of what the great mass of humanity—the proletariat—now have—slavery." Ironically, *The Alarm* looked to the French Commune as a model and inspiration for working-class agitation. Every spring it organized an annual celebration of the event, commemorating the massacre of shackled workers and the promise of future solidarity. While everywhere in New York the bands would play the *Marseillaise* in honor of the French delegation, the anarchists took the song to heart publishing a translation in which the last chorus began: "Oh liberty, can man resign thee / Once having felt thy gen'rous flame?"[34]

During the second week of October 1886 the accused were allowed to address the court. Sounding their keynote theme, Albert R. Parsons, the editor of *The Alarm*, read his poem entitled "Freedom." Its verses on the enslaved workingman no doubt inspired one New York paper to report the attempt of the anarchists "to place themselves before the eyes of the world in the attitude of martyrs to the cause of liberty and human progress." *Harper's Weekly,* which condemned all working-class organizations as "un-American," upheld the guilty verdict as a great service "to liberty in this country" by demonstrating "that liberty does not mean, and shall not be made to mean, license." This editorial was illustrated by a Thomas Nast cartoon depicting a colossal allegorical figure grasping the eight anarchists in her left hand (Fig. 51). The double meaning of the caption would have been clear to everyone: "LIBERTY IS NOT ANARCHY."[35]

The need to sharply distance the rhetoric of the radical Left from the American Committee's notion of liberty was quite evident in the inaugural addresses. Cleveland ended his talk with an observation on the moderate attributes of the statue: "Instead of grasping in her hand the thunderbolts of terror and death, she holds aloft the light that illumines the way to man's enfranchisement." His rather elliptical utterance was amplified still further by Chauncey M. Depew, the eloquent railway magnate who declared that the monument implied

> that with the abolition of privileges to the few and the enfranchisement of the individual, the equality of all men before the law, and universal suffrage, the ballot secure from fraud and the voter from intimidation, the press free and education furnished by the state for all, liberty of worship and free speech, the right to rise and equal opportunity for honor and fortune, the problems of labor and capital, of social regeneration and moral growth, of property and poverty, will work themselves out under the benign influences of enlightened lawmaking and law-abiding liberty, *without the aid of kings and armies, or of anarchists and bombs* [emphasis added].

Depew's closing statement not only referred to Henry George and the Chicago eight, but juxtaposed them with images of royal tyranny to imply that his

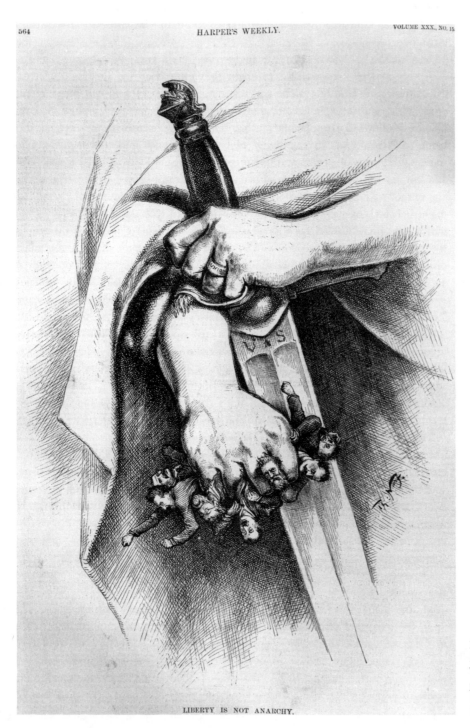

LIBERTY IS NOT ANARCHY.

Fig. 51. Thomas Nast, *Liberty is not Anarchy.* Wood engraving reproduced in *Harper's Weekly*, 4 September 1886, p. 564.

Excursus on the Statue of Liberty

notion of Liberty avoided the extremes of both sides of the political spectrum. *The World*'s editorial of the following day seconded this opinion in claiming that the *Statue of Liberty* teaches us that "there is boundless space for Liberty, Law and Order, but not a single foothold for License, Lawlessness and Anarchy. . . ."[36]

Less than two weeks earlier, Lucy Parsons, the activist wife of the Chicago anarchist on trial, arrived in New York to raise money for an appeal. An ex-slave known to Chicago police as "the black bitch," Parsons was an eloquent critic of capitalist exploitation and had the ear of the labor groups backing George. Following the playing of the *Marseillaise*, Parsons opened her address before a large crowd in Clarendon Hall with the declaration that those who monopolized talk of liberty in the United States mean "Liberty . . . for the rich and not for the poor." She proclaimed that she would carry "the red flag of the commune and plant it everywhere in New England, where in all the shops and factories the working people are slaves. . . ." She then took up the trial in Chicago which she called "a stain upon American liberty," and enlarged on this theme: "Is it American liberty when poor working men cannot talk for their rights; when seven men are doomed to die because they are socialists and a number of children are about to become fatherless and women made widows to die of broken hearts?" And she concluded that if the sentence of death were to be carried out in Chicago "the American flag is disgraced and the memory of the sons of 1776 insulted."[37]

As an educated black woman, Parsons also spoke for disaffiliated minority groups of more advantaged social backgrounds whose consciousness was heightened by the current debates. James Monroe Trotter, a writer and administrator, organized a conference in Boston in September 1886 of black "Independents" from the New England states to protest white injustice. Trotter blamed lack of organization on the fact "that we are not free and independent men. The time has come when the negro should demand a whole loaf and nothing else." *Harper's Weekly* took a dim view of a black pressure group, especially one bucking the Republican party which until then took the black vote for granted. It insisted that black people "regard themselves as equal American citizens, and 'live down' prejudice." *Harper's,* well aware that there were sixty thousand black members of the Knights of Labor, feared an independent black movement pressing for change in return for political allegiance.[38]

Depew's reference to "universal suffrage" in his inaugural address must have also sounded hollow to the various women's suffrage groups in New York. Indeed, the members of the New York State Woman Suffrage Association looked upon the inaugural ceremonies as an empty farce. They had applied for a place in the naval parade to Bedloe's Island (with a specially outfitted boat) and were not only denied but advised to board the vessel of another group. Disgusted with the rebuttal by the male managers of the parade, they stationed their vessel in a favorable position and invited the public to board. The president of

the Association, Lillie Devereux Blake—whose book *Woman's Place Today* (1883) had the electrifying effect of Betty Friedan's *The Feminine Mystique*—addressed the crowd with a denunciation of the unveiling. She declared "that in erecting a Statue of Liberty embodied as a woman in a land where no woman has political liberty men have shown a delightful inconsistency which excites the wonder and admiration of the opposite sex." *The New York Times* reported with characteristic smugness that the feminists "were the only people who looked with disfavor upon the grand pageant yesterday in celebration of Liberty's unveiling."[39]

But it was a socialist feminist who gave the *Liberty* its decisive and now mythical interpretation as a shrine to immigrant freedom and opportunity. In her legendary sonnet, "The New Colossus," Emma Lazarus stressed that *Liberty* was not "the brazen giant of Greek fame," but "A mighty woman with a torch . . . and her name/Mother of Exiles." The poem's last lines are the well-known invitation to the "huddled masses" and "wretched refuse" embossed on the bronze tablet in the interior of the pedestal. It was written at the request of Evarts who gathered manuscripts of contemporary authors to be sold at auction to raise funds for the Bartholdi Statue Pedestal Campaign. The sonnet was read at the auction on 3 December 1883 and recited again at the dedication of the statue three years later. But the engraved poem was not affixed to the interior of the pedestal until 1903 when the *Liberty* had already become the quintessential American icon.

What is not generally known is that the sonnet was written under the inspiration of Henry George. Lazarus had been drawn early to his program after having read *Progress and Poverty* in 1881. She wrote a sonnet in tribute to the book entitled "Progress and Poverty," published in *The New York Times* on 2 October 1881. It reveals an unmistakable sympathy for socialism and a plea for an end to exploitation. She claimed that her own social work among Russian-Jewish immigrants to New York in the 1880s was inspired by George. George espoused liberal immigration laws, but not for the reason the railway magnates and industrialists of the American Committee recruited immigrant labor. Depew's inaugural address made it quite clear that manufacturers wanted workers from abroad only if they played the capitalist game: "The rays from this beacon, lighting this gateway to the continent, will welcome the poor and the persecuted with the hope and promise of homes and citizenship. It will teach them that there is room and brotherhood for all who will support our institutions and aid in our development, but that those who come to disturb our peace and dethrone our laws are aliens and enemies forever."[40] Amidst the high-flown language and inflated rhetoric connected with the shrine, we have forgotten the price of admission charged to those who crossed the threshold of the "golden door."

The hundredth anniversary of the unveiling of the *Statue of Liberty*—celebrated nearly four months prematurely to make the "second coming" coincide with Independence Day—came off as expected as an extravagant pageant oozing commercial manipulation and political hype.[41] The hoopla ranged from the TV spectacular (costing ABC ten million dollars for exclusive rights) and corporate sponsorships to the Liberty hula-hoops and the predictable rhetoric of Presidents Ronald Reagan and François Mitterand.

The corporate commercialization and political manipulation seemed to some like a desecration of a great patriotic symbol. Yet it simply restated in contemporary terms the history of the statue when it was designed for conservative political goals and narrow business interests, not the lofty ideals held by defenders of "your tired, your poor, your huddled masses yearning to be free." A group of French businessmen chartered a replica of a De Witt Clinton steamboat for the torch lighting, with the excursion costing 625 dollars including dinner and pastries prepared by four Parisian chefs. Reagan's opening speech declared that, "We are the keepers of the flame of liberty," presumably referring to the corporate sponsors, the elite party of celebrities who paid five thousand dollars a ticket, and the captains of the thirty thousand pleasure boats, luxury liners, and yachts—surely a mocking spectacle of the course taken by immigrants a century ago.

The four-day Liberty Weekend extravaganza (3–6 July 1986) attempted to muster an epic display of national pride and contentment. But it had the characteristic stamp of a private entertainment for the super-rich and famous, a celebration of opulence and wealth. The contradiction between reality and the rhetoric about freedom for all was exposed by the discriminatory practice of the U.S. Immigration and Naturalization Service which welcomed far more political refugees from Communist regimes than from right-wing Central American countries. The current efforts to stop the flow of illegal immigrants from Latin America meant that victims of oppression were jailed and had to face deportation to their homelands where their probable fate would be torture or worse. The same day of the opening ceremonies thirty-two Nicaraguan men, women, and children were murdered by American-backed contras. The next day as Reagan beheld the spectacle of the great *Statue of Liberty* flotilla he could say that the vessels "embody our conception of liberty itself, to have before one no impediments, only open spaces." And Mitterand, president of France, made his contribution to the gargantuan distortion by declaiming in French: "One hundred years ago, thousands upon thousands of the sons and daughters of France presented the United States of America with this *Statue of Liberty,* today the symbol of our common values."

Surely Mitterand, titular head of the French socialist party, was aware of the corporate takeover of the most widely recognized symbol of the United States. When Lee Iacocca—the chair of the Statue of Liberty-Ellis Island Foundation—kicked off the fund-raising drive in June 1983, thirteen corporate giants

signed up as founding or corporate sponsors.[42] They included Coca-Cola (which owns an original zinc model of the statue by Bartholdi), Chrysler (which marketed a high-technology car called "The Liberty"), Nestle, Avon, Time Inc., Kellogg's, Oscar Mayer, American Airlines, and *USA Today*. Each of these corporations was given the exclusive right to use the statue in its advertisements and promotions. Such corporate commercialization and profiteering, capped by the Fourth of July weekend spectacle, recapitulated in a postmodernist idiom the early history of the *Statue of Liberty* when it was associated with World's Fairs and imperialist ventures. Then, as now, those who controlled the power to stage gigantic shows and exploit patriotic nationalism understood "liberty" to mean something quite particular to them.

<div style="float:left">Notes</div>

Chapter I. Introduction

1. In this my approach differs from the recent publication of the late H. W. Janson, *19th-Century Sculpture* (New York: Abrams, 1985). Janson's book is nevertheless an indispensable general guide to the sculpture of the last century. See also *La sculpture française au XIXe siècle*, ed. A. Pingeot (Paris: Editions de la Réunion des musées nationaux, 1986).

2. A. M. Wagner, "Learning to Sculpt in the Nineteenth Century: An Introduction," in *The Romantics to Rodin*, ed. P. Fusco and H. W. Janson (Los Angeles: Los Angeles County Museum of Art, 1980), 9.

3. J. de Caso, "Serial Sculpture in Nineteenth-Century France," in *Metamorphoses in Nineteenth-Century Sculpture*, ed. J. L. Wasserman (Cambridge: Harvard Univ. Press, 1975), 8–9.

4. L. de Fourcaud, *François Rude, sculpteur, ses oeuvres et son temps (1784–1855)* (Paris: Librairie de l'art ancien et moderne, 1904), 177ff., 347.

5. J. Lethève, *Daily Life of French Artists in the Nineteenth Century* (New York: Praeger, 1972), 150.

6. Lethève, *Daily Life*, 140; A. Etex, *J. Pradier, étude sur sa vie et ses ouvrages* (Paris, 1859).

7. P. Dupré and G. Ollendorff, *Traité de l'administration des Beaux-Arts*, 2 vols. (Paris, 1885), 2:216. This is essentially a restatement of the traditional official line: See P.J.B.P. Chaussard, *Le Pausanias français* (Paris, 1806):475.

8. "La Suisse accueillant l'armée française. Groupe de M. Falguière," *L'Illustration* 66 (4 September 1875): 160.

9. M. Agulhon, "La 'statuomanie' et l'histoire," *Ethnologie française* 7–8 (1977–78): 145–72.

10. For an excellent series on this monument at the time of its reconstruction during the early years of the Third Republic, see J. Dementhe, "Histoire de la Colonne," *L'Illustration* 162 (16, 23, 30 August, 6, 13 September 1873): 115, 118, 134–135, 150–151, 163, 166–167, 178–179. See also G. Castagnary, *Gustave Courbet et la colonne vendôme, plaidoyer pour un ami mort* (Paris, 1883), 8, 18, 35.

11. "Ministère du Commerce et des Travaux Publics," *Le Moniteur Universel*, 15 April 1831; "Salon de 1831," *L'Artiste* 1 (1831): 234. Three years later, however, the radical Thoré could appreciate this historical version of Napoleon. See his "L'art social et progressif," *L'Artiste* 7 (1834): 40.

12. H. Jouin, *David d'Angers, sa vie, son oeuvre, ses écrits et ses contemporains*, 2 vols. (Paris, 1878), 2:309.

13. Agulhon, 'La 'statuomanie,' " 147ff.

14. Agulhon, 'La 'statuomanie,' " 158; Agulhon, "Imagerie civique et décor urbain dans la France du XIXe siècle," *Ethnologie française* 5–6 (1975–76): 36.

15. G. Eyriès, *Simart, statuaire, membre de l'Institut* (Paris, n.d.): 34ff.

16. M. J. Mavidal and M. L. Laurent, eds., *Archives parlementaires de 1787 à 1860*, 47 vols. (Paris, 1867–96), 16:374; S. J. Idzerda, "Iconoclasm During the French Revolution," *American Historical Review* 60 (1954–55): 15–16.

Chapter II. The Restoration

1. Agulhon, "Imagerie civique," 153.

2. See J. Vilain's entry on Guérin's "Portrait of Henri de La Rochejaquelein" in *French Painting 1774–1830: The Age of Revolution* (Detroit: Réunion des Musées Nationaux, the Detroit Institute of Arts and the Metropolitan Museum of Art, 1975), 479–81; E. F. A. M. Miel, *Essai sur les beaux-arts, et particulièrement sur le Salon de 1817* (Paris, 1817), 316–18, 388–90. Ronald had evidently formulated the idea for the commission, but David d'Angers exaggerated the movement in his version.

3. Jouin, *David d'Angers* 2:148ff.

4. Jouin, *David d'Angers* 2:171ff., 344ff.

5. V. W. Beach, *Charles X of France: His Life and Times* (Boulder: Pruett Pub. Co., 1971), 232, 272–73; J. Lucas-Dubreton, *The Restoration and the July Monarchy* (London: W. Heinemann Ltd., 1929), 117–18.

6. Jouin, *David d'Angers* 1:478ff., 594.

Chapter III. The July Monarchy

1. For the Pantheon commission see Jouin, *David d'Angers* 1:322ff.; G. Planche, "Le fronton du Panthéon," *Revue des deux mondes*, 4e sér., 11 (1837): 410–34. For a recent and excellent discussion of the commission see N. McWilliam, "David d'Angers and the Panthéon Commission: Politics and Public Works under the July Monarchy," *Art History* 5 (1982): 426–46.

2. Planche, "Le fronton du Panthéon," 428.

3. Planche, "Le fronton du Panthéon," 415.

4. Jouin, *David d'Angers* 2:3–4, 8–9, 32, 74, 372. Of course, he did not always practice what he preached, but this is what he believed and represents his "ideal."

5. M. Rheims, *La sculpture au XIXe siècle* (Paris: Arts et métiers graphiques, 1972), 8, 41, 195.

6. L. Blanc, *History of Ten Years, 1830–1840,* 2 vols. (London, 1844–45), 1:508ff.

7. Blanc, *History of Ten Years* 2:153.

8. T. Gautier, *Histoire du romantisme* (Paris, 1874), 16–17, 30, 180.

9. Beach, *Charles X*, 308.

10. Blanc, *The History of Ten Years* 2:288, 474; H. d'Ideville, *Memoirs of Marshal Bugeaud,* 2 vols. (London, 1884), 1:202, hereafter cited as Bugeaud, *Memoirs; Catalogue du Salon de 1831,* 172, no. 2215.

11. J. Michelet, *La sorcière,* ed. P. Viallaneix (Paris: E. Flammarion, 1966), 284.

12. J. Janin, *Catalogue du cabinet de feu M. J. Feuchère, statuaire* (Paris, 1853), 16; P. Fusco's entry in *The Romantics to Rodin,* 266ff.

13. See A. Klumpke, *Rosa Bonheur, sa vie, son oeuvre* (Paris: E. Flammarion, 1908), 159–60.

14. Lucas-Dubreton, *Restoration,* 175.

15. Janin, *Catalogue,* 11–12.

16. De Fourcaud, *Rude,* 165–66.

17. Lucas-Dubreton, *Le culte de Napoléon 1815–1848* (Paris: A. Michel, 1960), 271ff., 281, 308–9; D. H. Pinkney, *The French Revolution of 1830* (Princeton, N.J.: Princeton Univ. Press, 1972), 50ff., 143–44. In celebration of the July Days in 1833 the town of Ceret inaugurated a column on the pedestal of which was placed a bust of Louis-Philippe and on the summit a bust of Napoleon. This celebration coincided with the inauguration of Seurre's statue of Napoleon on the Vendôme Column. In Paris the prefect de Seine, addressing a crowd in commemoration of the July Days, emphasized that the inauguration of Napoleon's statue "is not only a reparation in behalf of the memory of he who harnessed anarchy, endowed France with law, order, equality and power, but it also signifies the restoration of the glory of our country." See "Intérieur," *Le Moniteur Universel,* 5, 12 August 1833. See also M. P. Driskel, "Eclecticism and Ideology in the July Monarchy: Jules-Claude Ziégler's Vision of Christianity at the Madeleine," *Arts Magazine* 56 (May 1982): 121ff.

18. See R. Butler, "Long Live the Revolution, the Republic, and Especially the Emperor!: The Political Sculpture of Rude," in *Art and Architecture in the Service of Politics,* ed. H. Millon and L. Nochlin (Cambridge, Mass. and London: MIT Press, 1978), 96. See also "Intérieur," *Le Moniteur Universel,* 19 September 1833, which claims that the new program offers "a résumé of our military history from 1791 to 1815." This article further provides a rare glimpse of the definitive program in its initial stages subsequent to the rejection of the concept of four trophies for the four pillars. The new program is considered a type of national chronicle under allegorical guise. Rude's project would have made allusion to the arming of France at the outset of the Revolution; a warrior leaps onto his kneeling horse, accompanied by a foot-soldier, and overhead the Genius of War calls the people to combat. While this concept remained virtually unchanged except for the horse, it would have complemented another unrealized sketch for the arch by Rude entitled *Retreat from Russia* showing the ironic fate of the Men of 1792: here the horse is grounded and the cavalier is wounded. (See Butler, "Long Live the Revolution," 97.) Cortot's project was then called "Conquest" and showed a warrior crowned with palm branches striding the globe and

surrounded with eagles and genii of fame flying overhead. Etex's two commissions were "The Campaign of France," exemplifying the resistance of the country to the allies through its wounded soldiers protecting their homes and sustained by the Genius of France, and "Peace," represented by the union of the allegories of Commerce, Agriculture, the Arts, and Liberty under the aegis of Minerva. It is likely that the final changes on the project made between 1833 and its inauguration were dictated by Thiers.

19. T. E. B. Howarth, *Citizen-King: The Life of Louis-Philippe, King of the French* (London: Eyre & Spottiswoode, 1961), 215, 216.

20. A. Boime, "The Quasi-Open Competitions of the Quasi-Legitimate July Monarchy," *Art Magazine* 59 (April 1985): 94–105.

21. De Fourcaud, *Rude,* 178. De Fourcaud somewhat naively expresses disappointment to find his republican hero demonstrating zeal for a government "contrary to his faith."

22. De Fourcaud, *Rude,* 220.

23. See A. Etex, *Les souvenirs d'un artiste* (Paris, 1878), 192ff., 207ff.

24. Etex, *Souvenirs,* 210.

25. Etex, *Souvenirs,* 65ff., 71ff., 74–75, 93, 94ff., 118ff., 124ff.; P.-E. Mangeant, "Antoine Etex, peintre, sculpteur et architecte 1808–1888," *Réunion des Sociétés des Beaux-Arts des départements* 18 (1894): 1366–67.

26. Jean Reynaud's review of 1833 Salon quoted in P. Petroz, *L'art et la critique en France depuis 1822* (Paris, 1875), 264–65.

27. Petroz, *Art et la critique,* 265; Maxime du Camp quoted in P. Larousse, article "Cain," *Grand dictionnaire universel du XIXe siècle,* 17 vols. (Paris, 1866–90), 3:86.

28. Etex, *Souvenirs,* 245.

29. Etex, *Souvenirs,* 215, 317; Etex's dossier "Statue: Nyssia," letter to minister, 12 May 1851, Archives Nationales F^{21} 28, Paris.

30. For Préault see J. Locquin, "Un grand statuaire romantique, Auguste Préault 1809–79," *La renaissance de l'art français et des industries de luxe,* November 1920, 454–63; C. W. Millard III, "Antoine-Augustin Préault," in *Romantics to Rodin,* 323ff.; D. Mower, "Antoine-Augustin Préault (1809–1879)," *Art Bulletin* 63 (June 1981): 288–307.

31. See P.-J. David d'Angers, *Souvenirs de David d'Angers sur ses contemporains,* ed. L. Cerf (Paris: Renaissance du Livre, 1928), 189; Jouin, *David d'Angers* 2:431, 440. David recommended Préault to the president of the Committee for the Monument of Marceau, as an artist well qualified "to understand the character of the republican hero."

32. Petroz, *Art et la critique,* 266–67. As in his reading of Etex's *Cain,* the Saint-Simonist critic and philosopher Jean Reynaud interpreted *Mendicity* in terms of class oppression and social injustice.

33. V. Fournel, *Les artistes français contemporains* (Tours, 1885), 288; J. Claretie, *Peintres & sculpteurs contemporains,* 2 vols. (Paris, 1882–84), 1:292 (here the author confuses the sculptor with the painter "Corot"). See also Mower, "Préault," 292.

34. For a recapitulation of these events see Blanc, *History of Ten Years* 2:57, 61, 157, 175ff., 179, 230–31, 239, 248–49; Howarth, *Citizen-King,* 216ff.

35. F. Pillet, "Salon de 1834 (6e article)," *Le Moniteur Universel,* 7 April 1834; "Chambre des députés," *Le Moniteur Universel,* 8 January 1834.

36. For this and other pertinent information on the insurrections in Lyon see R. J. Bezucha, *The Lyon Uprising of 1834: Social and Political Conflict in the Early July Monarchy* (Cambridge, Mass.: Harvard Univ. Press, 1974), 122ff., 134ff.

37. Blanc, *History of Ten Years* 2:276ff.; Bugeaud, *Memoirs* 1:195ff. Bugeaud, who as the chief officer in charge of the National Guard was blamed for Rue Transnonain, disclaimed all connections with the incident. Rather, the responsibility lay with Thiers who ordered the swift and thorough suppression of the 1834 uprising. The official newspaper naturally tried to cover up the event. See "Intérieur," *Le Moniteur Universel,* 26 April 1834.

38. *Catalogue du Salon de 1834,* 1, 193, no. 2124. The brief catalogue description—hinting that the work was a fragment from a large frieze—probably was a subterfuge to make the violence more palatable to the jury.

39. Reproduced in A. Dayot, *Histoire contemporaine par l'image d'après les documents du temps 1789–1872* (Paris, n.d.), 228. See also the caption under Daumier's lithograph (p. 226) for another summary of the events leading to the tragedy. Préault exhibited his bronze version of *Tuerie* at the Salon of 1850–51 when such works as Meissonier's *Souvenir du guerre civile* recalled the insurrection of June 1848.

40. Chesneau quoted in Claretie, *Peintres,* 293; T. Silvestre, *Les artistes français,* 2 vols. (Paris: Les éditions Crès et Cie, 1926), 1:167 ("un nègre hideux et colossal"); Blanc, *History of Ten Years* 1:536 (Blanc refers to the weavers of Lyon as "these slaves of modern times," 543); Etex, *Souvenirs,* 165–66. David d'Angers is still another sculptor who held racist views; despite some works such as *Abolition of Slavery* (1854) which attested to his humanitarian rejection of oppression, he believed that black people possessed only "the power of sensation" and could never be thinkers. See Jouin, *David d'Angers* 2:98.

41. Saint-Marc de Giraudin, "France," *Journal des débats,* 8 December 1831.

42. C. De Kay, *Life and Works of Antoine-Louis Barye, Sculptor* (New York, 1889), 32.

43. "Variétés," *L'artiste* 8 (1834):12; Petroz, *Art et la critique,* 282–83; De Fourcaud, *Rude,* 212; on the obelisk see W. Kemp, "Der Obelisk auf der Place de la Concorde," *Kritische Berichte* 7, no. 2/3 (1979): 20; obelisk reproduced in C. Simond, *Paris de 1800 à 1900,* vol. 2, 1830–1870 (Paris: Plon-Nourrit et Cie, 1900), 116. The caption read "Obélisque de Luxe-Nez."

44. All contemporary studies of Barye must begin with the work of Glenn F. Benge who first made the political connection between *Lion Crushing a Serpent* and the July Days. Professor Benge's interpretation was based on the documentation of its successor, the *Lion of the Zodiac* for the July Column. He generously provided me with his documentation and pictorial sources (most notably Flaxman's illustration for *The Paradise,* Canto XVI) which he eventually published as part of his monograph on Barye. See his "Lion Crushing a Serpent," in *Sculpture of a City: Philadelphia's Treasures in Bronze and Stone* (New York: Walker Pub. Co., 1976), 33; Benge, "Antoine-Louis Barye (1796–1875)," in *Metamorphoses in Nineteenth-Century Sculpture,* ed. J. L. Wasserman (Cambridge: Harvard Univ. Press, Fogg Art Museum, 1975), 89; Benge, *Antoine-Louis Barye, Sculptor of Romantic Realism* (University Park and London: The Pennsylvania State Univ. Press, 1985), 34–35.

45. See document dated 29 December 1836, letter from Gaulle to Director of Public Buildings and Monuments, Archives Nationales, F¹³ 1244, Paris.

46. Bezucha, *Lyon Uprising,* 48ff., 65ff.

Chapter IV. Revolution and Counterrevolution, 1848–1870

1. A. Boime, "The Second Republic's Contest for the Figure of the Republic," *Art Bulletin* 53 (March 1971): 68.

2. See, for example, "Ecole des Beaux-Arts. Concours pour la figure symbolique de la république française," *L'Illustration* 12 (28 October 1848): 130.

3. G. F., "Décision du jury pour le concours de la république française," *L'Illustration* 12 (27 January 1849): 352; A. J. D., "Exposition des concours pour la statue colossale de la République," *L'Illustration* 12 (13 January 1849): 314. In Feuchère's dossier "Statue: Figure de la République" (Archives Nationales F²¹ 29, Paris), there is a list of the original ten semi-finalists: Barre, Devaulx, Lanno, Roguet, Duret, Feuchère, Soitoux, Diebolt, Allasseur, Jaley. Duret withdrew and Astyanax-Scévola Bosio replaced him in the definitive heat. See S. Lami, *Dictionnaire des sculpteurs de l'école française au dix-neuvième siècle,* 4 vols (Paris: E. Champion, 1914–21), 1:162.

4. J. Lethève, "Une statue malchanceuse 'La République' de Jean-François Soitoux," *Gazette*

des Beaux-Arts 6 (October 1963), 232. Soitoux's *Republic* is yet another case study of the extrinsic politicization of statuary: as late as 1942, during the German occupation, Fascist sympathizers vandalized and damaged this anachronistic allegory.

5. Article "Orléans," *Grand dictionnaire universel* 11:1478.

6. Feuchère's dossier "Statue: La Constitution," F. de Mercey's report to minister, 14 June 1854, Archives Nationales F^{21} 29, Paris.

7. For Simart's participation see Eyriès, *Simart*, 183ff., 199ff., 222ff., 439. Lanno, Ottin, and Petit collaborated in the execution of the bas-reliefs.

8. *Tombeau de Napoléon Ier érigé dans le dôme des Invalides, par M. Visconti, Architecte de S. M. l'Empereur* (Paris, 1853), 15–16.

9. Lucas-Dubreton, *Restoration,* 260ff., 268ff.

10. *Tombeau de Napoléon,* 30–31.

11. J. Vacquier, *A Visit to the Invalides* (Paris: Delagrave, 1927), 68–69.

12. *Tombeau de Napoléon,* 106–107.

13. Eyriès, *Simart,* 234.

14. Eyriès, *Simart,* 238.

15. De Fourcaud, *Rude,* 289–307. See also J. Vachet's undated pamphlet *Le réveil de Napoléon,* published by the Musée Noisot, Fixin.

16. Cited in De Fourcaud, *Rude,* 294.

17. J. de Biez, *E. Frémiet* (Paris: Jouve & Cie, 1910), v–vi.

18. A. Segard, *Albert Carrier-Belleuse 1824–1887* (Paris: Librairie Ollendorff, 1928), 23; J. E. Hargrove, *The Life and Work of Albert Carrier-Belleuse* (New York and London: Garland Pub., 1977), 55ff., 105–6.

19. H. Saalman, *Haussmann: Paris Transformed* (New York: George Braziller, 1971), 16.

20. A. Etex, *Beaux-Arts. Cours public fait à l'association polytechnique pour les élèves des écoles et pour les ouvriers* (Paris, 1861); Etex, *Cours élémentaire de dessin* (Paris, 1853); Etex, *Cours élémentaire,* 4th ed. (Paris, 1877), vi–vii; A. Ottin, *Esquisse d'une méthode applicable à l'art de la sculpture* (Paris, 1864); Ottin, *Méthode élémentaire du dessin* (Paris, 1868); Ottin, *Rapport sur l'enseignement du dessin à l'exposition universelle de Paris en 1878* (Paris, 1879), 10, 92ff.; T. Labourieu, *Organization du travail artistique en France* (Paris, 1863), iii–iv, 8ff.; E. Guillaume, "Idée générale d'un enseignement du dessin," in *Essais sur la théorie du dessin* (Paris, 1896), 1–91; A. Carrier-Belleuse, *Etudes de figures appliquées à la décoration* (Paris, 1866); A. Alphand, "Notice sur M. le Baron Haussmann," 26 December 1891, *Séance publique annuelle . . . 31 October 1891,* in *L'Institut. Académie des Beaux-Arts* 18 (1887–93): 19–20.

21. See Boime, "The Teaching Reforms of 1863 and the Origins of Modernism in France," *The Art Quarterly,* new ser., 1 (Autumn 1977): 1–39.

22. *Ecole impériale spéciale de dessin . . . Distribution des prix, 17 aout 1867* (Paris, 1868), 10. An intensive campaign was carried on by such government spokespersons as Nieuwerkerke, Houssaye, Chesneau, and Lecoq de Boisbaudran in the period just prior to the Exposition universelle of 1867 to persuade students of industrial design not to desert their specialty for the groves of academe, and this included encouraging the efforts of women. At the distribution of awards ceremony at the Ecole impériale de dessin pour les jeunes filles in 1866, Arsène Houssaye noted that the school's ex-director, Rosa Bonheur, had just become the first woman artist to obtain the Légion d'honneur and elevated her as an example of women's progress in French art. He also observed that "between art and industry there is no misalliance." He emphasized that there were numerous opportunities for women designers, that the great "doors of industry were open to those among you who will have the good sense not to be contemptuous of anything." When he finished his speech Rosa Bonheur made a dramatic entrance, much to the delight of the audience. See "Ecoles impériales de dessin,"

L'Artiste 1 (1866): 268ff.

23. Report of the school's director, Belloc, to Ministre de l'Etat et de la Maison de l'Empereur, 22 December 1859, Archives Nationales F²¹ 643, Paris.

24. For Carrier-Belleuse's links with industry see Segard, *Carrier-Belleuse,* 41–42, 44, 46–47; Hargrove, *Carrier-Belleuse,* chapter 1.

25. First issued in 1866 it was reprinted in 1884 under the title: *Application de la figure humaine à la décoration et à l'ornementation industrielles.*

26. Hargrove, *Carrier-Belleuse,* 236ff. For Rodin's relationship to Carrier-Belleuse see ibid, 239ff.; G. Coquiot, *Renoir* (Paris: A. Michel, 1925), 35–36; H. W. Janson, "Rodin and Carrier-Belleuse: The *Vase des Titans,*" *Art Bulletin* 50 (1968): 278–80. One of their joint projects was published as No. 173 (*Vase des Titans*) in *Application de la figure humaine à la décoration et à l'ornementation industrielles.* For the way in which he simplified his style for decorative commissions see A. Elsen and J. K. T. Varnedoe, *The Drawings of Rodin* (New York: Praeger, 1971), 29 (Figs. 4, 5), 51–53. Rodin's designs for vases are reduced to essential lines, adopting the methods learned at the Ecole de dessin and from Carrier-Belleuse.

27. A. Braunwald and A. M. Wagner, "Jean-Baptiste Carpeaux (1827–1875)," in *Metamorphoses in Nineteenth-Century Sculpture,* 109ff.

28. E. Chesneau, *Le statuaire J.-B Carpeaux, sa vie et son oeuvre* (Paris, 1880), 22 (the author claims that it was Rude himself who suggested the change); L. Clément-Carpeaux, *La vérité sur l'oeuvre et la vie de J.-B. Carpeaux,* 2 vols. (Paris: Dousset et Bigerelle, 1934–35), 1:20–21.

29. Chesneau, *Carpeaux,* 19–21; Clément-Carpeaux, *Vérité sur l'oeuvre* 1:16.

30. A. Mabille de Poncheville, *Carpeaux inconnu ou la tradition recueillie* (Brussels and Paris: G. van Oest, 1921), 58–59. Fourcart was a moderate republican in 1848 and evidently supported the candidacy of Louis-Napoleon in the December election. See also A. M. Wagner, "Art and Property: Carpeaux's Portraits of the Prince Imperial," *Art History* 5 (December 1982): 449. Shortly after the coup d'état, Carpeaux sketched a medallion of the Prince-Napoleon touring France declaiming his 1852 theme: "L'Empire, c'est la Paix."

31. Clément-Carpeaux, *Vérité sur l'oeuvre* 1:41. For a discussion of Tissier's work see Boime, "The Second Empire's Official Realism," in *The European Realist Tradition,* ed. G. Weisberg (Bloomington: Indiana Univ. Press, 1982), 52, 85.

32. For the zany escapades surrounding the Abd-el-Kader commission see Chesneau, *Carpeaux,* 30ff.; Clément-Carpeaux, *Vérité sur l'oeuvre* 1:34ff.; Mabille de Poncheville, *Carpeaux inconnu,* 109, 114, 119ff.

33. Chesneau, *Carpeaux,* i–ii; Clément-Carpeaux, *Vérité sur l'oeuvre* 1:43; Mabille de Poncheville, *Carpeaux inconnu,* 129.

34. Clément-Carpeaux, *Vérité sur l'oeuvre* 1:48.

35. Chesneau, *Carpeaux,* 69ff.; Clément-Carpeaux, *Vérité sur l'oeuvre* 1:78–139; G. Varenne, "Carpeaux à l'Ecole de Rome et la génèse d'Ugolin," *Mercure de France,* February 1908, 579ff.; A. Wagner introduction and entries in *Romantics to Rodin,* 144, 146–48.

36. For the insurrection, which broke out at Trélazé, and the Marianne see the following: "Faits divers," *La Presse,* 2 September 1855; "Tribunal de police. Correctionnelle d'Angers. Affaire dite des carrières," *Le Constitutionnel,* 23 September 1855; F. Attibert, *Quatre ans à Cayenne,* ed. L. Watteau (Brussels, 1859), xxv, 5ff.; H. Chabanne, *Evasion de l'Ile du Diable (Guyane française)* (Paris, 1862); Chabanne, *Guerre à l'ignorance* (Pouilly-sur-Loire [Nièvre], 1867); F. Rémi, *La Marianne dans les campagnes* (Auxerre, 1881), 53; F. Simon, *La Marianne, société secrète au pays d'Anjou* (Angers: Impr. Angevine, 1939), 41, 46, 49ff., 79ff., 83ff., 101ff., 118; J. Maitron, *Dictionnaire biographique du mouvement ouvrier français,* 3 vols. (Paris: Editions ouvrières, 1964–66), 1:116–17, 166–67, 2:372–73, 3:277, 396;

M. Agulhon, *Marianne in Battle: Republican Imagery and Symbolism in France, 1789–1880,* trans. J. Lloyd (Cambridge: Cambridge Univ. Press, 1981), 126–28. For an arch-conservative view of the Marianne see the anonymously published *La Marianne, ou la jacquerie de toutes les époques* (Paris, 1856). For a general study of Louis Napoleon's political police methods see H. C. Payne, *The Police State of Louis Napoleon Bonaparte* (Seattle: Univ. of Washington Press, 1966).

37. A. Wagner, *Jean-Baptiste Carpeaux* (New Haven and London: Yale Univ. Press, 1986), 159–60.

38. Chesneau, *Carpeaux,* 90. Carpeaux feared revolution, loathed the Commune, and was a thoroughly convinced Bonapartist. His style and content derive from the contradictions of the regime, which comprised both modernist and archaic features, imperialist and liberal institutions, industrialist and agrarian economies. See ibid., 209; Clément-Carpeaux, *Vérité sur l'oeuvre* 1:320, 328.

39. Charles Cordier (1827–1905) had the intention of visiting Algeria to sketch racial types that he thought were on the verge of extinction, but the government awarded him a stipend to reproduce "the different types of the native human race." His twelve busts were exhibited in the Salon of 1857 (nos. 2808–19) as comprising "part of a gallery devoted to Algerian types." See A. Pingeot entry in Philadelphia Museum of Art, *The Second Empire 1852–1870: Art in France under Napoleon III* (Philadelphia: Philadelphia Museum of Art, 1978), 225.

40. Chesneau, *Carpeaux,* 122ff.; Clément-Carpeaux, *Vérité sur l'oeuvre* 1:348ff.

41. P. Vitry, *Carpeaux* (Paris: Librairie Centrale des Beaux-Arts, 1911), 94; Clément-Carpeaux, *Vérité sur l'oeuvre,* 354; E. Roy, "Salon de 1869," *L'Artiste,* sér. 8, 2 (1869): 88–93.

42. Roy, "Salon de 1869," 92.

43. Wagner, *Carpeaux,* 216.

44. G. T. Grimm, "Les iconoclastes au nouvel Opéra," *Le Petit Journal,* 29 August 1869. For the relationship of the government to this newspaper see D. I. Kulstein, *Napoleon III and the Working Class* (Sacramento: The California State Colleges, 1969), 52–53.

45. G. Lafenestre, "Les sculptures décoratives," *Le Moniteur Universel,* 8 August 1869; Wagner, *Carpeaux,* 238.

46. G. B. Dijkstra, *Idols of Perversity* (New York: Oxford Univ. Press, 1986), 249.

47. G. Lecomte, *La vie héroique et glorieuse de Carpeaux* (Paris: Librairie Plon, 1928), 207.

48. F. C. Blanc, "Variétés. Les grandes sculptures du nouvel Opéra," *Le Temps,* 10 August 1869.

49. F. Dupanloup, *La souveraineté pontificale selon le droit catholique et le droit européen* (Paris, 1860); Dupanloup, *Seconde lettre de Mgr l'évêque d'Orléans à un catholique sur le démembrement dont les Etats pontificaux sont menacés* (Paris, 1860); Dupanloup, *La convention du 15 Septembre et l'encyclique du 8 Decembre* (Paris, 1865), 20, 49, 100ff.; Dupanloup, *La question romaine* (Paris, 1867); C. S. Phillips, *The Church in France, 1848–1907* (New York: Russell & Russell, 1967), 91ff. The literature often depicts Dupanloup as a liberal, referring to his stand on some doctrinal issues, but he was a social and political reactionary. See C. Marcilhacy, *Le diocèse d'Orléans sous l'épiscopat de Mgr Dupanloup 1849–78* (Paris: Plon, 1962), 20, 29, 433ff., 466, 469.

50. Clément-Carpeaux, *Vérité sur l'oeuvre* 1:283. Dupanloup cursed the empire after its fall: "Quelle décadence de Bas-Empire." Dupanloup's hysterical book, *L'athéisme et le péril social* (Paris, 1866), 156, 186, claims that atheism goes hand-in-hand with socialism and blames the emperor for betraying his promises to the Church over Italy.

Chapter V. The Third Republic

1. Phillips, *Church in France,* 172ff.

2. Phillips, *Church in France,* 173–75; M. Vallet, *Apropos d'un centenaire: Louis Veuillot 1813–1913* (Paris: Société française d'imprimerie et de librairie, 1913), 142ff.

3. Marcilhacy, *Diocèse d'Orléans,* 472ff.

4. L. Veuillot, "Projet d'un statue de Jeanne d'Arc," in *Mélanges,* 21 vols. (Paris, 1856–76), 17 (1870–71): 80–82; G. A. Sala, *Paris Herself Again in 1878–79* (London, 1882), 143, 298–99. The English critic Sala, discussing the various cranks that plagued the newspaper offices of *Le Figaro,* noted that since the collapse of the comte de Chambord's candidature "nothing has been heard of the lady who declares she is Joan of Arc." While Joan of Arc is an enduring hero throughout the nineteenth century, it is interesting to note that her greatest moments come during the Bourbon Restoration and the conservative early Third Republic. See N. Ziff, "Jeanne d'Arc and French Restoration Art," *Gazette des Beaux-Arts,* 6e pér., 93 (1979): 37ff.; A. Pingeot, *Images de Jeanne d'Arc* (Paris: Hôtel de la Monnaie, 1979), 187, 228, no. 165. In Alfred Caravanniez's monument to the comte de Chambord at Sainte-Anne d'Auray, statues of Joan of Arc, Sainte-Geneviève, du Guesclin, and Bayard support the Great Pretender.

5. V. de Laparade, "A Jeanne d'Arc," *Le Correspondant* 94 (1874): 1309–15.

6. Closely affiliated with the House of Orléans, Dupanloup used a vignette of the celebrated statue of Joan of Arc by Marie d'Orléans (daughter of Louis-Philippe) for the cover of several of his pamphlets. See for example his *Second panégyrique de Jeanne d'Arc, prononcé dans la Cathédrale de Saint-Croix le mai 1869* (Paris, 1869).

7. A.-P.-F. de Falloux, *L'évêque d'Orléans* (Paris, 1879), 181ff.; E. Veuillot, *Louis Veuillot,* 4 vols. (Paris, 1904), 4:791; Dupanloup, *Premières lettres à MM. les membres du conseil municipal de Paris sur le centenaire de Voltaire* (Paris, 1878); R. Sanson, "La 'fête de Jeanne d'Arc' en 1894, controverse et célébration," *Revue d'histoire moderne et contemporaine* 20 (1973): 445–46; A Guillemin, *Jeanne d'Arc: l'épée de Dieu* (Paris, 1875) i, viff.

8. R. Remond, *The Right Wing in France from 1815 to de Gaulle* (Philadelphia: Univ. of Pennsylvania Press, 1966), 249–50n. Numerous women of the aristocracy followed suit. See Sanson, "La 'fête de Jeanne d'Arc,' " and "Le centenaire de Voltaire," *Le monde illustré,* 8 June 1878, 367.

9. De Biez, *Frémiet,* 104, 133ff.; H. W. Janson entry in *Romantics to Rodin,* 272–74. Curiously, Carpeaux himself began making sketches of Joan of Arc in this same period. See Clément-Carpeaux, *Vérité sur l'oeuvre* 2:335.

10. De Biez, *Frémiet,* 142; P. L., "La statue de Jeanne d'Arc," *L'Illustration* 63 (28 February 1874): 132. Dupanloup also numbered among those lamenting the loss of territory; see his *Lettre de Mgr l'évêque d'Orléans au clergé de son diocèse, relative à la souscription nationale pour la libération du territoire* (Paris, 1872).

11. For the Orléans scandal see Marcilhacy, *Diocèse d'Orléans,* 490ff.; Veuillot, *Louis Veuillot,* 495ff.; Dupanloup, *Lettre de Mgr l'évêque d'Orléans au rédacteur en chef de 'l'Univers,' sur le scandale d'Orléans* (Paris, 1874).

12. De Biez, *Frémiet,* 68.

13. Nieuwerkerke, however, loved it and made a special place for it in the Palais de l'Industrie. See de Biez, *Frémiet,* 64–65.

14. De Biez, *Frémiet,* 64–65; M. Dubois and A. Terrier, *Les colonies français* (Paris: Augustin Challamel, 1902), 602ff.; J.-L. de Lanessan, *L'expansion coloniale de la France* (Paris, 1886), 273–74. While it was Jules Ferry, the republican, who became the "apostle" of French colonial expansion, the aristocratic view of the superiority of the races was enunciated by Ernest Renan following the Franco-Prussian War: "A nation that does not colonize will irrevocably be a prey to socialism, to the war between rich and poor. The conquest of a country of an inferior race by a superior race . . . is not in the least shocking. . . . Nature has made a race of workers; that is, the Chinese . . . a race of tillers of the soil, the Negro . . . a race of masters and soldiers, the European race." See E. Renan, *Pages françaises* (Paris: C. Levy, 1921), 199–200. For Ferry's similiar remarks see Dubois and Terrier, *Les Colonies français,* 405.

15. P. Fauré-Frémiet, *Frémiet* (Paris: Librairie Plon, 1934), 101, 132.

16. E. Drumont, *La France juive,* 2 vols. (Paris, 1886), one of the best-selling and most widely

read books in nineteenth-century France; Drumont, *De l'or, de la boue, du sang* (1892; Paris, 1896), 38–39.

17. Drumont, *La France juive,* 19th ed., 2 vols. (Paris, n.d.), 1:9, 11, 16, 427; Drumont, *Le testament d'un antisémite* (Paris, 1891), 435. Drumont's family had been monarchist, and he grew up admiring La Rochejacquelein, the Celtic hero of the Vendée. See Drumont, *La dernière bataille* (Paris, 1890), 231. Many anti-Semitic cartoons of the 1890s depicted confrontations between a saint or republican allegory and a dragon; see J. Grand-Carteret, *L'affaire & l'image* (Paris, 1899), 4, 150.

18. Drumont, *Dernière bataille,* viii; *Testament d'un antisémite,* 311, 371, 435; Drumont, *France juive* 1:427, 470, 2:175, 281n; Drumont, *Le secret de Fourmies* (Paris, 1892), 150–151; Drumont, *Les héros et les pitres* (Paris: E. Flammarion, 1900), 161ff.; Taxil quoted in Drumont, *Testament d'un antisémite,* 406–8; "La libération du territoire," *L'Illustration* 62 (27 September 1873): 214ff. Drumont quoted this article in *France juive* 1:390–91.

19. "Chez l'usurier, par Juglar," *L'Illustration* 61 (21 June 1873): 431. The battle painter, Edouard Detaille, also manifested the marked increase of anti-Semitism following the Franco-Prussian War in his series of pictures entitled "Nos vainqueurs." See E. Strahan, *Art Treasures of America,* 3 vols. (Philadelphia, 1879–81), 1:34.

20. Dupanloup, *Etude sur la Franc-Maçonnerie,* 4th ed. (Paris, 1875), 6–7, 12, 17, 32–33, 36, 63ff., 76, 78ff.; Drumont, *France juive* 2:175, 281n. Drumont claimed that Freemasonry was run by Jews, and generally Jews and Masons were seen by the Right as the sources of all misfortune and completely intermingled. See Phillips, *Church in France,* 203, 217. Finally, Drumont could note that the cult of Joan of Arc was expressly opposed by Jews and Freemasons (*France juive* 2:175,281n).

21. Fauré-Frémiet, *Frémiet,* 14–15; A. Alagna, *Les juifs dans la société française de la révolution de 1789 à l'affaire Dreyfus* (Naples: Liguori, 1975), Drumont, *Dernière bataille,* viii; Drumont, *La France juive devant l'opinion* (Paris, 1886), 12, 16, 17, 178n, 278n; Drumont, *Secret de Fourmies,* 106; Drumont, *Testament d'un antisémite,* v, viii–ix.

22. De Biez, "E. Frémiet," *L'Artiste,* sér. 9, 4 (1892): 77ff., 192ff., 348ff.; 5 (1893): 36ff.; 6 (1893): 215ff., 255ff., 491ff.; 7–8 (1894): 168ff., 336ff., 419ff.; 9 (1895): 401ff. These articles were assembled and published in book form in 1896. In the 1910 version he confines his virulent prejudice to such remarks as "Frémiet's Saint Louis has the straight nose . . . that is found among certain types with clean hands and judicious mind; these noses smell usurers from a mile away. . . ." (De Biez, *Frémiet* [1910], 187–188.)

23. De Biez, "Frémiet," *L'Artiste,* sér. 9, 8 (November 1894): 354–55, 356; 4 (August 1892): 79; 5 (October 1893): 271.

24. De Biez, *Frémiet,* 64; A. Toussenel, *Les juifs: rois de l'époque* (Paris, 1845); Toussenel, *L'esprit des bêtes. Zoologie passionnelle* (Paris, 1869), 46, 63; Toussenel, *L'esprit des bêtes. Le monde des oiseaux,* 3 vols. (Paris, 1859), 3:241. See also *Romantics to Rodin,* 278–79.

25. Drumont, *Les héros et les pitres,* 259ff., 263.

26. C. W. Lightbody, *The Judgements of Joan* (London: Allen and Unwin, 1961), 21–31, 162ff.; Remond, *Right Wing in France,* 249–50, 260; H. Tint, *The Decline of French Patriotism* (London: Weidenfeld and Nicolson, 1964), 115; M. Warner, *Joan of Arc: The Image of Female Heroism* (New York: Knopf, 1981), 260ff.; Gambetta quoted in C. Lemire, *Jeanne d'Arc et le sentiment nationale* (1891; Paris, 1898), 271, 2ff., 221.

27. Chapu's work was unmistakably based on the ideals of Dupanloup, especially *Second panégyrique,* 16–17.

28. O. Fidière, *Chapu, sa vie et son oeuvre* (Paris, 1894), 73–74, 80, 162, 137ff.

29. Fidière, *Chapu,* 141ff., 253; Guillemin, *Jeanne d'Arc,* 560; on shrine to Joan of Arc, see L'Abbé Sauvage, *Le monument de Jeanne d'Arc à Bonsecours* (Rouen, 1892), 13–14; on Barrias's statue, see entry by M. Busco and P. Fusco, *Romantics to Rodin,* 117–118 (the various categories of Joan's iconography—Joan the warrior, Joan the Pious Peasant, etc.—were

formulated by Dupanloup; Phillips, *Church in France,* 9–10; Sauvage, *Monument de Jeanne d'Arc,* 15; Mgr Thomas, *Discours sur Jeanne d'Arc* (Rouen, 1892), 36–37.

30. C. Judrin, M. Laurent, and D. Viéville, *Auguste Rodin, le monument des bourgeois de Calais* (Calais: Musée des Beaux-Arts, 1977); M. J. McNamara and A. Elsen, *Rodin's Burghers of Calais* (n.p.: Cantor, Fitzgerald Group, 1977); R. Butler's entry in *Romantics to Rodin,* 339–40.

31. J. L. Tancock, *The Sculpture of Auguste Rodin* (Philadelphia: D. R. Godine, Philadelphia Museum of Art, 1976), 392n. 8; Anon., *Livre d'or des bourgeois de Calais, 1347–1895* (Calais, 1895), 73, 86–87, 109–10, 122, 139ff.

32. A. M. Ludovici, *Personal Reminiscences of Auguste Rodin* (Philadelphia: J. B. Lippincott, 1926), 75, 80; F. Lawton, *The Life and Work of Auguste Rodin* (London: T. Fisher Unwin, 1906), 285–86; V. Frisch and J. T. Shipley, *Auguste Rodin* (New York: Frederick A. Stokes, 1939), 240ff., 250; A. Rodin, *Cathedrals of France,* trans. E. C. Geissbuhler (Boston: Beacon Press, 1965), vii, 9, 19–20, 36, 74, 77, 136–37.

33. Frisch and Shipley, *Rodin,* 136ff., 141. According to Frisch, Baron Alphonse de Rothschild, one of the owners of the weekly journal *L'Art,* was concerned about Rodin's difficult financial position and authorized the magazine's director "Gaucher" to subsidize the artist in 1883. The director in turn told Rodin that *L'Art* wanted to present Calais with a bronze statue of Eustache de Saint-Pierre and offered him fifteen thousand francs for the figure. Rodin's reading of Froissart's *Chronicles,* however, required him to represent all six characters involved, and he offered to execute the entire group for the same price. At Rothschild's urging, the Municipal Council of Calais, headed by Mayor Omer Dewavrin, declared itself ready to raise twenty thousand francs to add to the original sum.

 While the account is contradicted in part by other reports and is evidently rejected by major Rodin scholars, there is nevertheless much truth to this assertion. It essentially agrees with two accounts written during Rodin's lifetime by his friend Gustave Coquiot. In *Le vrai Rodin* (3d ed., Paris: J. Tallandier, 1913, 131ff.), Coquiot noted that Rothschild did indeed guarantee the costs of *L'Art* with the pretention of contributing to the course of contemporary art. He did this by organizing within the magazine's bureaucracy a type of foundation for the commissioning of art works. "Gaucher" communicated his boss's desire to Rodin who subsequently altered the commission to include all six burghers. The director then complained ironically that the sculptor was making it difficult for his benefactors to do him a good turn. (The author noted that the account was "scrupulously historical.") Coquiot's later *Rodin à l'hôtel de Biron et à Meudon* (Paris: Librairie Ollendorff, 1917), 104–5 told the story slightly differently but this time claimed it was a verbatim account given by Rodin. Here the director's name is spelled "Gauchez," and he is described as both an art dealer and part owner of *L'Art* who wrote art criticism under the name of "Paul Leroi," among others. This time when Rodin informed his benefactor of his intention to do six figures, the latter laughed derisively and swore never again to attempt to deliver the sculptor from his misery. Actually, the name of the magazine's art director was Leon Gaucherel who under the pseudonym of "Paul Leroi" wrote at least two articles praising the Rothschilds: "Sixième exposition de la société d'acquarellistes français," *L'Art* 36, pt. 1 (1884): 97–98; "Le Baron Alphonse," *L'Art* 64 (1905): 259ff. In his long obituary on Rothschild, Gaucherel-Leroi especially lauded Rothschild's philanthropic donations in the realm of the fine arts.

 There are several other factors that make the story plausible. *L'Art* was one of Rodin's greatest supporters during the period of the commission, consistently defending him against the attacks of hostile critics. In July 1882 it claimed he deserved a Medal of Honor for his bust of Jean-Paul Laurens (T. H. Bartlett, "Auguste Rodin, Sculptor," *The American Architect and Building News* 25 [January–June 1889]: 113), and in 1883 it published several of his sketches for Sèvres projects and the *Gates of Hell,* and could assert that the *St. John the*

Baptist—then exhibited at the annual Salon—was the outstanding piece in the show and deserved a better location. It further defended the controversial *Age of Brass* and praised the official bureaucracy for commissioning the *Gates of Hell* (Dargenty, "Le Salon national," 35, pt. 2 [1883]: 32–38).

Rothschild's association with Gaucherel and *L'Art* is demonstrated by the long obituary cited above. Rothschild also figures in the *Livre d'or des Bourgeois de Calais* (Calais, 1895; published to coincide with the inauguration of the monument and listing the various subscribers) and in the correspondence between Dewavrin and Rodin. Among the subscribers to the monument was the Compagnie du Chemin de fer du Nord (*Livre d'or*, 52), at the head of which was none other than Alphonse de Rothschild. See "Mort du Baron Alphonse de Rothschild," *Le Temps*, 23 May 1905; Fabien, "Alphonse de Rothschild," *Le Figaro*, 27 May 1905; F. Caron, *Histoire de l'exploitation d'un grand réseau* (Paris: Mouton, 1973), 263, 265. Dewavrin noted in a letter to Rodin on 4 October 1892 that in trying to raise still more funds for finalizing and installing the monument he contacted "the President of the Republic, Baron A. de Rottchild [*sic*] . . . Messieurs Osiris and Chauchart [*sic*] who are generous men. . . ." See D. Viéville, "La correspondence de A. Rodin et de O. Dewavrin: une commande de type municipal à la fin du XIXe siècle (1884–1895)," in *Auguste Rodin, le monument des bourgeois de Calais,* 71.

Finally, it should be noted that Rodin was not awarded this municipal commission through a public competition as was common in that period, but through influential friends "in high places." Rodin elsewhere claimed that the painter Jean-Paul Laurens (another favorite of *L'Art*) got him the order; Laurens's pupil, P. Auguste Isaac, of a leading Calaisian family, told the master that Calais needed a monument and Laurens recommended Rodin. Mayor Dewavrin had proposed on 26 September 1884 a monument to Eustache de Saint-Pierre and his fellow burghers to be funded by a national subscription. The following month he delegated Isaac to represent the *comité d'initiative* organized to fund the project; Isaac wrote him on 17 October 1884 that Laurens and others unanimously supported Rodin. In a letter of 25 November 1884 the estimated cost of the monument was raised to thirty-four thousand francs, a sum nearly equalling the original fifteen thousand francs offered by Rothschild and the additional twenty thousand he urged the Municipal Council to add to his offer. Rodin received a first payment of fifteen thousand francs, the original offer of Rothschild as reported by Frisch and Shipley.

34. See J. Bouvier, *Le Krach de l'Union Générale (1878–1885)* (Paris: Presses universitaires de France, 1960). Also Caron, *Histoire de l'exploitation,* 224, 265. During this period, Rothschild's firm, Compagnie du Chemin de fer du Nord, was also plagued by falling profits and a power struggle between the railway companies. Ironically, the Baron James de Rothschild backed out of buying Carpeaux's *Ugolino* because "they will accuse me of having made them all die of hunger" (Clément-Carpeaux, *Vérité sur l'oeuvre* 1:133.)

35. See Agulhon, "Esquisse pour une archéologie de la République: l'allégorie civique feminine," *Annales* 28 (1973): 5ff.; E. Hobsbawm, "Men and Woman in Socialist Iconography," *History Workshop* 6 (Autumn 1978): 121ff.; Agulhon, "On Political Allegory: A Reply to Eric Hobsbawm," *History Workshop* 8 (Autumn 1979): 167ff.; Agulhon, *Marianne into Battle,* 157–59, 162–63.

36. Agulhon, "La 'statuomanie,' " 161.

37. J. Hunisak, "Image of Workers: From Genre Treatment and Heroic Nudity to the Monument of Labor," in *Romantics to Rodin,* 54 ff.; J. A. Schmoll gen. Eisenwerth, "Denkmäler der Arbeit-Entwürfe und Planungen," in H.-E. Mittig and V. Plagemann, eds., *Denkmäler im 19. Jahrhundert* (Munich: Prestel-Verlag, 1972), 253–81; C. Keisch, "Ein Bildhauer Traum um die Jahrhundert Wende: Das Denkmal der Arbeit," *Bildende Kunst* 19 (1972): 187ff.

38. F. Lawton, *François-Auguste Rodin* (New York: M. Kennerley, 1908), 147–48; J. de Caso and P. S. Sanders, *Rodin's Sculpture: A Critical Study of the Spreckels Collection* (San Francisco:

The Fine Arts Museum of San Francisco, 1977), 227ff.; C. From, "Observations on Rodin's *Tower of Labor*" (unpublished M.A. thesis, University of California, Riverside, 1984). A recent study of Rodin's *Tower of Labor* shows a wide discrepancy between the inscription on the Meudon model and the actual reliefs which were sketchily executed. Of the eight scenes which can be identified with any degree of accuracy, at least five depict agricultural laborers, one clearly shows metal workers, and another shows a group of carpenters. The miners and divers emerge paradoxically in the closing scenes of the relief at the top of the tower. But this can be explained by the impossibility of showing the crypt scenes on the model, and while agricultural workers are given prominence in the hastily prepared maquette, it is clear that Rodin's description (which was confirmed by his secretary Rilke) answers to his definitive scheme. See R. Liebenwein-Kramer, "Le Monument au Travail: Rodin's architektonische Utopie," *Jahrbuch der Hamburger Kunstsammlungen* 25 (1980): 124–25. For Leclaire's hierarchical system and tight control over his employees see H.-A. Frégier, *Des classes dangereuses de la population dans les grandes villes,* 2 vols. (Paris, 1840), 1:301–3.

39. "Le monument de Jean Leclaire," *L'Illustration* 108 (7 November 1896): 376; Hunisak, *Image of Workers,* 57.

40. Hunisak, *Image of Workers,* 58–59; Hunisak, *The Sculptor Jules Dalou* (New York and London: Garland, 1977), 229ff.

Excursus on the Statue of Liberty

1. Marvin Trachtenberg's *The Statue of Liberty* (New York: Viking Press, 1976) remains the best single study of the monument. The more recent literature includes P. Provoyeur and J. Hargrove, eds., *Liberty: The French-American Statue in Art and History* (New York: Harper & Row, 1986); M. C. O'Brien, *In Support of Liberty: European Paintings at the 1883 Pedestal Fund Art Loan Association* (Southampton, N.Y.: The Parrish Art Museum, 1986); A. Boime, "Liberty: Inside Story of a Hollow Symbol," *In These Times* 10, no. 27 (11–24 June 1986): 12–13; "La Statue de la liberté: une icône vide," *le débat,* 44 (March/May 1987):126–143. See also H. Pauli and E. B. Ashton, *I Lift My Lamp: The Way of a Symbol* (New York and London: Appleton-Century-Crofts, 1948) for the most extensive political background, and J. Betz, *Bartholdi* (Paris: Editions de Minuit, 1954) for the details of the sculptor's life.

2. "M. Bartholdi Interviewed," *The World,* 20 October 1886.

3. A. Bartholdi, *The Statue of Liberty Enlightening the World* (New York, 1885), 14.

4. E. Laboulaye, *L'état et ses limites,* 3d ed. (Paris, 1865), viii.

5. Laboulaye, *Etat,* 101.

6. J. Bigelow, *Some Recollections of the Late Edouard Laboulaye* (New York, 1889), 1–6.

7. Laboulaye, *Etat,* 367–68.

8. Laboulaye, *Etat,* 391.

9. Betz, *Bartholdi,* 98.

10. "French Visitors Dined," *The New York Times,* 29 October 1886; "Our Distinguished Guests," *The World,* 27 October 1886; "La Statue de la Liberté," *Le Temps,* 9 November 1886.

11. Bartholdi, *The Statue of Liberty,* 11.

12. Laboulaye, *Etat,* 101; Laboulaye on Delacroix, cited in Trachtenberg, *Statue of Liberty,* 68.

13. The best discussion of this is Agulhon, *Marianne into Battle,* 158, 162, 174.

14. I am grateful to Professor Vivien Fryd, Vanderbilt University, for this information. See also R. L. Gale, *Thomas Crawford, American Sculptor* (Pittsburgh: Univ. of Pittsburgh Press, 1964):124, 150, 155–156.

15. Agulhon, *Marianne into Battle,* 173–74.

16. Agulhon, *Marianne into Battle,* 174.

17. "In the Mart of Trade," *The World,* 28 October 1886.

18. Hewitt was one of the U.S. commissioners to the Paris Exposition universelle of 1867 and wrote a report on "The Production of Iron and Steel in its Economic and Social Relations"

for volume 2 of the *Reports of the United States Commissioners to the Paris Universal Exposition of 1867* (Washington, D.C., 1870).

19. Pauli and Ashton, *I Lift My Lamp*, 295–96.

20. Trachtenberg, *Statue of Liberty*, 49–57.

21. Bartholdi, *Statue of Liberty*, 58.

22. See "The Panama Canal," *Harper's Weekly* 30 (1 May 1886): 274. The writer noted that John Bigelow's report on the canal to the New York Chamber of Commerce "will hardly stimulate investments in the canal shares, and M. De Lesseps's sharp strictures upon the report seem to show that he is of that opinion."

23. "A Banquet to De Lesseps," *The World*, 28 October 1886; "Banqueted by Merchants. The French Visitors honored by the Solid Men of New York," *The World*, 29 October 1886.

24. "France's Gift Accepted," *The New York Times*, 29 October 1886.

25. Bartholdi, *Statue of Liberty*, 31.

26. Betz, *Bartholdi*, 217.

27. "France's Gift Accepted."

28. Pauli and Ashton, *I Lift My Lamp*, 271–72.

29. "1888," *Harper's Weekly* 30 (13 March 1886): 162; "An Appeal," *The World*, 13 March 1885. "Now for the People's Gift!" *The World*, 23 March 1885. This was a constant theme in Pulitzer's crusade; see also "3,000 for the Statue," 19 April 1885, and "An Army for the Statue," 20 April 1886.

30. *The New York Times*, 29 October 1886; "Irving Hall for George," *The World*, 20 October 1886. The same day the statue was dedicated, George declared: "It matters little whether a man lives under a monarchy or a republic if he cannot bring up his children in decency. A man is a slave who can't do that, although he may be called a freeman." See "George Still on the Stump," *The World*, 29 October 1886.

31. "Liberty, Equality and Property," *The World*, 15 October 1886.

32. "A Talk with Miss Liberty," *The World*, 31 October 1886; "George in his Carriage," *The World*, 3 November 1886.

33. See H. David, *The History of the Haymarket Affair* (New York: Farrar & Rinehart, 1936); P. Avrich, *The Haymarket Tragedy* (Princeton, N.J.: Princeton Univ. Press, 1984.

34. "Anarchists," 18 April 1885; "Vive la Commune!" 4 April 1885; "The Marseilles Hymn [*sic*]," 21 February 1885, all from *The Alarm*.

35. L. Stein and P. Taft, eds., *The Accused and the Accusers* (New York: Arno, 1969), 90–91; "The Anarchists' Fate," *The New York Times*, 10 October 1886; "The Verdict at Chicago," *Harper's Weekly*, 30 (4 September 1886): 561, 564. The figure is shown only partially and probably represents Columbia, but the colossal proportions suggest that Bartholdi's monument was in Nast's mind.

36. "France's Gift Accepted"; "The Lesson of the Statue," *The World*, 29 October 1886.

37. "Mrs. Parsons in New York," *The World*, 18 October 1886.

38. "The Color Line," *Harper's Weekly* 30 (2 October 1886): 631; R. W. Logan and M. R. Winston, *Dictionary of American Negro Biography* (New York and London: Norton, 1982), 602–3; P. M. Bergman, *The Chronological History of the Negro in America* (New York, 1969), 297.

39. "Liberty Island Crowded," *The World*, 18 October 1886; "They Enter a Protest," *The New York Times*, 29 October 1886.

40. D. Vogel, *Emma Lazarus* (Boston: Twayne Publishers, 1980), 21, 97; "France's Gift Accepted."

41. See "The Statue of Liberty—A Centennial Preview," *The New York Times Magazine*, 2, 18 May 1986.

42. See R. B. Gratz and E. Fettmann, "Iacocca's Golden Door: The Selling of Miss Liberty," *The Nation* 241 (9 November 1985): 465–66, 468–76.

I. Books and Articles on Sculpture and Related Art

Agulhon, M. "Imagerie civique et décor urbain dans la France du XIXe siècle." *Ethnologie française* 5–6 (1975–76): 33–56.

———. *Marianne into Battle: Republican Imagery and Symbolism in France, 1789–1880.* Trans. J. Lloyd. Cambridge: Cambridge University Press, 1981.

———. "La 'statuomanie' et l'histoire." *Ethnologie française* 7–8 (1977–78):145–72.

Attibert, F. *Quatre ans à Cayenne.* Ed. by L. Watteau. Brussels, 1859.

Benge, G. "Antoine-Louis Barye (1796–1875)." In *Metamorphoses in Nineteenth-Century Sculpture.* Ed. by J. L. Wasserman. Cambridge: Harvard University Press, 1975.

———. *Antoine-Louis Barye, Sculptor of Romantic Realism.* University Park and London: The Pennsylvania State University Press, 1984.

Betz, J. *Bartholdi.* Paris: Editions de Minuit, 1954.

de Biez, J. *E. Frémiet.* Paris: Jouve & Cie., 1910.

Boime, A. *The Academy and French Painting in the Nineteenth Century.* New edition. New Haven and London: Yale University Press, 1986.

———. "American Culture and the Revival of the French Academic Tradition." *Arts Magazine* 56, no. 9 (May 1982): 95–101.

———. "Liberty: Inside Story of a Hollow Symbol." *In These Times* 10, no. 27 (11–24 June 1986): 12–13.

———. "The Quasi-Open Competitions of the Quasi-Legitimate July Monarchy." *Arts Magazine* 59 (April 1985): 94–105.

———. "The Second Empire's Official Realism." In *The European Realist Tradition.* edited by G. Weisberg, 31–123. Bloomington: Indiana University Press, 1982.

———. "The Second Republic's Contest for the Figure of the Republic." *Art Bulletin* 53 (March 1971): 63–83.

———. "The Teaching of Fine Arts and the Avant-Garde in France During the Second Half of the Nineteenth Century." *Arts Magazine* 60, no. 4 (December 1985): 46–57.

———. "The Teaching Reforms of 1863 and the Origins of Modernism in France." *The Art Quarterly,* new ser., 1 (Autumn 1977): 1–39.

Butler, R. "Long Live the Revolution, the Republic, and Especially the Emperor!: The Political Sculpture of Rude." *Art and Architecture in the Service of Politics.* Ed. H. Millon and L. Nochlin. Cambridge: MIT Press, 1978.

Carrier-Belleuse, A. *Etudes de figures appliquées à la décoration.* Paris, 1866.

de Caso, J., and P. S. Sanders. *Rodin's Sculpture: A Critical Study of the Spreckels Collection.* San Francisco: The Fine Arts Museum of San Francisco, 1977.

Cerf, L., ed. *Souvenirs de David d'Angers sur ses contemporains.* Paris: Renaissance du Livre, 1928.

Chesneau, E. *Le statuaire J.-B. Carpeaux, sa vie et son oeuvre.* Paris, 1880.

Claretie, J. *Peintres & sculpteurs contemporains.* 2 vols. Paris, 1882–84.

Clément-Carpeaux, L. *La vérité sur l'oeuvre et la vie de J.-B. Carpeaux.* 2 vols. Paris: Dousset et Bigerelle, 1934–35.

Coquiot, G. *Renoir.* Paris: A. Michel, 1925.

———. *Rodin à l'hôtel de Biron et à Meudon.* Paris: Librairie Ollendorff, 1917.

———. *Le vrai Rodin.* 3d ed. Paris: J. Tallandier, 1913.

De Kay, C. *Life and Works of Antoine-Louis Barye, Sculptor.* New York, 1889.

154

Elsen, A., ed. *Rodin Rediscovered*. Washington, D.C.: National Gallery of Art, 1981.

Elsen, A., and J. K. T. Varnedoe, *The Drawings of Rodin*. New York: Praeger, 1971.

Eméric-David, T. B. *Recherches sur l'art statuaire*. Paris, 1805.

Etex, A. *Beaux-Arts. Cours public fait à l'association polytechnique pour les élèves des écoles et pour les ouvriers*. Paris, 1861.

————. *J. Pradier, étude sur sa vie et ses ouvrages*. Paris, 1859.

————. *Les souvenirs d'un artiste*. Paris, 1878.

Eyriès, G. *Simart, statuaire, membre de l'Institut*. Paris, n.d.

Fauré-Frémiet, P. *Frémiet*. Paris: Librairie Plon, 1934.

Fidière, O. *Chapu, sa vie et son oeuvre*. Paris, 1894.

de Fourcaud, L. *François Rude, sculpteur, ses oeuvres et son temps (1784–1855)*. Paris: Librairie de l'art ancien et moderne, 1904.

Fournel, V. *Les artiste français contemporains*. Tours, 1885.

Frisch, V., and J. T. Shipley. *Auguste Rodin*. New York: Frederick A. Stokes, 1939.

Fusco, P., and H. W. Janson, eds. *The Romantics to Rodin*. Los Angeles: Los Angeles County Museum of Art, 1980.

Grand-Carteret, J. *L'affaire & l'image*. Paris, 1899.

Guillaume, E. "Idée générale d'un enseignement du dessin." In *Essais sur la théorie du dessin*, 1–91. Paris, 1896.

Hargrove, J. *The Life and Work of Albert Carrier-Belleuse*. New York: Garland, 1977.

Hunisak, J. M. *The Sculptor Jules Dalou: Studies in his Style and Imagery*. New York: Garland, 1977.

Janin, J. *Catalogue du cabinet de feu M. J. Feuchère, statuaire*. Paris, 1853.

Janson, H. W. *19th-Century Sculpture*. New York: Abrams, 1985.

————. "Rodin and Carrier-Belleuse: The *Vase des Titans*." *Art Bulletin* 50 (1968): 278–80.

Jouin, H. *David d'Angers, sa vie, son oeuvre, ses écrits et ses contemporains*. 2 vols. Paris, 1878.

Judrin, C., M. Laurent, and P. Viéville. *August Rodin, le monument des bourgeois de Calais*. Calais: Musée des Beaux-Arts, 1977.

Keisch, C. "Ein Bildhauer Traum um die Jahrhundert Wende: Das Denkmal der Arbeit." *Bildende Kunst* 19 (1972): 187–93.

Kemp, W. "Der Obelisk auf der Place de la Concorde." *Kritische Berichte* 7, no. 2/3 (1979): 19–29.

Klumpke, A. *Rose Bonheur, sa vie, son oeuvre*. Paris: E. Flammarion, 1908.

Lami, S. *Dictionnaire des sculpteurs de l'école française du XIXe siècle*. 4 vols. Paris: E. Champion, 1914–21.

Lawton, F. *François-August Rodin*. New York: M. Kennerley, 1908.

————. *The Life and Work of Auguste Rodin*. London: T. Fisher Unwin, 1906.

Lethève, J. *Daily Life of French Artists in the Nineteenth Century*. New York: Praeger, 1972.

————. "Une statue malchanceuse 'La République' de Jean-François Soitoux," *Gazette des Beaux-Arts* 6 (October 1963): 229–40.

Locquin, J. "Un grand statuaire romantique, Auguste Préault 1809–79." *La renaissance de l'art français et des industries de luxe*, November 1920, 454–63.

Ludovici, A. M., ed. *Personal Reminiscences of Auguste Rodin*. Philadelphia: J. B. Lippincott, 1926.

Mabille de Poncheville, A. *Carpeaux inconnu ou la tradition recueillie.* Brussels and Paris: G. van Oest, 1921.

McWilliam, N. "David d'Angers and the Panthéon Commission: Politics and Public Works under the July Monarchy." *Art History* 5 (1982): 426–46.

Mangeant, P.-E. "Antoine Etex, peintre, sculpteur et architecte 1808–1888." *Réunion des Sociétes des Beaux-Arts des départements* 18 (1894): 1363–1402.

Mirolli, R. B., and J. Van Nimmen. *Nineteenth-Century French Sculpture: Monuments for the Middle Class.* Louisville, Ky.: J. B. Speed Art Museum, 1971.

Mittig, H.-E., and V. Plagemann, eds. *Denkmäler im 19 Jahrhundert.* Munich: Prestel-Verlag, 1972.

Mower, D. "Antoine-Augustin Préault (1809–1879)." *Art Bulletin* 63 (June 1981): 288–307.

Ottin, A. *Esquisse d'une méthode applicable à l'art de la sculpture.* Paris, 1864.

————. *Méthode élémentaire du dessin.* Paris, 1868.

————. *Rapport sur l'enseignement du dessin à l'exposition universelle de Paris en 1878.* Paris, 1879.

Pauli, H., and E. B. Ashton, *I Lift My Lamp: The Way of a Symbol.* New York and London: Appleton-Century-Crofts, 1948.

Petroz, P. *L'art et la critique en France depuis 1822.* Paris, 1875.

Philadelphia Museum of Art. *The Second Empire 1852–1870: Art in France under Napoleon III.* Philadelphia: Philadelphia Museum of Art, 1978.

Pingeot, A. *Images de Jeanne d'Arc.* Paris: Hôtel de la Monnaie, 1979.

————. *La sculpture française au XIXe siècle.* Paris: Editions de la Réunion des musées nationaux, 1986.

Planche, G. "Le fronton du Panthéon. *Revue des deux mondes,* 4e sér., 11 (1837): 410–34.

Provoyeur, P., and J. Hargrove. *Liberty: The French-American Statue in Art and History.* New York: Harper & Row, 1986.

Rheims, M. *La sculpture au XIXe siècle.* Paris: Arts et métiers graphiques, 1972.

Rodin, A. *Cathedrals of France.* Trans. E. C. Geissbuhler. Boston: Beacon Press, 1965.

Saalman, H. *Haussmann: Paris Transformed.* New York: George Braziller, 1971.

Segard, A. *Albert Carrier-Belleuse 1824–1887.* Paris: Librairie Ollendorff, 1928.

Silvestre, T. *Les artistes français.* 2 vols. Paris: Les éditions O. Crès & Cie., 1926.

Tancock, J. L. *The Sculpture of Auguste Rodin.* Philadelphia: D. R. Godine, 1976.

Trachtenberg, M. *The Statue of Liberty.* New York: Viking Press, 1976.

Varenne, G. "Carpeaux à l'Ecole de Rome et la génèse d'Ugolin." *Mercure de France,* February 1908, 577–93.

Wagner, A. M. "Art and Property: Carpeaux's Portraits of the Prince Imperial." *Art History* 5 (December 1982): 447–71.

————. *Jean-Baptiste Carpeaux.* New Haven and London: Yale University Press, 1986.

II. Books and Articles on Social and Cultural History

Alagna, A. *Les juifs dans la société française de la révolution de 1789 à l'affaire Dreyfus.* Naples: Liquori, 1975.

Avrich, P. *The Haymarket Tragedy.* Princeton, N.J.: Princeton University Press, 1984.

Beach, V. W. *Charles X of France: His Life and Times.* Boulder: Pruett Pub. Co., 1971.

de Beauvoir, S. *The Second Sex.* New York: Vintage Books, 1974.

Bezucha, R. J. *The Lyon Uprising of 1834: Social and Political Conflict in the Early July Monarchy.* Cambridge: Harvard University Press, 1974.

Blanc, L. *The History of Ten Years, 1830–1840.* 2 vols. London, 1844–45.

Bouvier, J. *Le Krach de l'Union Générale (1878–1885).* Paris: Presses universitaires de France, 1960.

Caron, F. *Histoire de l'exploitation d'un grand réseau.* Paris: Mouton, 1973.

Castagnary, G. *Gustave Courbet et la colonne vendôme, plaidoyer pour un ami mort.* Paris, 1883.

David, H. *The History of the Haymarket Affair.* New York: Farrar & Rinehart, 1936.

Dayot, A. *Histoire contemporaine par l'image d'après les documents du temps 1789–1872.* Paris, n.d.

Dementhe, J. "Histoire de la colonne." *L'Illustration* 62 (16, 23, 30 August, 6, 13 September 1873): 115, 118, 134–35, 150–51, 163, 166–67, 178–79.

Drumont, E. *De l'or, de la boue, du sang.* Paris, 1896.

———. *La dernière bataille.* Paris, 1890.

———. *La France juive.* 2 vols. Paris, 1886.

———. *Le secret de Fourmies.* Paris, 1892.

———. *Le testament d'un antisémite.* Paris, 1891.

———. *Les héros et les pitres.* Paris: E. Flammarion, 1900.

Dubois, M., and A. Terrier. *Les colonies français.* Paris: Augustin Challamel, 1902.

Dupanloup, F. *Etude sur la Franc-Maçonnerie.* 4th ed. Paris, 1875.

———. *La question romaine.* Paris, 1867.

———. *La souveraineté pontificale selon le droit Catholique et le droit européen.* Paris, 1860.

de Falloux, A.-P.-F. *L'évêque d'Orléans.* Paris, 1879.

Gautier, T. *Histoire du romantisme.* Paris, 1874.

Gratz, R. B., and E. Fettmann. "Iacocca's Golden Door: The Selling of Miss Liberty." *The Nation* 241 (9 November 1985): 465–66, 468–76.

Guillemin, A. *Jeanne d'Arc: l'épée de Dieu.* Paris, 1875.

Howarth, T. E. B. *Citizen-King: The Life of Louis-Philippe, King of the French.* London: Eyre & Spottiswoode, 1961.

d'Ideville, H. *Memoirs of Marshal Bugeaud.* 2 vols. London, 1884.

Kulstein, D. I. *Napoleon III and the Working Class.* Los Angeles: The California State Colleges, 1969.

Laboulaye, E. *L'état et ses limites.* 3d ed. Paris, 1865.

Labourieu, T. *Organization du travail artistique en France.* Paris, 1863.

de Lanessan, J.-L. *L'expansion coloniale de la France.* Paris, 1886.

Lightbody, C. W. *The Judgements of Joan.* London: Allen and Unwin, 1961.

Lucas-Dubreton, J. *Le culte de Napoléon 1815–1848.* Paris: A. Michel, 1960.

———. *The Restoration and the July Monarchy.* London: W. Heinemann Ltd., 1929.

Maitron, J. *Dictionnaire biographique du mouvement ouvrier français.* 3 vols. Paris: Editions ouvrières, 1964–66.

Michelet, J. *La sorcière.* Ed. P. Viallaneix. Paris: E. Flammarion, 1966.

Phillips, C. S. *The Church in France, 1848–1907.* New York: Russell & Russell, 1967.

Pinkney, D. H. *The French Revolution in 1830.* Princeton, N.J.: Princeton University Press, 1972.

Remond, R. *The Right Wing in France from 1815 to de Gaulle.* Philadelphia: University of Pennsylvania Press, 1966.

Renan, E. *Pages françaises.* Paris: C. Levy, 1921.

Sanson, R. "La 'fête de Jeanne d'Arc' en 1894, controverse et célébration." *Revue d'histoire moderne et contemporaine* 20 (1973): 444–63.

Tint, H. *The Decline of French Patriotism.* London: Weidenfeld and Nicolson, 1964.

Toussenel, A. *L'esprit des bêtes. Le monde des oiseaux.* 3 vols. Paris, 1859.

———. *L'esprit des bêtes. Zoologie passionnelle.* Paris, 1869.

———. *Les juifs: rois de l'époque.* Paris, 1845.

Veuillot, L. *Mélanges.* 21 vols. Paris, 1856–76.

Warner, M. *Joan of Arc: The Image of Female Heroism.* New York: Knopf, 1981.

Index

Numbers in italics refer to pages with illustrations.

Academy (Académie des Beaux-Arts), 22, 30, 38, 69, 75. *See also* Ecole des Beaux-Arts
Academy at Rome, French, 14, 74
Allegory in art, 60, 65, 99; Arts, 60; Benedictions, 106; Conquered City, 38; Fame, 38; Four quarters of the globe, 78; France (Patrie), 21, 25; Future, 41; History, 25, 38; Joan of Arc (militancy and piety), 87, 88; Jupiter, 68; Justice, 58, 60, 85; Liberty, 6, 25, 37, 38, 58, 85, 113, 115, 122, 125; Peace, 71; Religion, 21, 60; Republic, 6, 58, 105–6, 124–25; Resistance, 41; Science, 60; Victory, 6, 9, 38, 62; War, 38; Work, 45, 88, 105, 106, 108, 111. *See also* Imagery in art
American Civil War, and France, 117–18
Angoulême, Charles de Valois, duc d', 36
Anti-Semitism, 94–95, 97, 102, 148 nn. 17, 19, 20, 22; Anti-Semitic League, 95, 97
Arc de Triomphe de l' Etoile, 3, 33, 36–41, *39, 40, 42, 43,* 55, 63, 83; as honoring the Grande-Armée, 36, 37
Armour & Co. strike, 133
Arrivée du duc d'Orléans au Palais-Royal le 30 juillet 1830 (Vernet), 48
Arthur, Chester A., Pres. USA, 129
Astor family, 124
Awakening of the Arts and of Industry with the advent of Napoleon III, The (Simart), 65

Barbedienne, F., 3, 4, 69
Barre, Jean Jacques, Seal of the Republic, 124, *126*
Barrias, Louis-Ernest, 99
Bartholdi, Frédéric-Auguste, 113, 120–24, 125, 128–29, 131, 139; genesis of *Statue of Liberty,* 115–16, 118–19; *The Curse of Alsace,* 119; *The Lion of Belfort,* 119; *Progress (Egypt Carrying the Light of Asia),* 129; *The Statue of Liberty (Liberty Enlightening the World),* 105, *114,* 113–39
Barye, Antoine Louis, 4, 53, 55, 56; *Lion Crushing a Serpent,* 53, *54,* 55, 56
Baudelaire, Charles Pierre, 33
Bell, Clark, 124
Belmont family, 124
Béranger, Pierre Jean de, 70, 71
Bernini, Giovanni Lorenzo, 16
Berry, duchesse de (Marie-Caroline), 28–30
Bigelow, John, 117, 152 n. 22
Blaine, James G., 131
Blake, Lillie Devereux, 136–37; *Woman's Place Today,* 137
Blanc, Charles, 86
Blanc, Louis, 28, 30, 57
Bonaparte. *See* Napoleon I, Napoleon III
Bonchamps, Charles, General, 21–22

Bonheur, Raimond, 33
Bonheur, Rosa, 33, *35,* 144 n. 22
Bonnechose, Cardinal, Bishop of Rouen, 99, 102
Burghers of Calais, The (Rodin), *101,* 102, 105

Cain and His Race Accursed of God (Etex), 41, *44, 45,* 46
Carpeaux, Jean Baptiste, 4, 69, 70–71, 74–75, 77–78, 80, 83, 85, 94, 146 n. 38, 147 n. 9; *La Danse,* 68, *82,* 83, *84,* 85–87, 88, 89; *La Fiancée,* 85; *The Four Parts of the World,* 78, *79; Génie de la Marine,* 74; *Hector and His Son Astyanax,* 74; *Holy Alliance of the People,* 70–71; *Napoleon III Receiving Abd-el-Kader at Saint Cloud,* 71, *72,* 74; *Neapolitan Fisherboy,* 77; *Princess Mathilde* (bust), 77; *Ugolino and His Sons,* 74, 75, *76,* 77–78; *Why Be Born a Slave? (Negress),* 80, *81,* 83
Carrier-Belleuse, Albert Ernest, 4–5, 6, 68, 69–70; *Etudes de figures appliquées à la décoration* (album), 70; *Hebe,* 68
Cavaignac, Louis Eugène, General, 45, 57
Chambord, Comte de, 88
Chapu, Henri, 99; *Joan of Arc at Domrémy,* 99, *100*
Charles X, 22, 24, 25, 28, 30, 31, 36, 88
Chateaubriand, François René de, 24
Chaudet, Antoine Denis, 8; Vendôme Column, 8–9
Chesneau, Ernest, 74, 78, 70, 144 n. 22
Chez l'usurier (Juglar), 95, *96*
Christina, Queen of Sweden, 28, 30
Clésinger, Auguste, *Figure of the Republic,* 125, *127*
Cleveland, Grover, Pres. USA, 130, 131, 134
Commission des Monuments Historiques, 36
Commune, 6, 9, 87, 88, 92, 118, 119–23
Condé, Louis II. *See* Grand Condé
Constitution (Feuchère), 58, 60
Cooper, Peter, 121, 128
Cordier, Charles-Henri-Joseph, 78, 80, 94, 146 n. 39
Cortot, Jean-Pierre, 33, 37, 41, 48, 141 n. 18; *Triumph of Napoleon I (1810),* 38, *39,* 48
Coudert, Frédéric René, 124, 128, 133
Courbet, Gustave, 1, 6; *Stone-Breakers,* 111
Crawford, Thomas, 122; *The Statue of Liberty* (U.S. Capitol), 122
Credo (Frémiet), 92, 97
Curse of Alsace, The (Bartholdi), 119
Cuvier, Baron Georges, 27, 53

Dalou, Jules, 4, 69, 70, 106, 108, 111; *Estates General, Meeting of 23 June 1789 (Mirabeau Re-*

sponding to Dreux-Brézé), 108; *Jean-Edme Le-claire* (monument), 108, *109; Monument to Workers,* 108, *110; Triumph of the Republic,* 105–6, 108

Dana, Charles A., 124

Danse, La (Carpeaux), 68, 82, 83, *84,* 85–87, 88, 89

d'Argout, Comte, 27

Darwin, Charles, 80, 83

Darwinian theory, 80, 92, 94

Daumier, Honoré, 1, 33, 48, 50; *Ratapoil,* 66; *Rue Transnonain,* 48, 50, *51*

David (Bernini), 16

David, Jacques Louis, 1, 3, 18, 27

David d'Angers, Pierre Jean, 3, 9, 16–27, 46, 48, 58, 65, 106, 143 n. 40; *The Death of General Bon-champs,* 20, 21–22; *The Grand Condé,* 16, 17, 18, 21; *Memorial to Marco Botsaris,* 22, *23,* 24; *Pediment of the Pantheon,* 25, *26,* 27; *Recep-tion of the Duke of Angoulême at the Tuileries after the Spanish War,* 22

Davis, Jefferson, 122

d' Azeglio, Massimo, 3

Death of General Bonchamps, The (David d'Angers), *20,* 21–22

de Biez, Jacques, 94, 95, 97, 102

Delacroix, Eugène, 1, 9, 22, 24, 25, 30, 121; *Greece Expiring on the Ruins of Missolonghi,* 24; *Lib-erty Leading the People,* 1, *2,* 14, 25, 30, 121; *Massacre at Scios,* 24, 77

de Lesseps, Ferdinand, 128–31, 152 n. 22

Depew, Chauncey M., 134–35, 137

Documents inédits de l'Histoire de France (Guizot), 36

Dreyfus Affair, 13, 95, 97, 102

Drumont, Edouard, 94–95, 97, 102, 148 nn. 17, 20; *La France juive,* 94–95; *Les héros et les pitres,* 97, *98*

du Guesclin, Bertrand, 16, 95

Dumont, Augustin-Alexandre, 9; Vendôme Col-umn, 7

Dupanloup, Félix Antoine Philibert, Bishop of Orléans, 87, 88, 92, 95, 99, 146 nn. 49, 50, 147 n. 10; promoted Joan of Arc as cult figure, 89, 147 n. 6, 149 n. 29

Dupin, André Marie Jean Jacques, 46, 48–49

Duret, Francisque, 70

Duseigneur, Jean, 30–32; *Roland furieux,* 30–31, *32; Satan Vanquished by the Archangel Saint Michael, Announcing God's Reign,* 31

du Sommerard, Alexandre, 36

Ecole de Chartes, 36

Ecole de dessin, 69, 70

Ecole de dessin pour des jeunes filles, 69

Ecole des Beaux-Arts, 5, 14, 68–69, 70; Union Cen-trale des Beaux-Arts appliqués à l'industrie, 68. *See also* Academy

Eiffel Gustave, 128

1815 (Peace) (Etex), 41, *43*

1814 (Resistance) (Etex), 41, *42*

Émeric-David, Touissaint Bernard, *Recherches sur l'art statuaire,* 5

Enghien, duc d' (Louis Antoine Henri de Bourbon-Condé), 21

Estates General, Meeting of 23 June 1789 (Mira-beau Responding to Dreux-Brézé) (Dalou), 108

Etat et ses limites, 116, 117, 121

Etex, Antoine, 3, 4, 5, 33, 37–38, 41–46, 53, 68–69, 141 n. 18; *Cain and His Race Accursed of God, 41, 44,* 45, 142 n. 32; *1815 (Peace),* 41, *43; 1814 (Resistance),* 41, *42; Olympia Abandoned in the Hebrides Islands,* 46; *Paris Imploring God for the Victims of the Cholera in 1832,* 46; *Sainte-Geneviève,* 46

Evarts, William Maxwell, 124, 132, 137

Falguière, Jean Alexandre Joseph, 4, 6, 70; *Switzer-land Welcoming the French Army,* 6; *The Wrestlers,* 6

Fauveau, Félicie de, 28, 30, 99; *Judith and Holo-phernes,* 30; *Queen Christina of Sweden Refus-ing to Spare the Life of Her Equerry Monalde-schi,* 28, *29; Subject based on Sir Walter Scott's novel, The Abbey,* 28

Feminine Mystique, The (Friedan), 137

Ferry, Jules, 94, 124, 130–31

Feuchère, Jean-Jacques, 4, 5, 31, 33, 58, 60, 68; *Constitution,* 58, 60; *Napoleon Crossing the Pont d'Arcole* (Arc de Triomphe), 33; *Satan,* 31, 33, *34*

Fiancée, La (Carpeaux), 85

Field, Cyrus, 121, 129

Figure of the Republic (Clésinger), 125, *127*

Figure of the Republic (Soitoux), 58, *59,* 125, 143 n. 4

Foucart, J.-B., 70, 71, 74

Fould, Achille, 69, 74

Fourier, Charles, 48

Four Parts of the World, The (Carpeaux), 78, *79*

France juive, La (Drumont), 94–95

Franco-American Union, 121, 123, 125, 128, 129, 131

Franco-Prussian War, 6, 9, 99, 102, 118–19, 122

Frémiet, Emmanuel, 89, 92, 94, 95, 97; *Credo,* 92; *Gorilla Carrying off a Human Female, 93,* 94; *The Grand Condé,* 92; *Joan of Arc on Horse-back,* 13, 89, *90,* 92; *Orang-utan Strangling a Native of Borneo,* 94

Friedan, Betty, *The Feminine Mystique,* 137

Gaget, Gauthier & Co., 128

Gambetta, Léon, 99, 119, *120*

Garnier, Charles, 68

Gasparin, Agénor, 118

Gates of Hell (Rodin), 106, 150 n. 33
Génie de la Marine (Carpeaux), 74
Geoffroy St.-Hilaire, Étienne, 55
George, Henry, 132–33, 134, 136, 137, 152 n. 30; *Progress and Poverty,* 132, 137
Géricault, Théodore, 1; *Raft of the Medusa,* 77
Godwin, Parke, 124
Gorilla Carrying off a Human Female (Frémiet), 93, 94, 97
Grand Condé, the, 16, 21, 95
Grand Condé, The (d'Angers), 16, *17,* 18, 21
Grand Condé, The (Frémiet), 92
Grant, Ulysses S., Pres. USA, 121, 124
Greece Expiring on the Ruins of Missolonghi (Delacroix), 24
Grévy, Jules, 123, 124
Gros, Antoine Jean, 18; *Napoleon at Arcole,* 18
Guérin, Pierre-Narcisse, *Portrait of Henri de La Rochejacquelein,* 18, *19*
Guillaume, E., 5, 68
Guillemin, A., *Jeanne d'Arc: l'épée de Dieu,* 89
Guizot, François, 27, 36, 37; *Documents inédits de l'Histoire de France,* 36

Haussmann, Georges Eugène, 68, 70
Hayes, Rutherford B., Pres. USA, 129
Haymarket affair, 132, 133
Hebe (Carrier-Belleuse), 68
Hector and His Son Astyanax (Carpeaux), 74
Héros et les pitres, Les (Drumont), 97, *98*
Hewitt, Abram, 128, 133, 151–52 n. 18
Histoire du Consulate et de l'Empire (Thiers), 37
Holy Alliance of the People (Carpeaux), 70–71
Houssaye, Arsène, 69, 144 n. 22
Hugo, Victor, *Notre-Dame de Paris,* 30, 33, 105
Hundred Days (Napoleon I), 8, 13, 18, 65

Iacocca, Lee, 138
Imagery in art, 68; animal, 53, 55, 97; astrology, 55; ethnicity, 78, 80; lion (as symbol of royalty and government), 55, 56; serpent (as symbol of anarchy), 55; sexual fantasy, 80, 83, 85–86; slavery, 24, 80. *See also* Allegory in art; Anti-Semitism; Racism; Sexism
Ingres, Jean-Auguste-Dominique, 14–15

Jaurès, Admiral, 131
Jean-Edme Leclaire (Dalou), 108, *109*
"Jeanne d'Arc, A" (Laparade), 88–89
Jeanne d'Arc et le sentiment national (Lemire), 99, *100*
Jeanne d'Arc: l'épée de Dieu (Guillemin), 89
Joan of Arc, 87, 92, 97, 99; as symbol, 87, 88, 89, 95, 102, 147 n. 4
Joan of Arc at Domrémy (Chapu), 99, *100*
Joan of Arc on Horseback (Frémiet), 13, 89, *90,* 92
John the Baptist (Rodin), 102, 149–50 n. 33

Judith and Holophernes (Fauveau), 30
Juglar, Victor-Henri, *Chez l'usurier,* 95, *96*
Juifs, Les: rois de l'époque (Toussenel), 97
July Monarchy, 5, 8, 9, 16, 25–55, 57, 60, 62, 65
July Revolution. *See* Revolution of 1830

King Henri IV (Lemot), 8, 16
Klagmann, Jean-Baptiste-Jules, 5, 68
Knights of Templar, secret society, 33

Labor organizations, France: 5, 38; Association Internationale de Travailleurs, 3; Société de Crédit Mutual des Ouvriers de Bronze, 3; USA: Knights of Labor, 136
Labor unrest, France: 48, 49–50, 55–56, 86, 105, 106, 120; USA: 132–34, 136
Laboulaye, Edouard-René Lefebvre de, 115–18, 120–24, 129; *L'état et ses limites,* 116, 117, 121
Lafayette, Marquis de, 27, 117
Lafayette, Oscar de, 118
Lamarque, Maximilien, General, 24, 27, 37, 49
Laparade, Victor de, "A Jeanne d'Arc," 88–89
Laplace, Pierre Simon de, 25
La Rochejacquelein, Henri de, 18, 21
La Rochejacquelein, Louis de, 18
Lasteyrie, Jules de, 118
Lazarus, Emma, 137; "The New Colossus," 137
Lefuel, Hector Martin, 74
Légion d'honneur: received by David d'Angers, 22; by Barye, 53; by Bonheur, 144 n. 22
Legitimists, 88, 123
Lemaire, Philippe Joseph Henri, 3
Lemire, Charles, 99; *Jeanne d'Arc et le sentiment national,* 99, *100*
Lemot, François-Frédéric, 8, 16; *King Henri IV,* 8
Liberty (Pradier), 37
Liberty Enlightening the World. See *Statue of Liberty*
Liberty Leading the People (Delacroix), 1, *2,* 9, 14, 25, 30, 121
Lion Crushing a Serpent (Barye), 53, *54,* 55, 56
Lion of Belfort, The (Bartholdi), 119
Longfellow, Henry Wadsworth, 121
Louis XIII, 15
Louis XIV, 15, 16
Louis XV, 15
Louis XVI, 15
Louis XVIII, 16
Louis-Napoleon. *See* Napoleon III
Louis-Philippe, 28, 30, 31, 33, 62; and anticlericalism of masses, 25, 36; and efforts to co-opt Bonapartist legacy, 8, 36, 37, 41, 62–63, 112; and fear of effigy vandalism, 55, 60; instability of reign, 48, 50, 56

McCormick Harvester strike (Haymarket affair), 133

McGee, James, 128

MacMahon, Maréchal, Marie Edme Patrice Maurice de, 123

Malesherbes, Chrétien Guillaume de Lamoignon de, 27

Marat, Jean Paul, 25

Marceau, François, General, 48

"Marianne," secret society, 77

Marseillaise, The (The Departure of the Volunteers of 1792) (Rude), 38, *40,* 41, 48

Marti, José, 115, 119

Martin, Henri, 118

Marx, Karl, 86

Massacre at Scios (Delacroix), 24, 77

Meade, George G., 121

Medal of the Republic (Oudiné), 124–25, *126*

Meissonier, Louis-Ernest, *Recollection of Civil War,* 48, 143 n. 39

Memorial to Marco Botsaris (David d'Angers), 22, 23, 24

Mendicity (Préault), 46

Méryon, Charles, 33

Metternich, Prince Clemens von, 22

Michelet, Jules, 33, 48

Millet, Jean François, *The Sower,* 111

Mirabeau, Honoré Gabriel Riqueti, 25

Mitterand, François, Pres. France, 138

Montfort, Amélie-Clotilde de (wife of Carpeaux), 85

Monument to Workers (Dalou), 108, *110*

Morgan, Edwin D., 124

Napoleon I (Napoleon Bonaparte), 8–9, 16, 18, 21, 25, 36, 37, 60, 71, 117; tomb in the Invalides, 60, *61, 63*–65. *See also* Hundred Days; Return of the Ashes

Napoleon III (Louis-Napoleon Bonaparte), 46, 62, 65–66, 69, 70, 75, 89, 116; capitalizing on Napoleonic image, 9, 60, 63, 65, 68, 71, 112; and Carpeaux, 71–72, 74; as emperor of Second Empire, 57; and fall, 88, 120; and political captives, 77, 78; as president of Second Republic, 57, 58, 60; realism in art during reign, 66, 68, 83

Napoleon at Arcole (Gros), 18

Napoleon Awakening to Immortality (Rude), 66, 67

Napoleon I in a Frock Coat (Seurre), *10*

Napoleon III Receiving Abd-el-Kader at Saint Cloud (Carpeaux), 71, *72, 74*

Nast, Thomas, "Liberty is not Anarchy" (cartoon), 134, *135*

Neapolitan Fisherboy (Carpeaux), 77

"New Colossus, The" (Lazarus), 137

Newspapers and journals, France: *L'Artiste,* 97; *Le Bonnet Rouge,* 122; *Le Constitutionnel,* 45; *Le Français,* 92; *L'Illustration,* 95; *Journal de dé-* *bats,* 53; *La Liberté,* 30; *La libre parole,* 95; *Le Moniteur Universel,* 85; *Le Temps,* 86; *Tribune,* 49; *L'Univers,* 86, 92; USA: *The Alarm,* 134; *Harper's Weekly,* 134, 136; *The New York Times,* 132, 137; *The New York World,* 131–32, 133, 136

Nieuwerkerke, Count Emilien, 58, 60, 68, 69, 71, 74, 89, 144 n. 22, 147 n. 13

Noisot, Claude, 60, 65–66

Notre-Dame de Paris (Hugo), 30, 33, 105

Oath of the Horatii (David), 1

Oath of the Tennis Court (David), 1

Olympia Abandoned in the Hebrides Islands (Etex), 46

Orang-utan Strangling a Native of Borneo (Frémiet), 94

Orléanists, 88, 92, 99, 122–23

Orléans, duc d' (Ferdinand Philippe), 55, 56

Orsini, Felice, 77

Oudiné, Eugène-André, 63; Medal of the Republic, 124–25, *126*

Pacification of Civil Troubles (Simart), 63, *64, 65*

Panama Canal, 128, 129, 130, 131

Pantheon, 16, 24, 25, 27

Paris, Comte de, 88

Paris Imploring God for the Victims of the Cholera in 1832 (Etex), 46

Parsons, Albert R., 134

Parsons, Lucy, 136

Pediment of the Pantheon (David d'Angers), 16, 25, *26,* 27

Petite Ecole, 14

Phrygian bonnet (red cap), symbol of liberty, 25, 58, 121–22, 125

Pillet, F., 48

Pinchot, James W., 124

Planche, Gustave, 25, 27

Portrait of Henri de La Rochejacquelein (Guérin), 18, *19*

Pradier, James, 4, 14; *Liberty,* 37; *Public Order,* 37

Préault, Antoine Auguste, 33, 46, 48, 50, 53; Gabriel Laviron (bust), 46; *Mendicity,* 46; *Tuerie [Slaughter],* 46–48, *47,* 50, 53; *Two Poor Women,* 46

Princess Mathilde (bust) (Carpeaux), 77

Prix de Rome, 14–15, 70, 71, 74

Progress (Egypt Carrying the Light of Asia) (Bartholdi), 129

Public Order (Pradier), 37

Pulitzer, Joseph, 131–32

Queen Christina of Sweden Refusing to Spare the Life of Her Equerry Monaldeschi (Fauveau), 28, *29*

Racism, France: 50, 53, 80, 94–95, 147 n. 14; USA: 136

Raft of the Medusa (Géricault), 77

Ratapoil (Daumier), 66

Reagan, Ronald, Pres. USA, 115

Reception of the Duke of Angoulême at the Tuileries after the Spanish War (David d'Angers), 22

Recherches sur l'art statuaire (Emeric-David), 5

Recollection of Civil War (Meissonier), 48

Red cap. *See* Phrygian bonnet

Reid, Whitelaw, 124

Rémusat, Charles de, 60, 62, 118

Republic (Roguet), 58, 60

Republic, Second: 33, 57, 58, 60; Third: 5, 6, 9, 88–108, 112, 122–23, 130

Republic of 1848. *See* Second Republic

Restoration, 16, 18–24, 28, 33, 36, 38, 112

Return of the Ashes, 60, 62, 66

Revolution of 1789, 15, 16, 25, 38, 63

Revolution of 1830 (July Revolution), 24, 30, 36, 37, 55, 56, 65–66

Reynaud, Jean, 45, 142 n. 32

Rodin, Auguste, 4–5, 6, 69, 70, 83, 102, 105, 106, 108, 111, 149–50 n. 33; *The Burghers of Calais, 101,* 102, 105; *Gates of Hell,* 106, 150 n. 33; *John the Baptist,* 102, 149–50 n. 33; *The Thinker,* 13; *Tower of Labor,* 106, *107,* 108, 151 n. 38

Roguet, Louis, *Republic,* 58, 60

Roland, Philippe-Laurent, 18

Roland furieux (Duseigneur), 30–31, *32*

Roosevelt, Theodore, 133

Rothschild, Alphonse de, 105, 149 n. 33, 150 n. 34

Rousseau, Jean Jacques, 25–27

Royal Volunteers of La Rochejacquelein, 18

Rude, François, 3, 33, 37–38, 41, 46, 48, 66, 70, 89, 141 n. 18, 145 n. 28; *The Marseillaise (The Departure of the Volunteers of 1792),* 38, *40, 41; Napoleon Awakening to Immortality,* 66, 67

Rue Transnonain (Daumier), 48, 50, *51*

Sainte-Geneviève (Etex), 46

Saint-Marc Girardin, François Auguste, 53

Saint Pierre, Eustache de, 102, 105, 149 n. 33

Saint-Simon, Comte de, 48

Saint-Simonists, 33, 45, 49

Salon, Paris, 4, 85; exhibitions: (1817), 18; (1827), 22, 28; (1831), 30, 31; (1833), 41, 46, 48, 55; (1834), 31, 48, 50; (1842), 30, 46; (1850–51), 48; (1853), 71; (1857), 146 n. 39; (1859), 92; (1861), 71; (1863), 75, 77; (1869), 80; (1870), 99; (1873), 95; (1875), 6

Satan (Feuchère), 31, 33, *34*

Satan Vanquished by the Archangel Michael, Announcing God's Reign (Duseigneur), 31

Schnetz, Director, 74, 75

Seal of the Republic (Barre), 124, *126*

Second Empire, 5, 9, 57–58, 60, 68–70, 88, 99, 118; realism in art during regime, 66, 68, 70, 75, 77, 83, 85–87

Second Republic, 33, 57, 58, 60

Seurre, Charles-Emile-Marie, 9, 37; *Napoleon I in a Frock Coat, 10*

Sexism, France: 80–81, 85; USA: 136–37

Sheridan, Philip H., 121

Simart, Pierre-Charles, 14–15; *The Awakening of the Arts and of Industry with the advent of Napoleon III,* 65; *Pacification of Civil Troubles, 63, 64,* 65; tomb for Napoleon, 60, 63

Simon, Jules, 95

Société des Droits de l'Homme, 49

Soitoux, Jean-François, 58; *Figure of the Republic, 58, 59,* 125, 143 n. 4

Soult, Maréchal, Nicholas Jean de Dieu, 27, 56

Sower, The (Millet), 111

Spaulding, Henry Foster, 124, 132

Statue of Liberty, The (Liberty Enlightening the World) (Bartholdi), 105, *114,* 113–39; centennial, 115, 138; corporate commercialization of, 138–39; meaning of, 113, 115, 119, 122, 125, 131, 134, 136; support for construction, 118, 121, 123, 124, 128–30, 131–32; as symbol for immigrants, 118, 137; as symbol for laborers, 132–34; as symbol of relationship between France and U.S., 113, 116–17, 121, 125, 128, 132, 138; and women's movement, 136–37

Statue of Liberty, The (U.S. Capitol) (Crawford), 122

Stone-Breakers (Courbet), 111

Subject based on Sir Walter Scott's novel, The Abbey (Fauveau), 28

Submission of Abd-el-Kader, The (Tissier), 71, 73

Suez Canal, 80, 83, 128–29

Sumner, Charles, 118, 121

Switzerland Welcoming the French Army (Falguière), 6

Temple of Great Men. *See* Pantheon

Thiers, Adolphe, 27, 88, 95, 120, 122, 141 n. 18, 143 n. 37; and influence on Arc de Triomphe, 33, 37–38, 41, 48; *Histoirie du Consulate et de l'Empire,* 37

Thinker, The (Rodin), 13

Third Republic, 5, 6, 9, 88–108, 112, 122–23, 130

Thoré, Théophile, 4, 66, 140 n. 11

Tissier, Jean-Baptiste Ange-, *The Submission of Abd-el-Kader,* 71, 73

Tocqueville, Hippolyte de, 118

Toussenel, Alphonse, 97; *Les juifs: rois de l'epoque,* 97

Tower of Labor (Rodin), 106, *107,* 108, 151 n. 38

Triumph of Napoleon I (1810) (Cortot), 38, *39,* 48

Triumph of the Republic (Dalou), 105–6, 108

Trotter, James Monroe, 136
Tuerie [Slaughter] (Préault), 46, 47, 48, 50
Two Poor Women (Préault), 46

Ugolino and His Sons (Carpeaux), 74, 75, 76, 77–78

Vendôme Column, 7, *10–12*, 21, 37, 38, 106, 121; honoring the Grande-Armée, 8, 36; Reinterpreted politically, 8–9, 16, 58
Vernet, E. J. Horace, *L'arrivée du duc d'Orléans au Palais-Royal le 30 juillet 1830*, 48
Veuillot, Louis-François, 86, 87, 92
Villa Medici, 14
Viollet-le-Duc, Eugène Emmanuel, 33, 36
Visconti, Louis-Tullius-Joachim, 60, 63
Vitet, Ludovic, 36
Voltaire, François Marie Arouet, 25–27, 89, 99; *La Pucelle d'Orléans*, 89

Why Be Born a Slave? (Negress) (Carpeaux), 80, *81*
Wolowski, Louis François Michel Raymond, 118
Woman Suffrage Association, 136–37
Woman's Place Today (Blake), 137
Wrestlers, The (Falguière), 6

Zola, Emile, 13, 83, 85, 102